PHOENIX
THEN & NOW

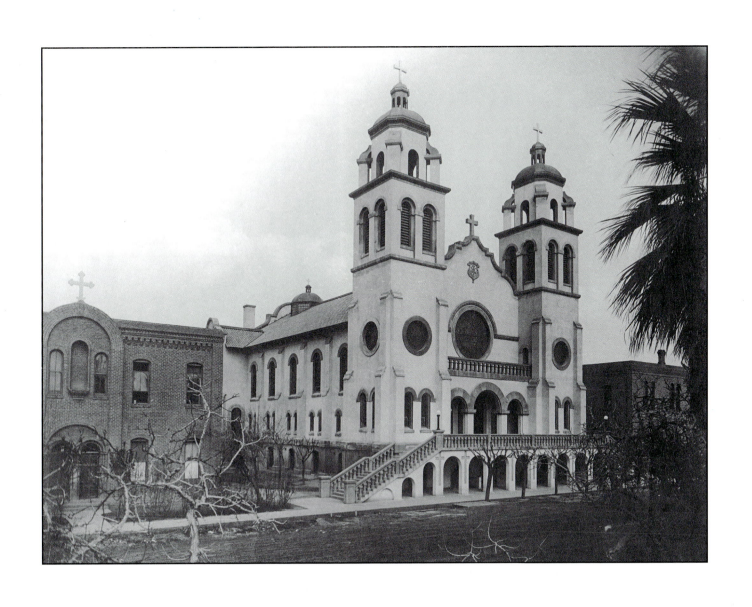

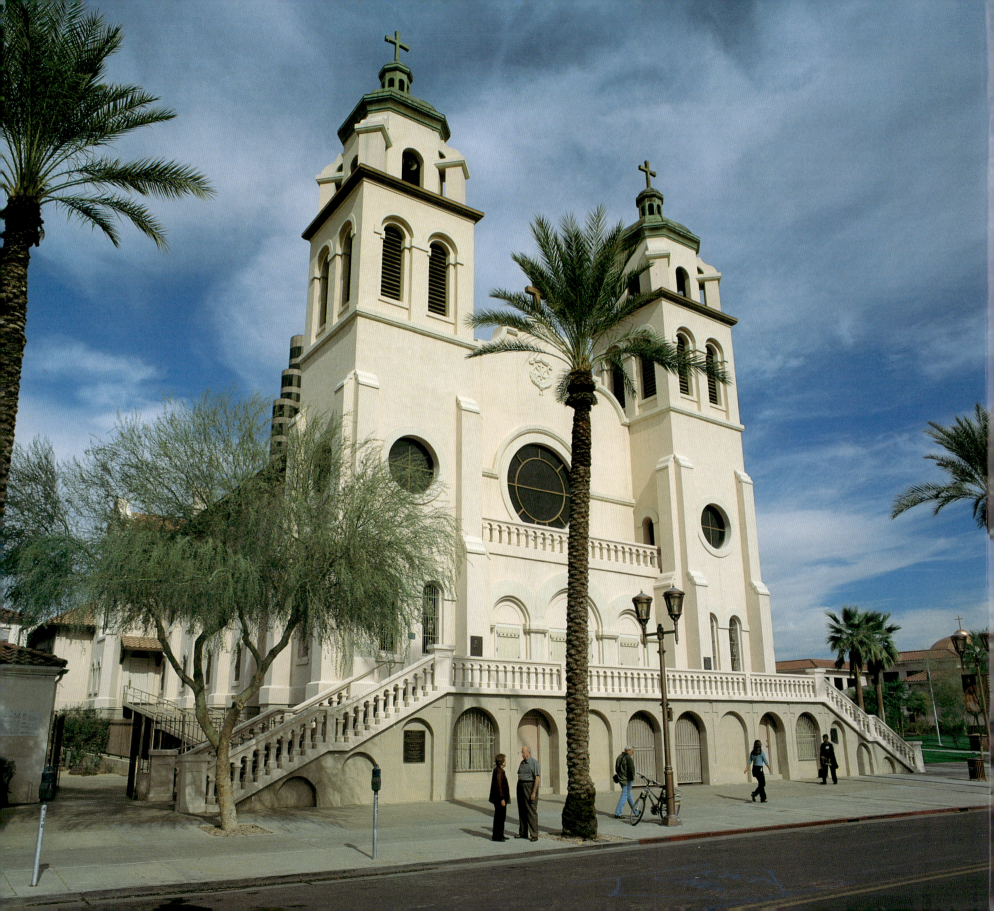

PHOENIX THEN & NOW

PAUL SCHARBACH AND JOHN H. AKERS

THUNDER BAY
P·R·E·S·S

San Diego, California

Thunder Bay Press
An imprint of the Advantage Publishers Group
5880 Oberlin Drive, San Diego, CA 92121-4794
www.thunderbaybooks.com

Produced by PRC Publishing
The Chrysalis Building
Bramley Road, London W10 6SP, England

An imprint of **Chrysalis** Books Group plc

Library of Congress Cataloging-in-Publication Data
Scharbach, Paul.
 Phoenix then & now / Paul Scharbach and John Akers.
 p.cm.
 ISBN 1-59223-302-3
 1. Phoenix (Ariz.)--Pictorial works. 2. Phoenix (Ariz.)--History--Pictorial works. I.
Title: Phoenix then and now. II. Akers, John. III. Title.

F18.P57S35 2005
979.1'73'0222--dc22. 2004065927

Printed and bound in China

1 2 3 4 5 09 08 07 06 05

Acknowledgments

The authors would like to thank Victoria and Marcus Scharbach and Cathleen, John,
and Judy Akers. A special dedication to the McCulloch brothers (James and William),
whose early commercial photography in Phoenix made many of the wonderful historical
images possible. Also to Herb and Dorothy McLaughlin, who purchased all of the original
McCulloch photographs and later donated those and all of the images they took of
Arizona over the years to the Arizona State University Library. Thanks to Jim Todd of
Todd Photographic Services for providing the "now" aerial photographs, and all the
individuals and companies that granted access to buildings, rooftops, etc. Without this
access, many of the "now" photographs would not have been successful comparisons to
their "then" counterparts. Thanks to the staff of the Arizona Collection at Arizona State
University, Tom Canasi, Amy Douglass, Christine Moore, the staff of the Arizona Room
at the Phoenix Burton Barr Central Library, the staff of the Scottsdale Historical Society,
Carol St. Clair, and Anna Uremovich. John would especially like to thank John
Jacquemart for the lead. Paul Scharbach can be reached at paul@arizonaimages.com.

Picture Credits

The publisher wishes to thank the following for kindly supplying the photographs that
appear in this book:

Courtesy of Arizona Biltmore Resort: 94
Arizona Historical Society Museum at Papago Park: 8 [AZH-77.57.01], 18 [AZH-
79.95.140], 20 [AZH-1975.48.07C], 60 [AZH-1976.125.07], 64 [AZH-81.164.02], 72
[AZH-1992.78.139], 76 [AZH-89.113.01]
Arizona Historical Society/Tucson: 22 [AHS #23,713], 66 [AHS #PC180-F248-0222]
Courtesy of Arizona Jewish Historical Society: 78
Arizona State University Libraries: Courtesy Forrest Doucette Photographs, Arizona
Collection, Arizona State University Libraries: 36/Courtesy Herb and Dorothy
McLaughlin Collection, Arizona State University Libraries: 48, 52, 58, 86, 90, 128,
134/Courtesy McCulloch Brothers Photographs, Herb and Dorothy McLaughlin
Collection, Arizona State University Libraries: 6, 12, 16, 24, 28, 32, 34, 38, 40, 42, 44, 50,
84, 88, 96, 142
Courtesy Jacques Family, Glendale Arizona Historical Society: 102
Courtesy of Glendale Arizona Historical Society: 104, 106
Collection of Jeremy Rowe Vintage Photography: 14, 30, 46, 68, 70, 98, 100, 130
Courtesy of Kennilworth School: 74
Courtesy the Mesa South West Museum: 92, 136, 138, 140
McClintock Collection, Arizona Room, Phoenix Public Library: 10, 26, 62, 80, 82
Courtesy of Scottsdale Historical Society: 132
Courtesy of St. Mary's Basilica: 1, 54, 56
Courtesy Tempe Historical Museum: 108, 110, 112, 114, 116, 118, 120, 122, 124, 126

All "now" photographs were taken by Paul Scharbach paul@arizonaimages.com
(© Chrysalis Image Library)

INTRODUCTION

While Phoenix might still be young compared to most large American cities, its location has a fascinating story that stretches back well before the city was founded. Hundreds of years before enterprising settlers established Phoenix in central Arizona's Salt River valley, a group of Native Americans, who archaeologists call the Hohokam, made their homes here and built miles of irrigation canals for a series of villages. In the mid-1400s, they suddenly and mysteriously abandoned everything and moved away.

There were no settlements in the area for a few hundred years after that. The United States captured the region in the Mexican-American War in 1848, but it wasn't until 1865, when the U.S. military initiated the development of the Salt River valley, that people decided to establish a town here. Once the army established Camp McDowell on the valley's east end, people flocked to the region to claim the rich farmland, sell food to the fort and nearby mining towns, and make a living.

Phoenix was the first town to get started and it became the center of the Salt River valley's growth. After Phoenix's founders rehabilitated the Hohokam canals, they named their town after the mythical firebird that regenerated itself. In 1870 they established a formal town site that today is between Seventh Avenue and Seventh Street, and Van Buren and the railroad tracks. Today this is Phoenix's downtown, a district of skyscrapers, schools, government buildings, churches, hotels, and warehouses in a variety of architectural styles, such as art deco and Mission Revival.

Phoenix became the seat of the newly created Maricopa County in 1871, although the town did not incorporate until 1881. Once the railroad connected Phoenix to the rest of the country in 1887, the town leaders started to assert themselves. They lobbied for Phoenix to become the territorial capital in 1889 and completed a new neoclassical-Revival capitol building in 1900. Phoenix remained the capital when Arizona gained statehood in 1912.

Several outlying farming towns have become part of metropolitan Phoenix. Tempe, named for the fertile Vale of Tempe in Greece, started on the south bank of the Salt River around 1870. The Mormons started Mesa to the east in 1878. Far out in the northwest, land developer W. J. Murphy founded the town of Glendale in 1892, naming it after the Glendale in California; he banned alcohol there to ensure that he would attract dependable settlers. Northeast of Phoenix, the tiny village of Scottsdale was established in 1894, near where former army general Winfield Scott first homesteaded.

The inhabitants of the valley dreamed of creating an agricultural empire, but water was a big problem in the early years. Salt River floods destroyed irrigation systems in the 1890s, then droughts followed. Completed in 1911, the Roosevelt Dam ensured the water supply and the local economy blossomed as a result. In the 1920s, skyscrapers rose up in Phoenix's downtown, and new resorts, such as the Arizona Biltmore, sprung up in the surrounding desert to attract tourists.

The Phoenix area grew steadily through the 1940s. World War II dynamically transformed the valley from a place of small farming towns to a sprawling metropolis. Attracted by the region's sunny climate, the government built military bases, especially airfields to train pilots. Those servicemen returned with their families after the war seeking jobs and housing, joining in the nation's big postwar migration to the "Sun Belt." Home builders met the insatiable demand for houses by building farther away from the downtown area and creating suburban neighborhoods. The open spaces between the towns eventually disappeared.

Businesses were attracted to the area by the burgeoning work force, and new shopping centers enticed shoppers away from the old downtown. Many offices moved from Phoenix's downtown for new skyscrapers in the uptown district of Central Avenue. Downtown Phoenix suffered from the relocation of businesses and movement away from residential buildings, but things started to change in the 1970s. Small businesses were attracted by the cheap rents, and residents were drawn to historic neighborhoods. Phoenix preserved the last of its original houses in a block-long district called Heritage Square. In the 1990s the City also built two sports venues: America West Arena, home of the National Basketball Association's Phoenix Suns, and Bank One Ballpark, home of the 2001 baseball world-champion Arizona Diamondbacks. Today Phoenix's historic heart, the Copper Square district, is on the verge of a renaissance thanks to the arrival of the biotechnology industry, the promise of a new branch campus for Arizona State University, and the desire of many to experience urban living in new condominiums.

The valley's other cities also underwent similar ebbs and flows of suburbanization, downtown decline, and rebirth. Tempe is transforming the area around the usually dry Salt River bed with a lake. Tempe's Mill Avenue district and its turn-of-the-twentieth-century commercial buildings cater to university students and shoppers alike. Mesa is building a new performing arts center to help revitalize its downtown. Glendale's downtown includes Arizona's largest antiques district. Scottsdale attracts tourists and winter residents to its Western-themed downtown and art galleries. Every year thousands of people move into or visit the Phoenix area. Phoenix is now America's fifth largest city and the region has over 3.5 million people.

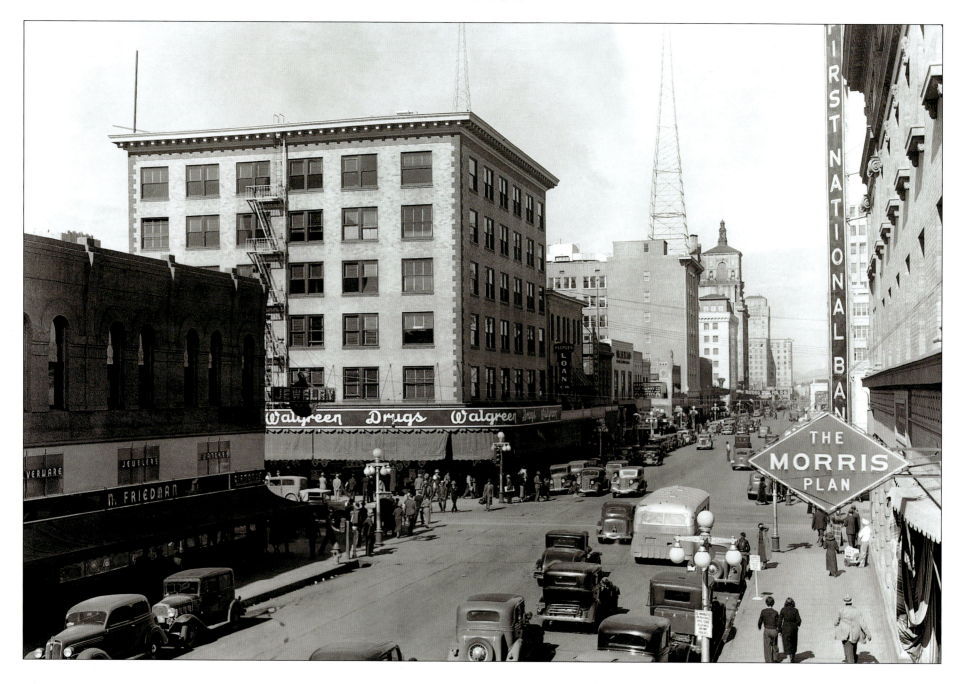

The intersection of Washington Street and Central Avenue, shown here around 1940, was considered Phoenix's "peak land-value intersection," the geographic center of the original Phoenix town site. City residents and visitors from the outlying areas would flock here on Saturdays to shop and see movies, rituals preserved until the 1950s. In the center is the Goodrich Building, which, for many years, housed a Walgreen Drugs complete with a lunch counter. Down Central can be seen the Heard Building (with the radio tower), the Hotel San Carlos, the Security Building (with the ornate tower), and the Hotel Westward Ho. Crossing Central is one of Phoenix's public buses, which completely replaced Phoenix's streetcar system by 1947.

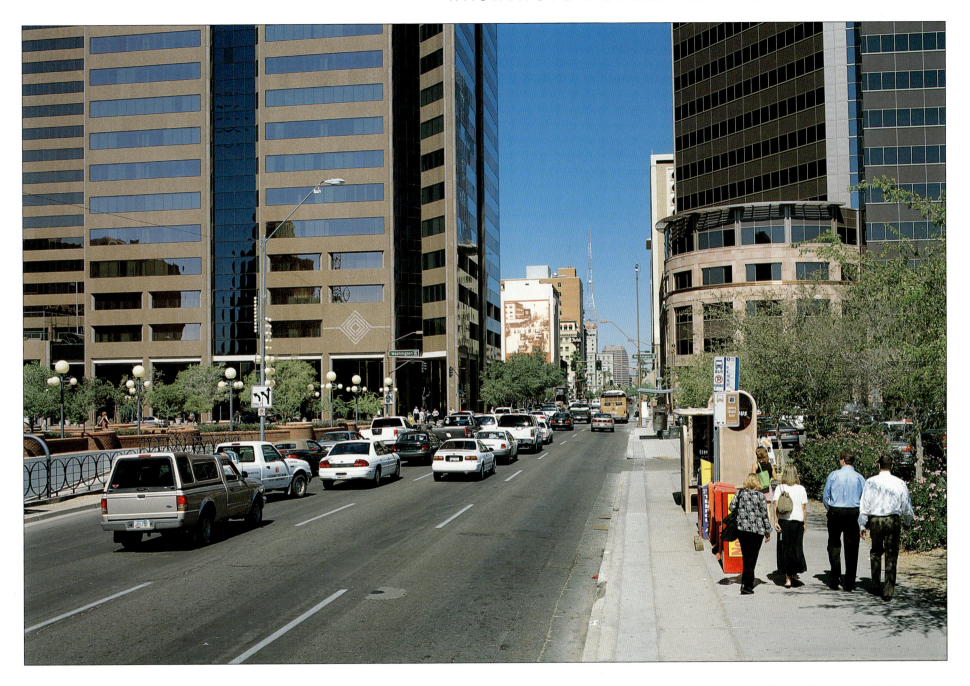

This is now probably one of the most changed intersections in Phoenix. Patriots Park, built in the 1970s, takes up the entire block across the street to the lower left. The area to the lower right is a parking lot. The Goodrich Building is gone, replaced by the towering Renaissance Square. To the right across Washington Street is the Phelps Dodge Tower. Just visible behind it is Arizona's tallest building, the Bank One Center. Down Central Avenue to the left, most of the buildings from the previous view are still standing. Now, at the very end, the Viad Tower stands.

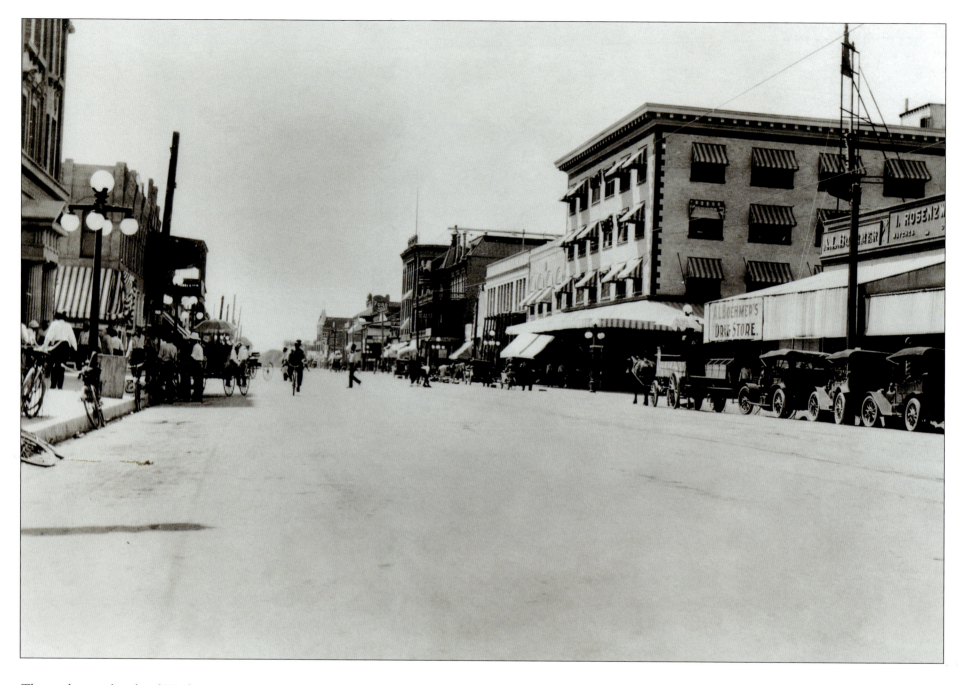

This is the north side of Washington Street, near First Avenue, in the late 1890s. Washington Street, which ran through the center of the original Phoenix town site, was the place for parades, marches, and funeral processions. On the right-hand side of the street, in the far distance, is the Ford Hotel (see the Ford sign). The tall structure to its right with the metal point is the Fleming Building, home to the Phoenix National Bank. The next building down is the Monihan Building. The street also housed retail establishments—the white building in the center of the photo is the Dorris-Heyman Furniture Company, and Alboehmer's Drug Store and a watch store are on the right.

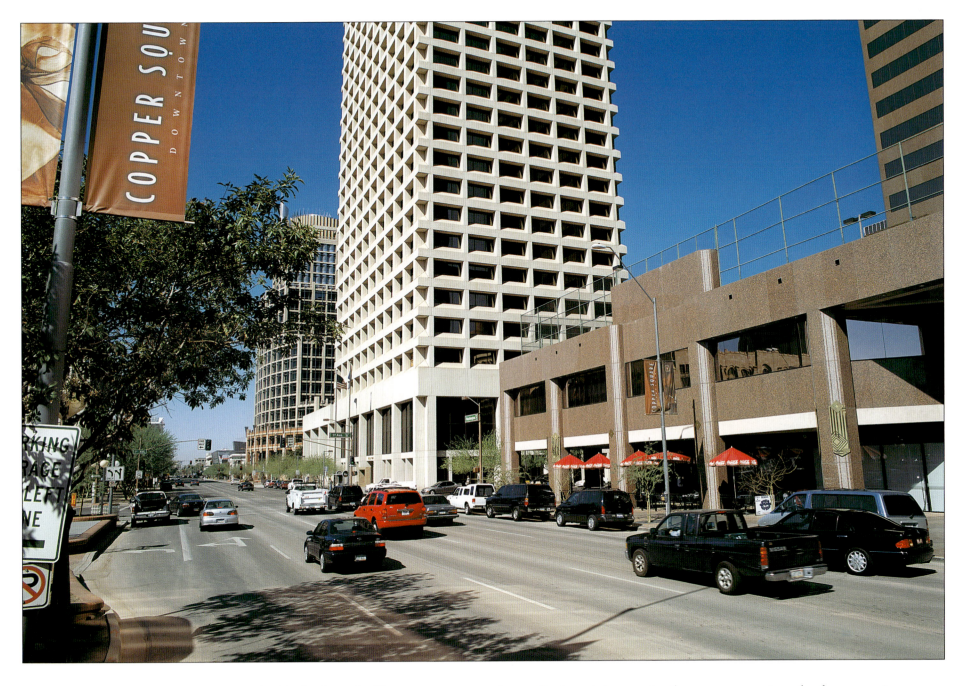

The Wells Fargo skyscraper now sits on the block where the Fleming Building and the Ford Hotel once stood. Before the demolition of both old buildings around 1970, the Fleming continued to look much the way it used to, but the Ford was barely recognizable. The twenty-seven-story Wells Fargo tower, which first belonged to First Interstate Bank, was completed in 1971.

It was the first of three major skyscrapers to go into the downtown in the 1970s. All were banks, and they represented the commitment of the local financial industry to downtown when so many other corporate headquarters were still moving to the uptown section of Central Avenue. Wells Fargo bought out First Interstate in 1996.

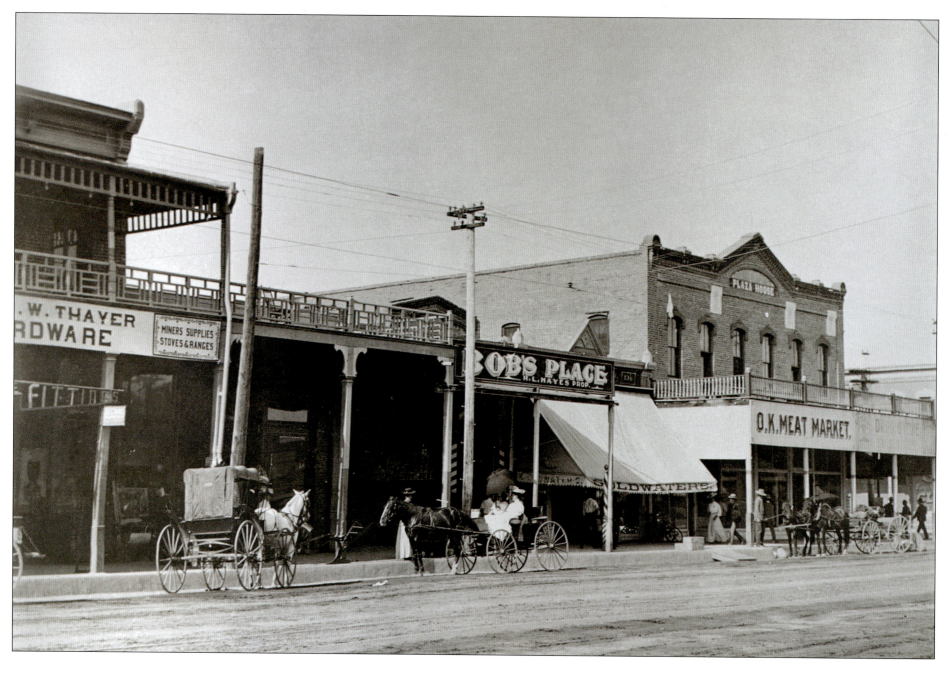

This is the north side of Washington Street, between First and Second streets, around 1900. To the far left is the Ezra W. Thayer Hardware Store, an important early Phoenix business. To the right is Bob's Place Saloon. Next door is the Goldwater Store, which opened in this location in 1899 and was owned by the father of future Arizona Senator Barry Goldwater. The two-story building to the right is the Fry Building. Built in 1885, it was designed by prominent architect James Creighton. The Plaza Boarding House was on the second floor. The building's owners remodeled it around 1929, changing its appearance. To the far right, on the other side of Second Street, is the Dennis Block.

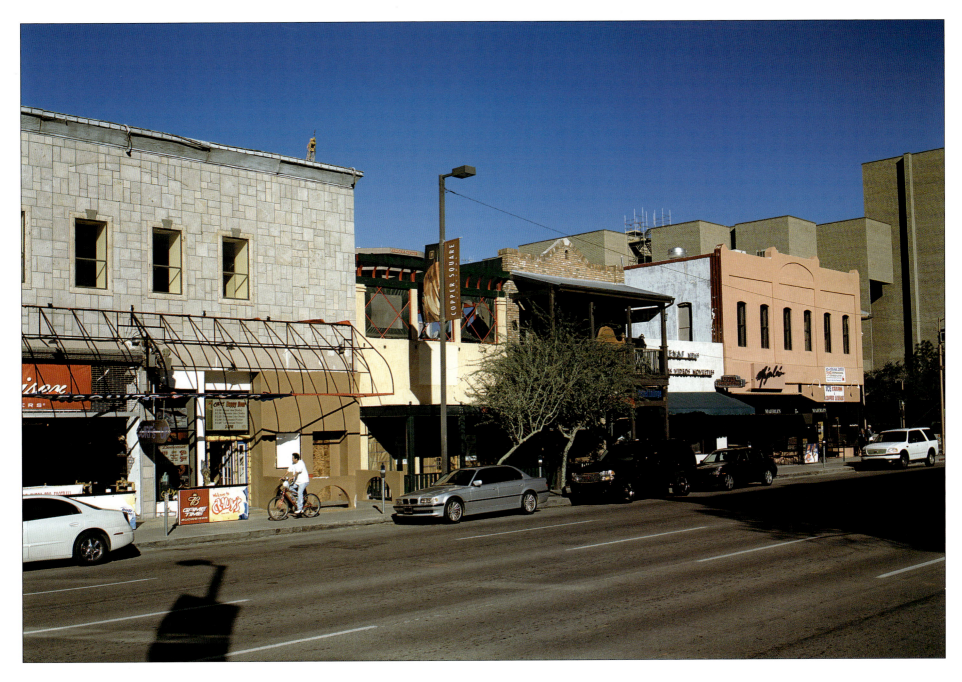

Although some of the buildings on Washington between First and Second streets have changed, this is still one of the most intact blocks left in downtown Phoenix. A modern multistory building now sits just to the left of the old Thayer Building. Several of the storefronts, including the Thayer Building, now feature restaurants, taking advantage of their close location to the America West Arena—home of the NBA's Phoenix Suns—which is just a block to the south. The arena's construction brought in many new businesses, including Majerle's Sports Grill in the Fry Building, the oldest-surviving commercial building left in Phoenix. The grill is named for and owned by former Phoenix Suns player Dan Majerle, who helped the team reach the NBA championship finals in 1993.

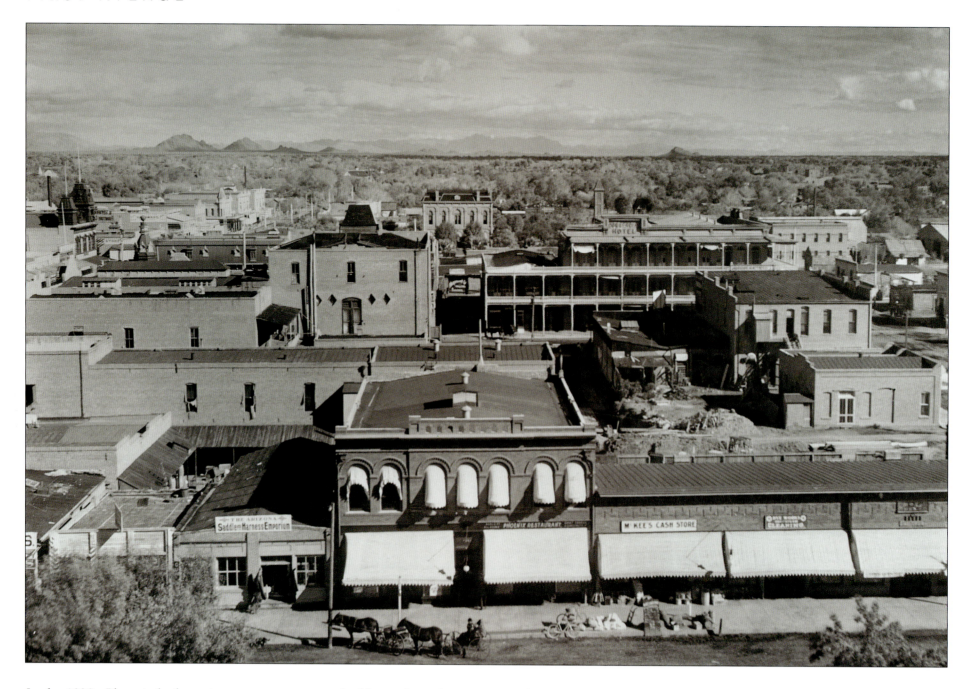

In the 1890s, Phoenix had two important government buildings. One of them can be seen about a block away, on the other side of Central Avenue, before the landscape gives way to trees and brush. That's the two-story Phoenix City Hall, completed in 1888. The photographer got this view looking east from the Maricopa County Courthouse tower, built in 1884 on First Avenue between Washington and Jefferson streets. The Territorial Legislature created Maricopa County in 1871 and designated Phoenix as the county seat. Phoenix incorporated in 1881. The territorial legislature met in the Phoenix City Hall for several years after the capital moved to Phoenix in 1889. Standing in the foreground, right in the center of town, was one of Phoenix's most important commercial blocks in its early years. To the upper left, the small hills are the Papago Buttes.

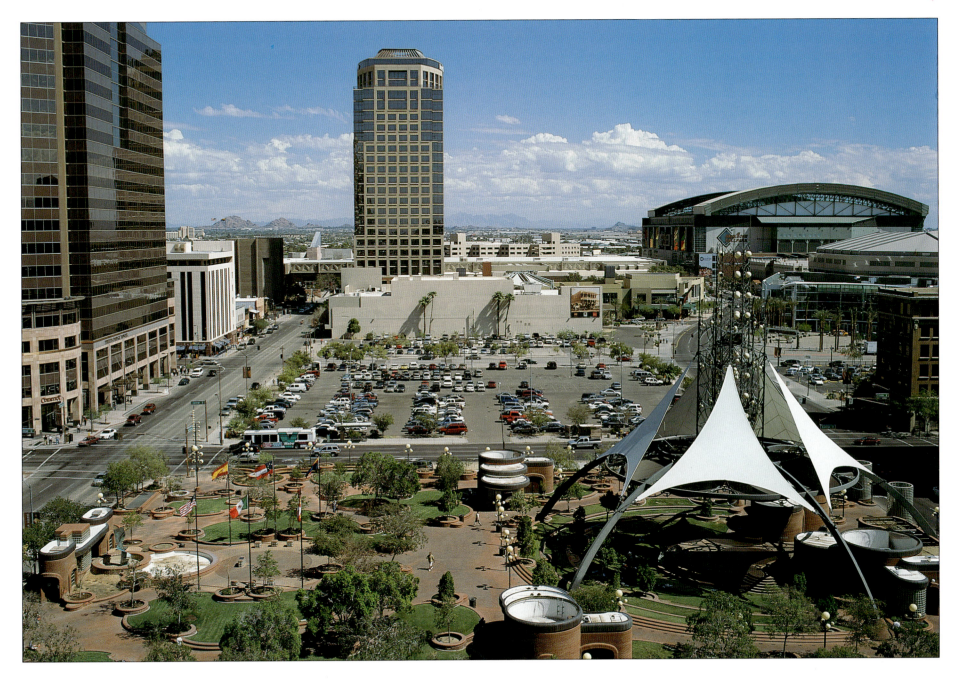

In 1971, when Phoenix was trying to revitalize its downtown by building a convention center, the then-mayor John Driggs proposed turning this block into a park modeled on San Francisco's Union Square. The city cleared the block and opened Patriots Square in 1975, only to tear it down and rebuild it in the mid-1980s in order to put a parking garage underneath. It's now called Patriots Park. The towerlike structure in the park rises over a stage. During

the early 1990s, it contained a fixed pulsing laser that the public could operate, but this is no longer there. Phoenix's current mayor, Phil Gordon, has suggested bulldozing the entire park and replacing it with something more inviting. The Bank of America Tower, in the center, stands over the vacant Hanny's Building, the last of downtown's old department stores. The Papago Buttes are visible to the left.

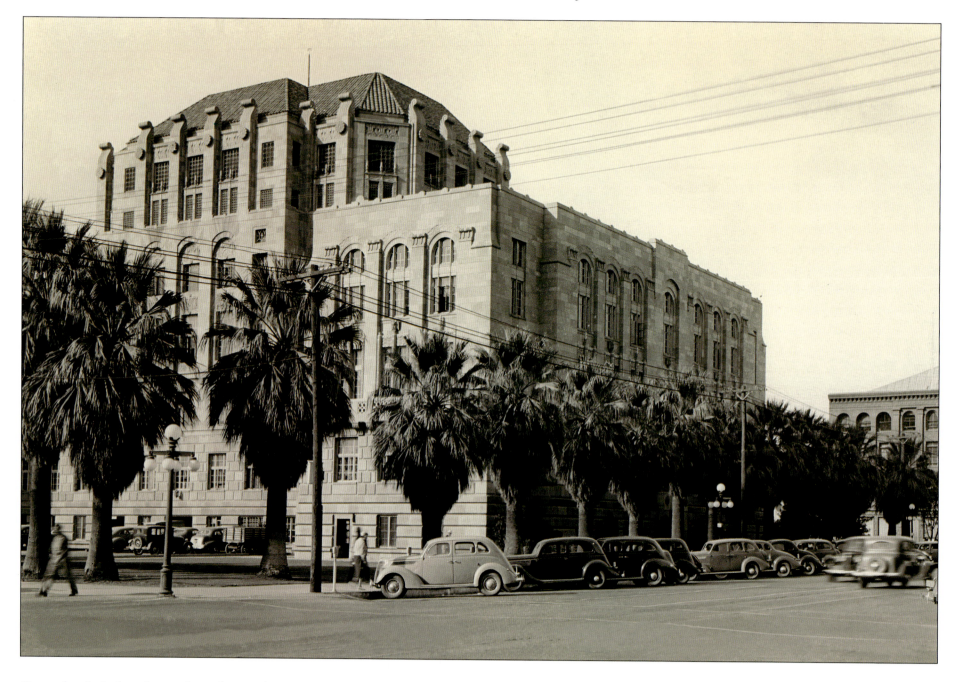

Opened right before the stock market crash of 1929, the combined Maricopa County Courthouse and Phoenix City Hall is pictured here in 1930. The building was the result of a partnership between the county and the city. Phoenix had been the seat of Maricopa County since its creation in 1871, and the first county courthouse stood on this very spot near the center of town. That building came down in 1928 to make room for this one. Both the County and the City contributed to the construction, and each hired its own architect. The County hired Edward Neild, an architect from Shreveport, Louisiana, to design its portion of the building. The City of Phoenix hired the prolific local firm of Lescher and Mahoney to design the western side. Together the architects came up with a building that combined elements the neoclassical, Spanish Colonial Revival, and art-deco styles.

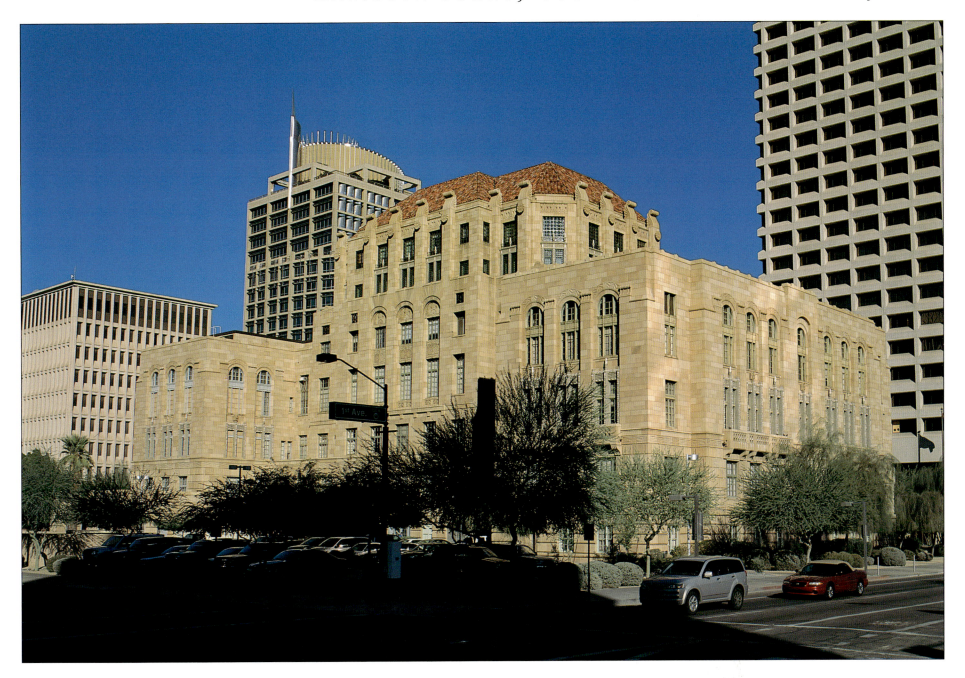

Many of the original uses of this building have since been relocated to other structures surrounding it. Elected city officials moved to the new twenty-story city hall across the street in 1994. The city renovated its portion of the building in 1987. It now houses meeting rooms and a small number of city programs, such as the Sister Cities program. In the county portion of the building, one of the courtrooms witnessed a trial that had a national impact.

The county convicted Ernesto Miranda of rape, kidnapping, and robbery, but the U.S. Supreme Court overturned the conviction in 1966 because Miranda was not told that he had a right to legal counsel under the Sixth Amendment. As a result, police now read suspects their Miranda rights. The County is currently renovating the thirteen courtrooms and related offices in its portion and plans to add a small museum.

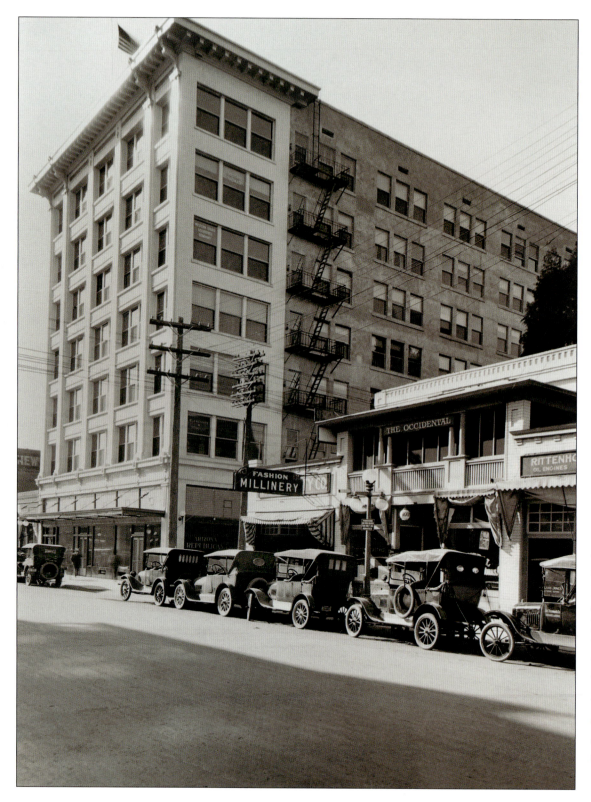

The Heard Building, on Central Avenue south of Monroe, in the 1920s. Dwight Bancroft Heard was probably one of the biggest movers and shakers in Phoenix's early history. Appropriately, his eight-story building was Phoenix's first skyscraper and one of its tallest buildings for many years. Heard was a successful Chicago businessman who moved out to Phoenix in 1895 to improve his health. He joined his former boss and father-in-law A. C. Bartlett in the Bartlett-Heard Cattle Company and founded the Dwight B. Heard Investment Company. Heard found success and built a couple of skyscrapers, including the Heard Building in 1920. He also bought a languishing Phoenix newspaper called the *Arizona Republican*, changed its name to the *Arizona Republic*, and made it the state's largest newspaper and strongest booster. Heard died in 1929.

The Heard Building has probably been seen by more people worldwide than any other Phoenix structure. Alfred Hitchcock's 1960 shocker, *Psycho*, opens with a shot of this building. For many years the Heard had a large radio tower on top for local station KTAR (part of which stands for the *Arizona Republic*, Dwight Heard's old newspaper). The tower is still there in the movie but was later taken down, leading many people to think that the Hotel Westward Ho (which still has a tower on top) got the cameo. This might be why director Gus Van Sant features the Westward Ho in his 1998 remake of Hitchcock's classic. The Heard Building today is used for stores and offices.

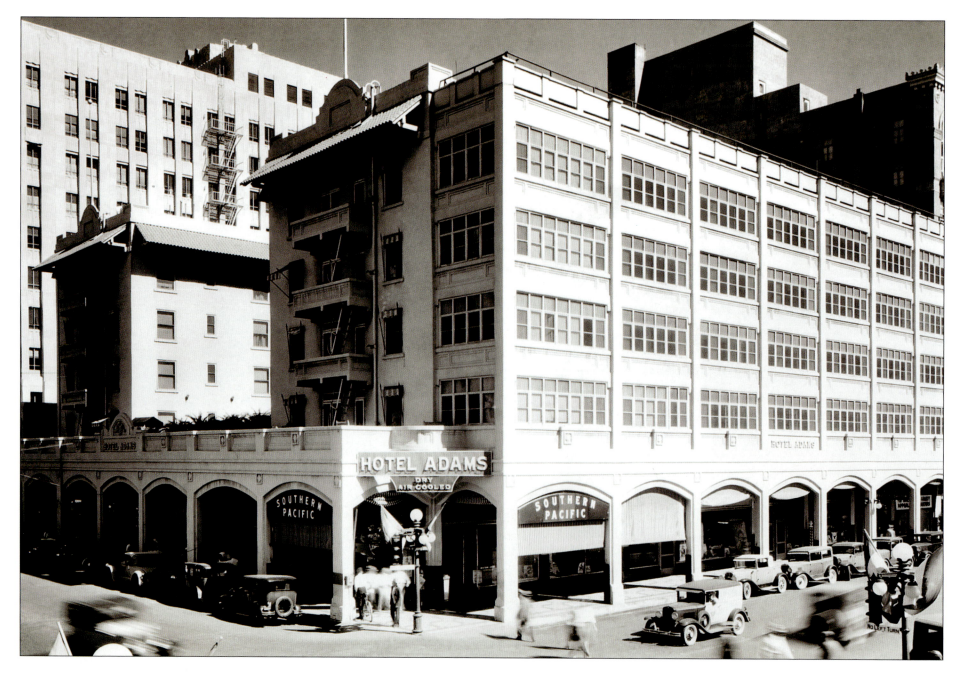

Every city had its notable big hotels, and the Adams was legendary in Phoenix. Here is the second hotel with that name, located at First Street and Adams, about 1930. The original Hotel Adams was a massive 200-room structure, built in 1896, that quickly became a popular meeting place for political leaders and businessmen. Due to its mostly wooden structure, it burned down in one of Phoenix's most spectacular fires on May 17, 1910.

The second Adams was constructed on the site of the first within a year or so. The new hotel continued the tradition of being an important meeting place for many state legislators from outside Phoenix, so much so that the Adams was often called the "Second Capitol of Arizona." A sign on the hotel points out that its rooms are "air cooled," an important amenity for those tourists who visited in the summer months.

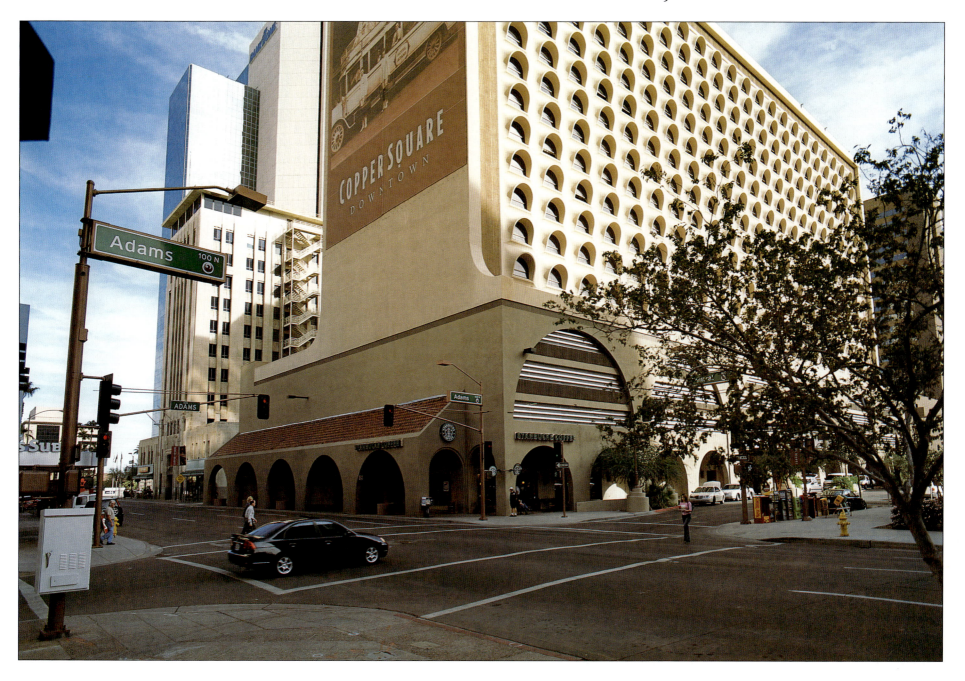

Today the Wyndham Phoenix Hotel, one of three major hotels in Phoenix's downtown, sits on the same spot. The second Hotel Adams came down in 1973 to make room for this towering structure. The 532-room hotel opened in 1975 as a Hilton, later became the Crowne Plaza Phoenix-Downtown, and then affiliated with Wyndham in 2003. The semicircular arches on the side of the hotel act as sunshades. In 2004, the City of Phoenix decided to build a fourth major hotel to help attract larger conventions to the downtown area. That new hotel will be located just a couple blocks north of the Wyndham. The City attempted to attract a private developer for the fourth hotel by offering a subsidy. Interestingly, the previous operator of the Crowne Plaza blocked the City's effort by collecting enough signatures to force a public vote. The City decided instead to build the hotel itself.

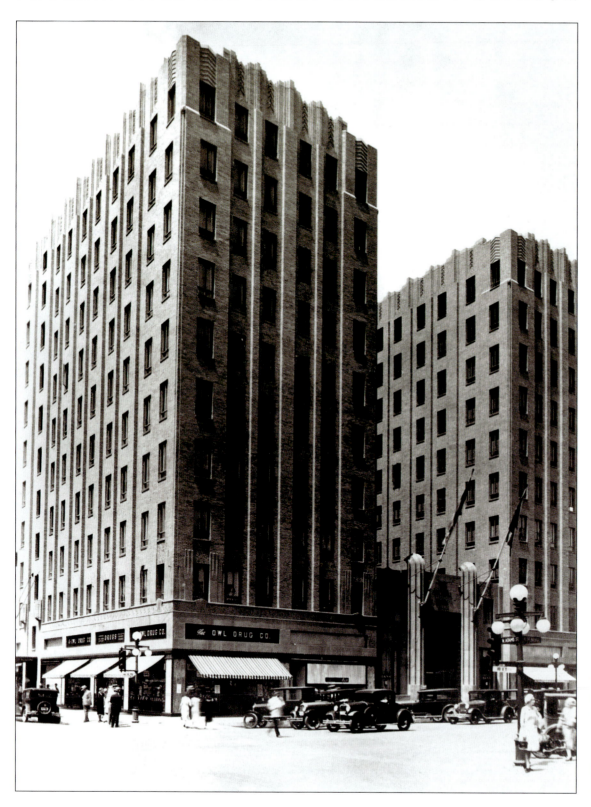

Here is the Phoenix Title and Trust Building, located at Adams and First Avenue, shortly after its completion in 1931. This U-shaped building had eleven stories with a steel frame and brick and terra-cotta exterior. The shape let natural light into each office. At the time it was the largest office building in the state. It is an early example of the art-deco style in Arizona and was designed by the prolific local architectural firm of Lescher and Mahoney, which then moved its office into the building. The Title and Trust was one of the last buildings tied to the 1920s building boom. It was a symbol of prosperity and hopefulness that arrived in a time of financial trouble and despair during the Great Depression.

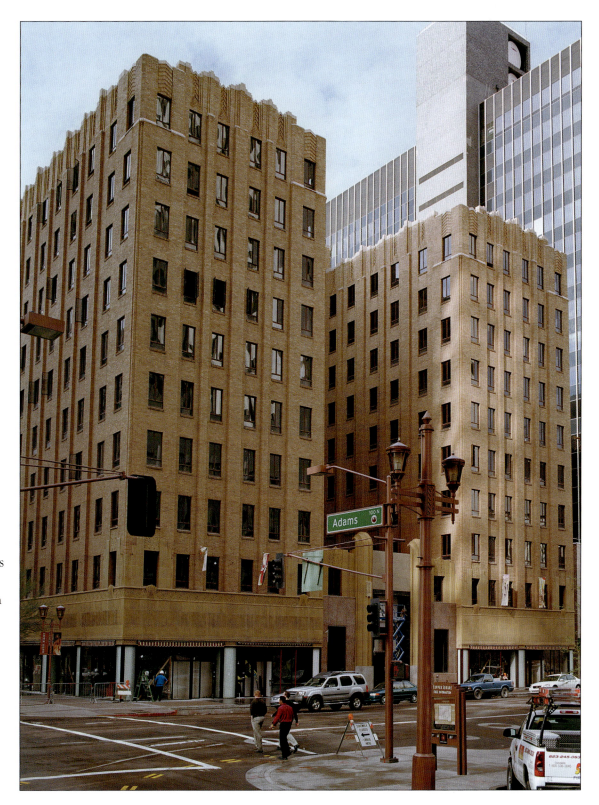

No longer an office building, the Title and Trust Building is being transformed into residential loft condominiums. The renovation is a little challenging because the building is on the City of Phoenix Historic Registry, which protects the exterior style and materials, though the City did provide $2.5 million in subsidies for the project. When completed, the building, now called the Orpheum lofts, will have ninety lofts and 10,000 square feet of retail space. The condominium prices are well above the regional median price, and this renovation is evidence that the national trend for urban living has finally reached Phoenix.

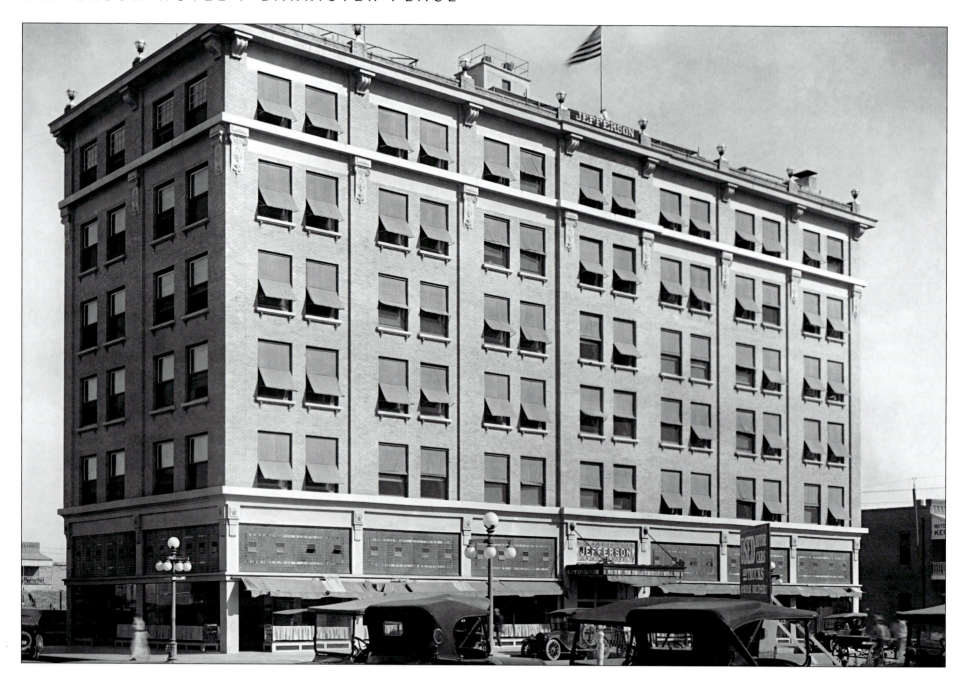

The Jefferson Hotel, located on the southeastern corner of Central Avenue and Jefferson Street, in the 1920s. One of Phoenix's first upscale hotels and the area's first "high-rise" building, the Jefferson was built in 1915 by Salim Ackel, an early immigrant who owned a Phoenix clothing store, a café, a cattle ranch near Chandler, and lots of local real estate. The Jefferson had 150 rooms and half of those had private baths. The hotel was fairly popular because it was only a few blocks from the train station and close to downtown theaters and businesses. This hotel was also featured in Alfred Hitchcock's 1960 movie, *Psycho*. It is here that John Gavin and Janet Leigh carry out their affair. Hitchcock takes viewers up to the top of the building and lets them peek in the window.

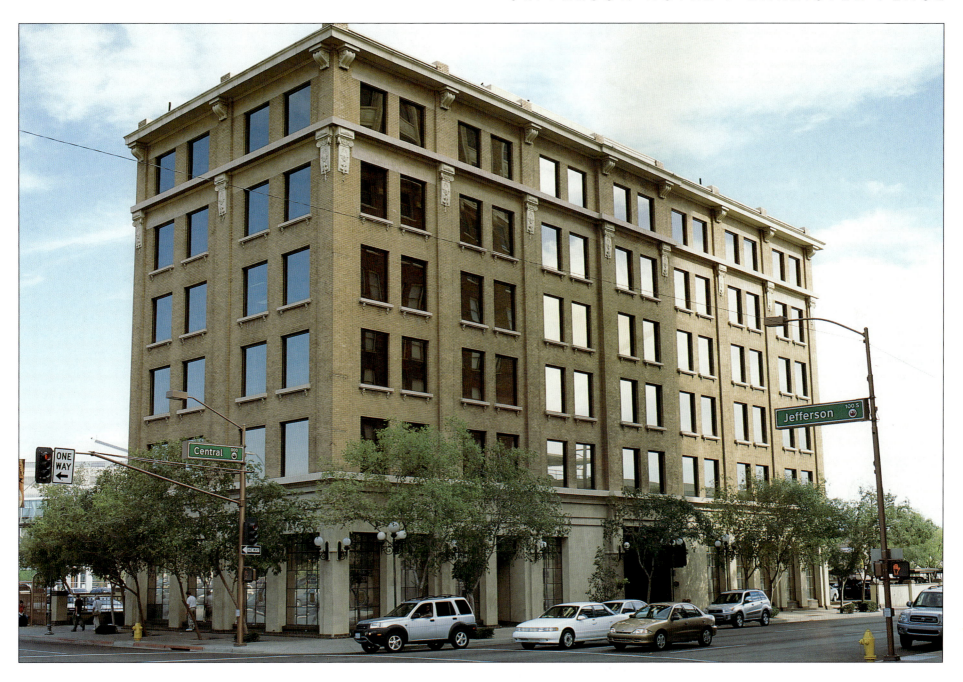

Today the building is called Barrister Place. Although passenger trains no longer stop at Union Station and guests no longer spend the night in the old rooms, the building is still in a prominent location. New owners completely gutted the former hotel in 1982 and, capitalizing on the building's close location to downtown courts, tried to entice law firms to locate offices there, hence the name change. The plan didn't work, and today it is an office building owned by the City of Phoenix, and the first floor is home to the Phoenix Police Museum. The museum opened in 1995 and tells the story of the law in Phoenix from territorial times to the present.

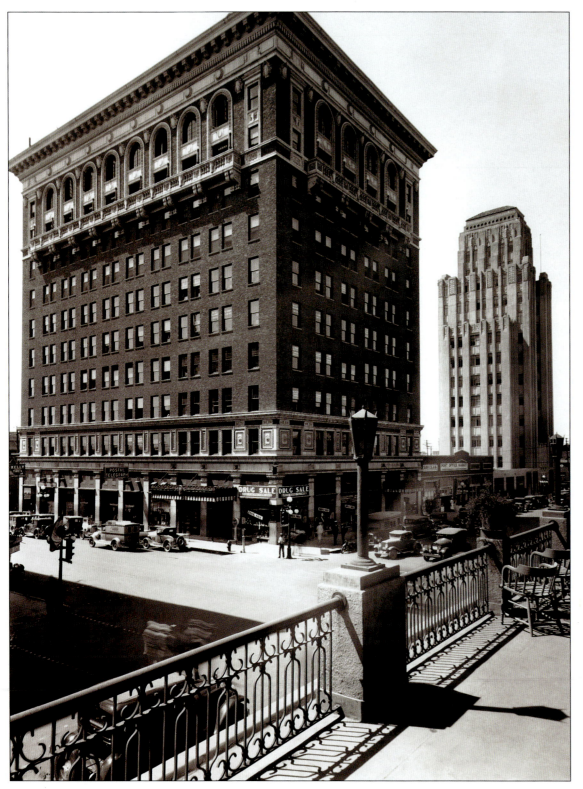

The Luhrs Building, to the left, and the Luhrs Tower are two of the most important commercial buildings in Phoenix's early history. Located southwest of Central Avenue and Jefferson Street, they are seen here in about 1930 from the nearby Luhrs Hotel. George H. N. Luhrs, a German immigrant who came to Phoenix in 1878, purchased the entire city block that both buildings now stand on and built his home. After a successful business career, Luhrs decided to promote the growth of Phoenix by building the Luhrs Building. The ten-story structure opened in 1924 and was the tallest building between El Paso, Texas, and Los Angeles. Luhrs and his son followed this by building the thirteen-story, art-deco Luhrs Tower in 1929. The Luhrs Building was especially important to Phoenix as the home of the Arizona Club. Located at the top of the building, its members included many of the city's most important business and political leaders.

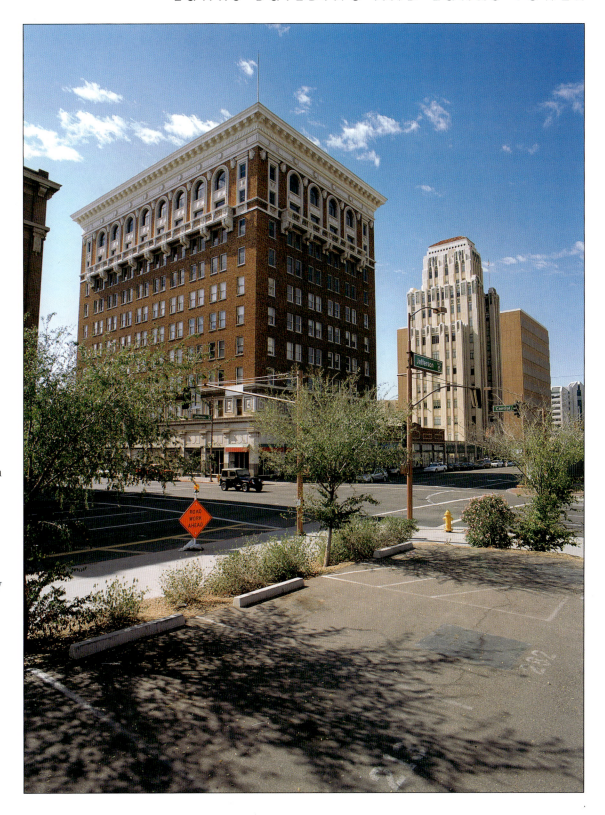

Both buildings are still here today, although there is now a parking lot where the Luhrs Hotel once stood. Luhrs and his son made several additions to their block, including the Luhrs U.S. Post Office Station/Arcade, a two-story annex behind the tower, and a parking garage. Today the buildings have a front-row seat to the recent rebirth of Phoenix's downtown. Patriots Park takes up the entire city block directly across the street. Immediately to the east is America West Arena, home to the NBA's Phoenix Suns. Thanks to the arena, a few restaurants have moved into the buildings' first floors. The upper floors are still used as offices. The Luhrs family sold the complex in 1976.

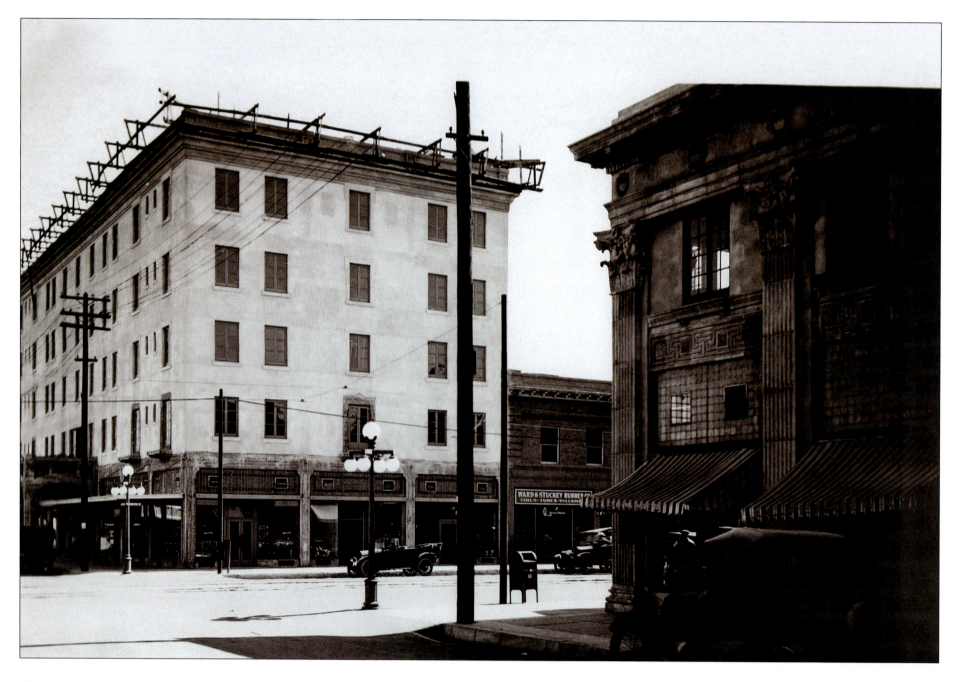

This is the intersection of Third Avenue and Washington in Phoenix, about 1925. Toward the south, the Arizona Hotel is under construction on the other side of Washington. To the right is the neoclassical-Revival Walker Building, built by developer J. W. Walker in 1920. Local architect L. M. Fitzhugh of the Fitzhugh and Bryan firm designed the structure, which was built of concrete and hollow tile. The building was the first Phoenix location of the J. C. Penney Company department store, which stayed there until 1926. The Central Arizona Light and Power Company (CALPCO) then made its headquarters in the building, mounting a huge sign that lit up at night. In the 1940s, CALPCO merged with the Arizona Edison power company to become Arizona Public Service.

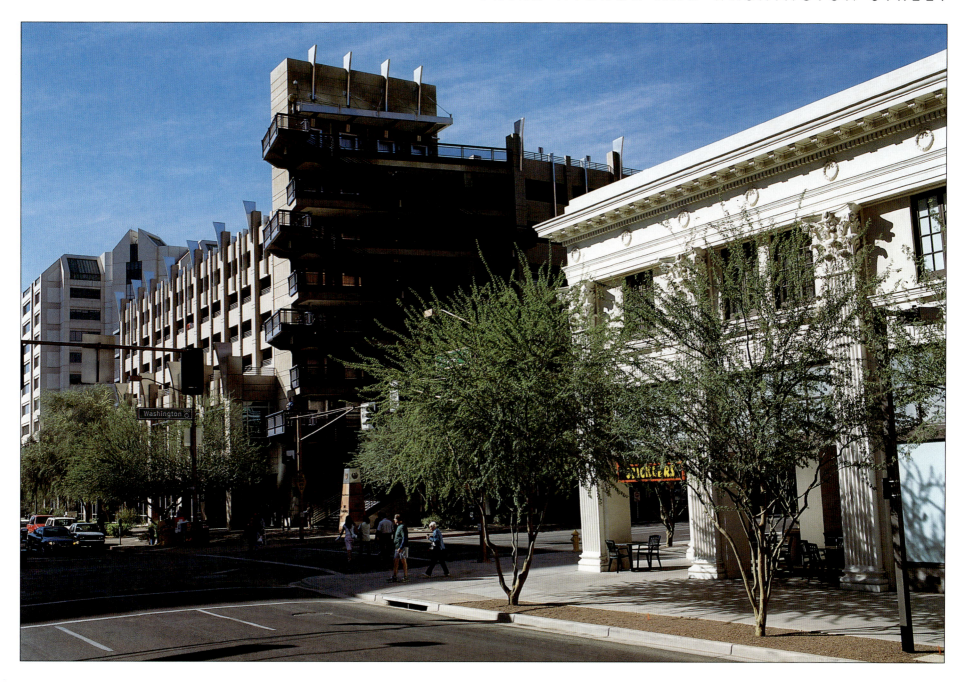

The Walker Building later housed a furniture company and then a labor union before the City of Phoenix purchased it in 1959 for office space. Today the Walker Building has been practically swallowed up by Phoenix government buildings. Where the Arizona Hotel once was, the city-owned 305 Building now stands. The structure serves mostly as a parking garage, but city offices and some businesses occupy the ground floor. Phoenix renovated the Walker Building, which opened in 2001, as part of the City's construction of the Phoenix Municipal Courthouse. The building almost didn't make it—at one point the city even issued a demolition permit for it. Now Walker's Café occupies the ground floor of the Walker Building and the American Institute of Architects has an office on the second floor.

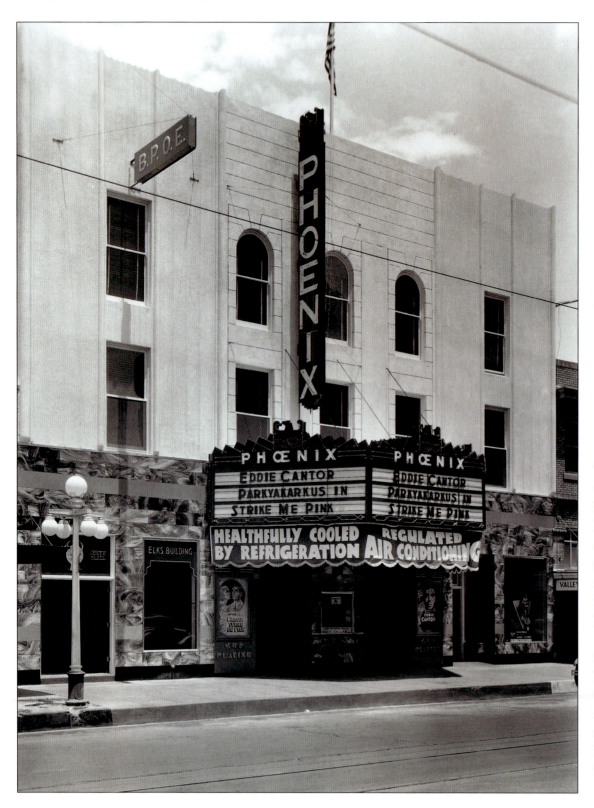

The Phoenix Theater, shown here in 1936, was the oldest theater in Phoenix at the time. Located on Washington, between Third and Fourth avenues, it opened in 1898 as Patton's Grand Theater. Built by S. E. Patton, a theater enthusiast, the Victorian-style theater had two turrets at the top, which were later removed. As one of the largest indoor gathering places, Patton's theater was also an important site for sizeable meetings held in the city. Phoenix-area civic and agricultural leaders met here in 1900 to discuss how to build a water storage dam on the Salt River (which was later built as the Roosevelt Dam). New owners changed the theater's name to the Dorris Opera House. The Elks fraternal lodge bought it in 1908, moved into the second floor, and changed the theater's name to the Elks Theater. John Philip Sousa, the well-known composer and band leader, and his band played in this building on October 21, 1915.

The Phoenix Municipal Courthouse sits on the theater's location today. Completed in 1999, it is next door to the Phoenix City Hall, which opened in 1993. The nine-story, flagstone-covered courthouse provides room for the Municipal Court, the City Prosecutor's Office, the Public Defender Eligibility Office, and part of the police department, among other offices. The City demolished the old Phoenix Theater to make way for the courthouse. At the time, the theater had a modern front and bore little resemblance to the Phoenix Theater from the 1936 view. The City also knocked down the historic A. L. Moore and Sons Mortuary, located to the north of the theater and built in 1911, to clear space for the courthouse.

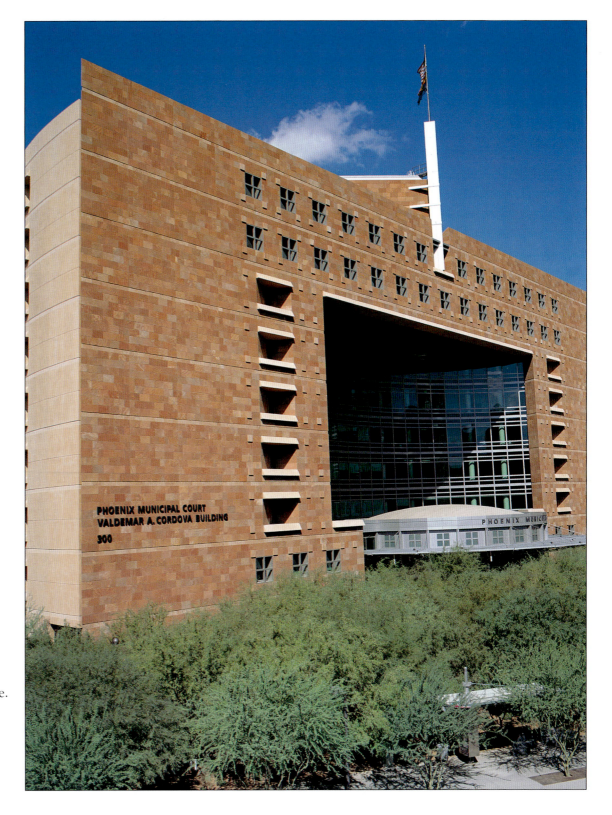

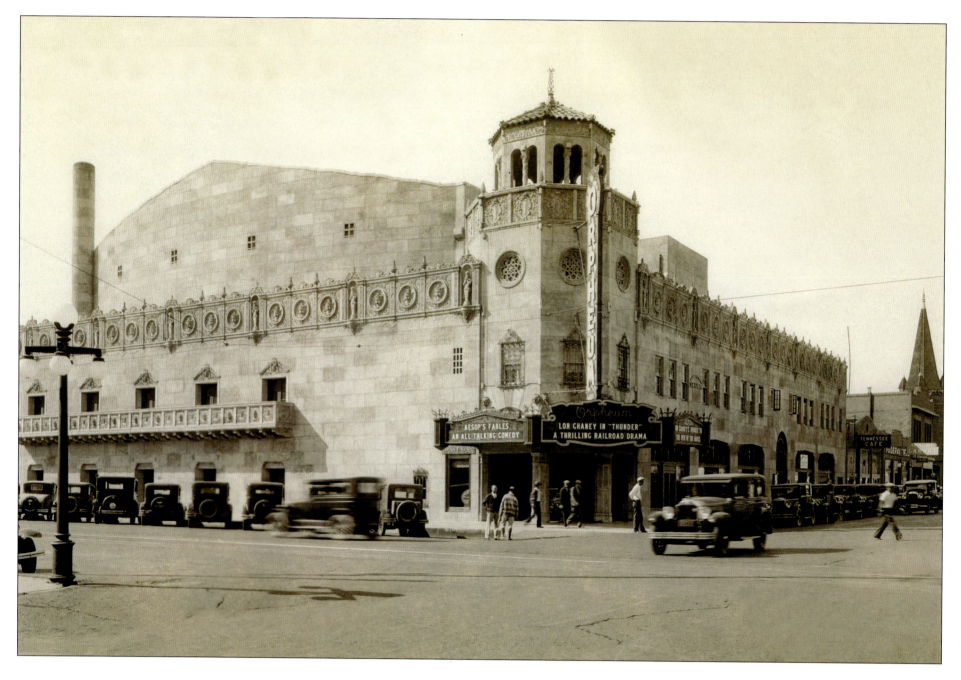

The Orpheum Theatre, shown here shortly after its opening in January 1929, sits on the southwestern corner of Second Avenue and Adams Street in Phoenix. Local theater-chain owners Henry Nace, a former circus acrobat who came to Phoenix in 1910, and J. E. Rickards built the theater. They ended up with thirty-six Arizona theaters before selling out to Paramount in 1936. The noted Phoenix architectural firm of Lescher and Mahoney designed the lavish Spanish Colonial venue. It was their first commercial project and would lead to many more. At the time, the theater represented the latest innovations in entertainment. Inside visitors could admire the domed ceiling, which featured an illusionary nightfall projected by a magic-lantern machine. Called an "atmospheric-style" theater, with 1,800 seats, it staged plays, featured vaudeville, and showed movies.

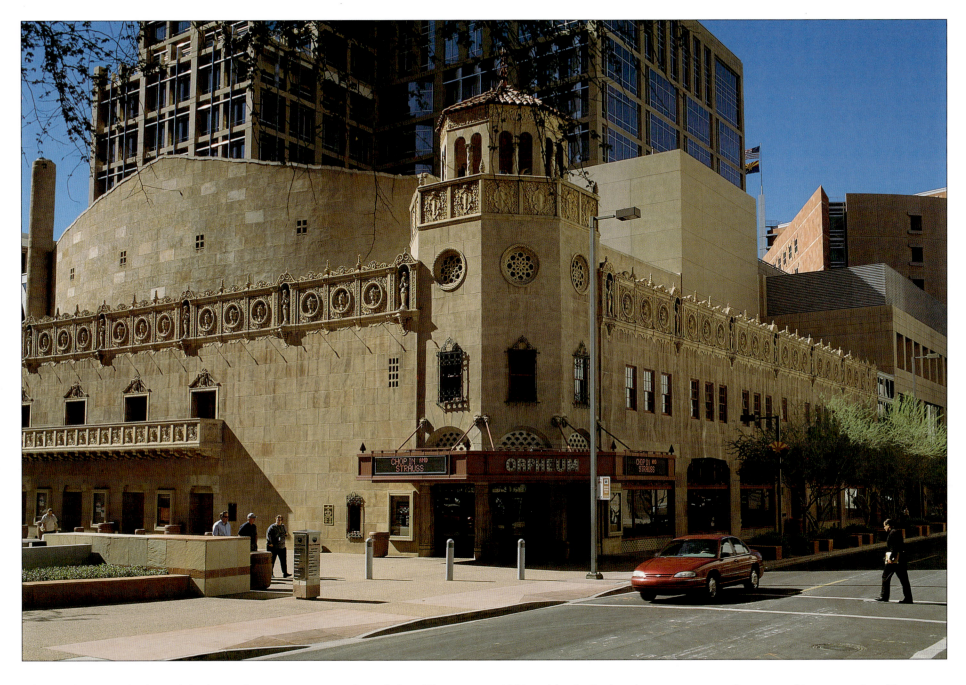

The Orpheum is the last of the large theater or movie palaces left in Phoenix today—all of the others were demolished by the 1980s. The Orpheum also went through a series of owners and mistreatments that threatened its survival. At that point the Junior League of Phoenix took on the cause of saving the Orpheum. They pushed the City of Phoenix to buy the building in 1984 and backed a bond program to pay for some of its restoration. To finance the rest, Phoenix decided to build its new twenty-story City Hall, which was completed in 1993, directly behind the old theater. The theater was both modernized and extensively restored, and it reopened as a multiuse performing-arts center in 1997.

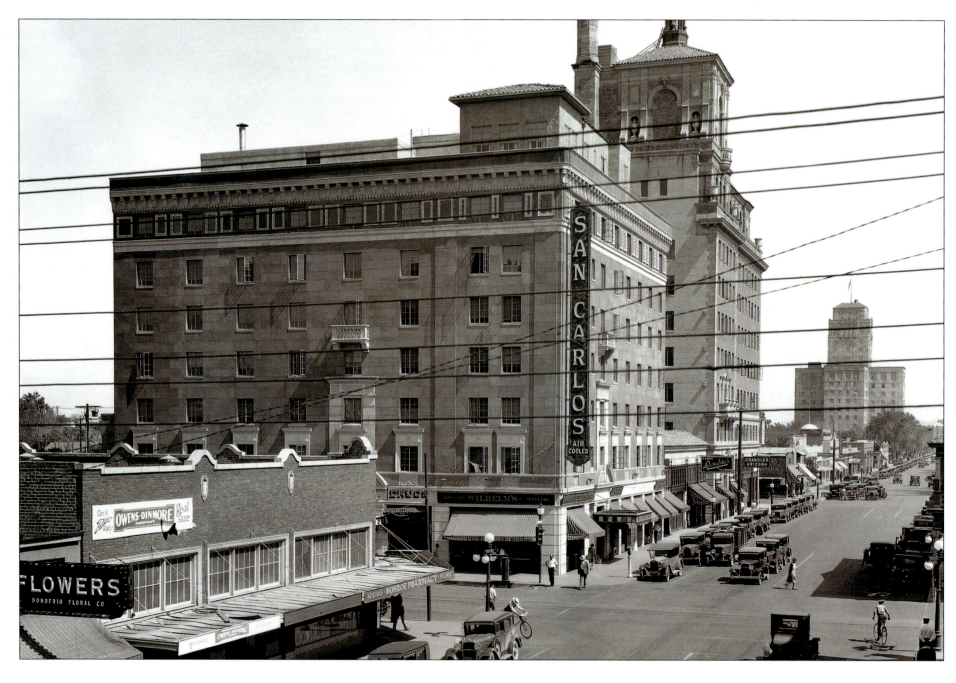

The Hotel San Carlos around 1930. Dwight B. Heard, a wealthy real estate developer, and Charles Harris became partners and opened the seven-story Hotel San Carlos in 1928. The site, at Central and Monroe avenues, once the location of Phoenix's Central School, sat vacant for many years. Heard and Harris wanted a high-end hotel to cash in on Arizona's growing tourism industry. They hired G. Whitecross Ritchie to design the Renaissance Revival structure. Among its modern conveniences at the time were air-conditioning, steam heat, and elevators. It was the most expensive place to stay in Phoenix when it opened, but that was not a deterrent. The place quickly attracted a crowd of locals and Hollywood movie stars, including Jean Harlow, Clark Gable, Spencer Tracy, and Mae West.

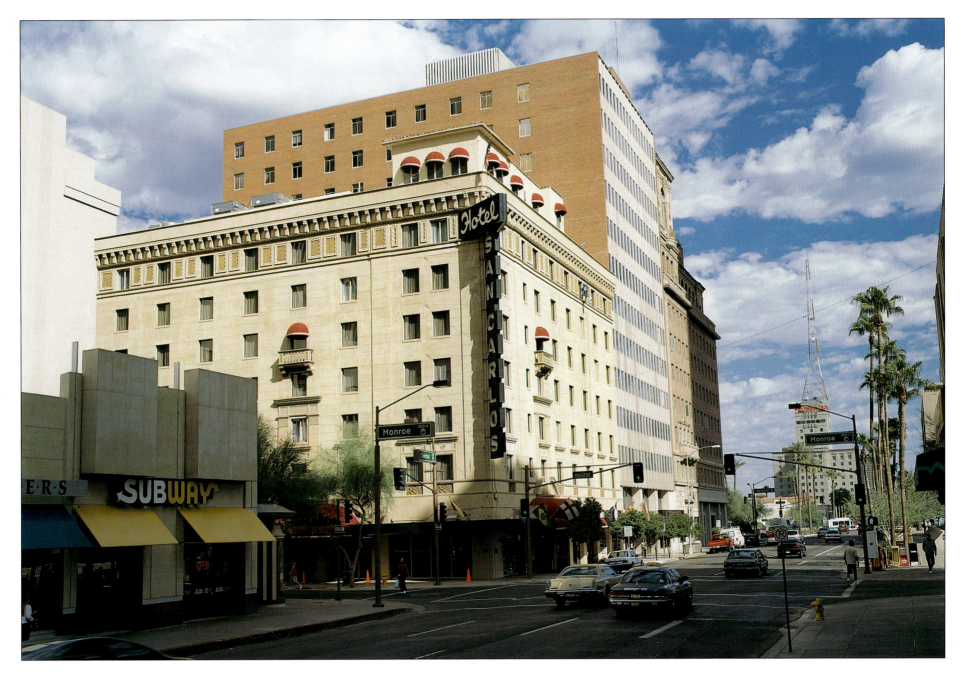

Later owners remodeled the hotel in 1955, adding a swimming pool to the rooftop sundeck. The hotel has undergone additional renovations since then, each trying to restore the hotel's original grandeur. Those efforts paid off—the San Carlos earned the prestigious Historic Hotels of America affiliation in 1991. In 1993, its operators added the San Carlos Hollywood Star Walk on the streets around the hotel with the names of movie stars and band leaders who had stayed there. The hotel still contains many of its original historical elements, and one of the two elevators from 1928 still operates today. The San Carlos is the only historic hotel still operating in Phoenix's downtown area.

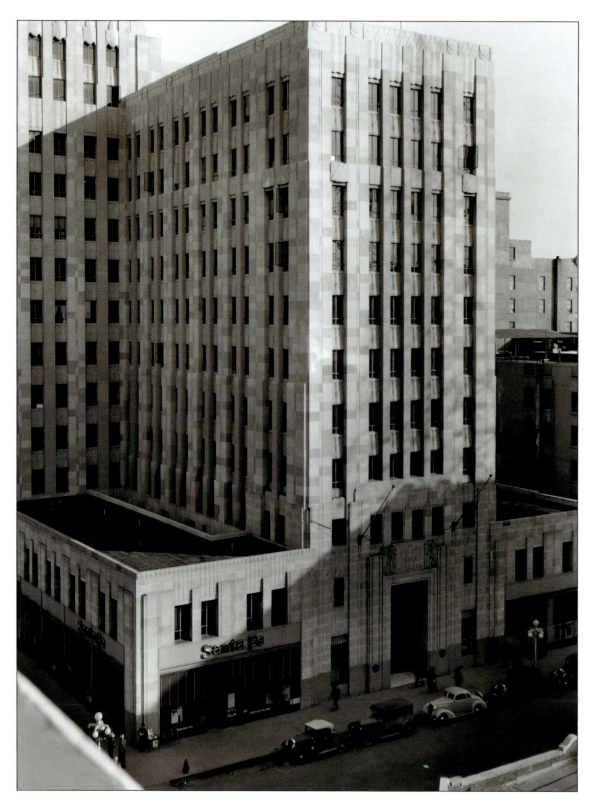

The twelve-story Professional Building opened at Monroe Street and Central Avenue in 1931. Here it is in 1935. This art-deco skyscraper was originally designed to serve as a centralized place for medical and dental offices, clinics, and laboratories. For many years, it was the place in Phoenix to go to see a doctor or dentist. The lower stories are made out of real Indiana Limestone, while the upper stories are stuccoed but made to look like stone. Valley National Bank once had its offices in the building, and for a time a forty-foot revolving sign promoting Valley National Bank stood on top. The bank left in the early 1970s with the completion of its new forty-story tower near Central and Van Buren.

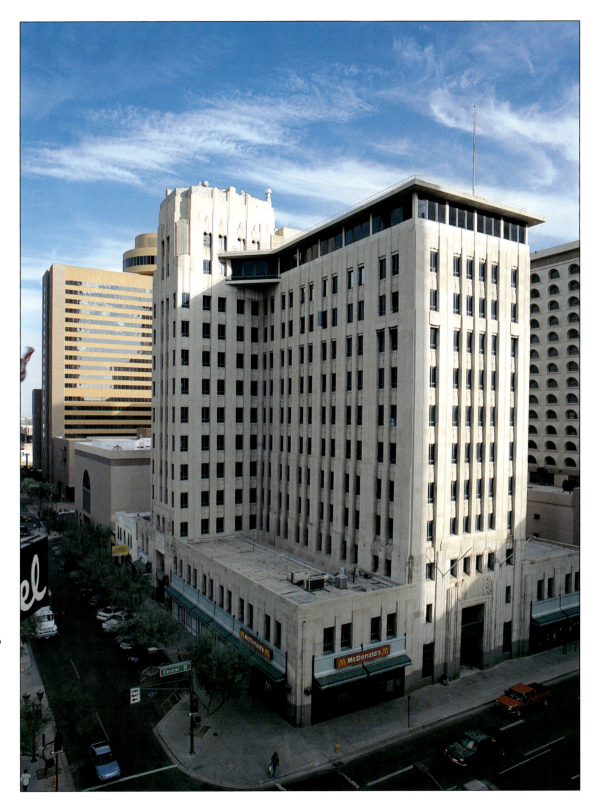

The building grew upward in 1958 with the addition of the top story, but its commercial growth hit the skids by the 1970s. For many years the building sat vacant, with the exception of three restaurants on the ground floor. In 2002, along with businessman Mark Doerflein, Fred Unger, who renovated and revived the Royal Palms resort in Phoenix and the Hermosa Inn in Paradise Valley, bought the structure. They announced plans to transform the building into a mixed-use development with loft-style condominiums, a boutique hotel, and restaurants. With all the new projects and construction coming to downtown, they are waiting for the right time to make their plans a reality.

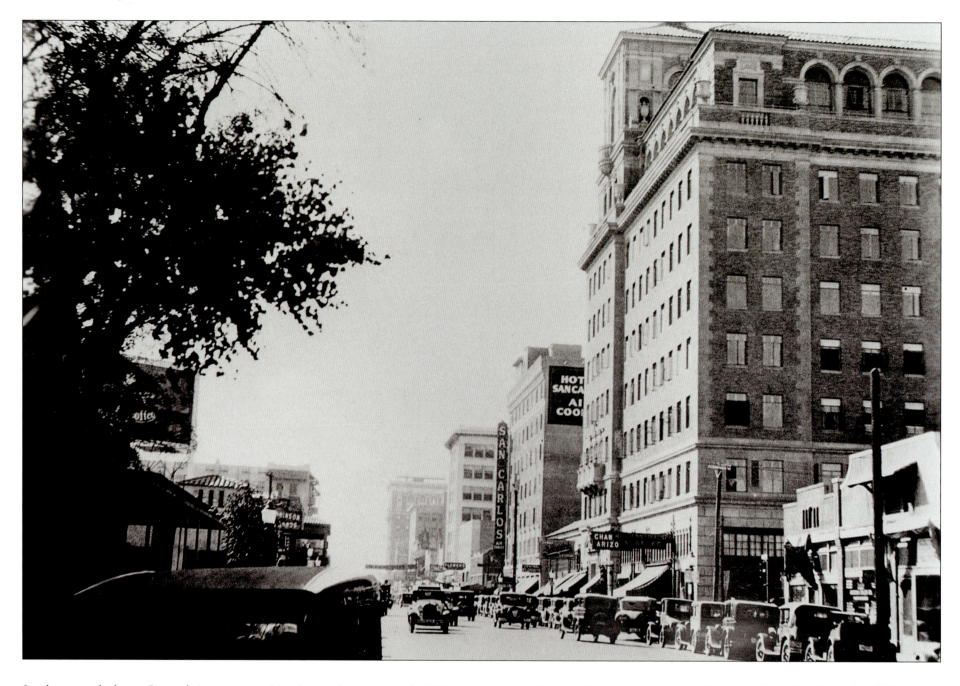

Looking south down Central Avenue near Van Buren Street around 1930, the tall structure to the right is the Security Building. This was the second of real estate developer and city booster Dwight G. Heard's major projects (the other was the Heard Building, completed in 1920). While this eight-story building was not among Phoenix's tallest, it did have the most commercial space of any building in the state at the time of its completion in 1928. This grand Renaissance Revival building has an arcaded gallery at the top floor and a corner tower. A glass-covered cupola on top of the tower contained a light beacon that could be seen for thirty miles.

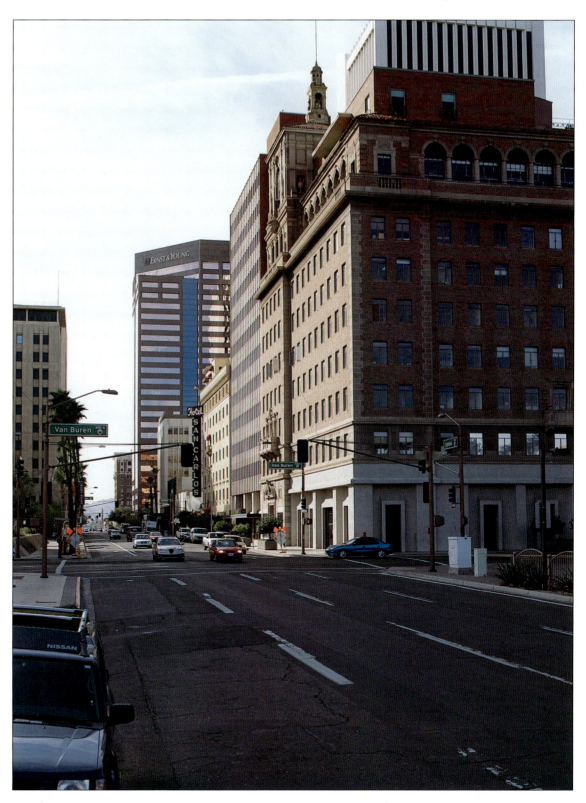

The Security Building remains in the heart of downtown's office district, but it no longer holds the record for commercial space. A modern skyscraper, built in the 1960s, now stands between the Security Building and the San Carlos Hotel. Across the street, just out of view to the left, is the tallest building in the state. Completed in 1972, the forty-story skyscraper was originally the headquarters of the Valley National Bank, Arizona's largest. Weakened by the tough Phoenix real estate market of the 1980s, however, it was acquired by Bank One in 1992. Bank One's name was emblazoned on the building for even less time than Valley National's, as Chase Bank took over Bank One in 2004.

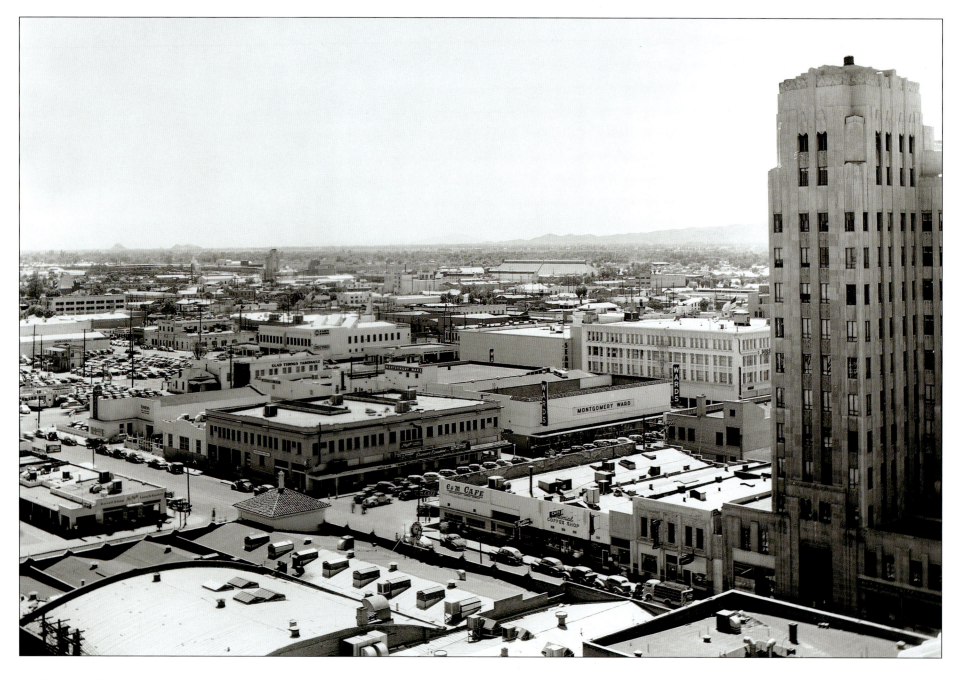

Looking northeast from the San Carlos Hotel about 1949, the intersection of Monroe and First streets is visible. Monroe runs from the left and stretches to the tall Professional Building on the right. The edge of the department store district is visible near the center right of the view. Downtown Phoenix was a vital commercial district, attracting shoppers until the early 1950s (J. C. Penney actually built the last downtown department store in 1953).

Montgomery Ward is visible, and just above it is Sears. Walking south on First Street across from Montgomery Ward, a shopper would also find the Dorris-Heyman furniture store and Goldwater's department store. This block was full of shoppers every Saturday. Just to the left of the Professional Building is the Golden West Hotel. Built in 1899 as the Steinegger Lodging House, the modern facade was added in the 1930s.

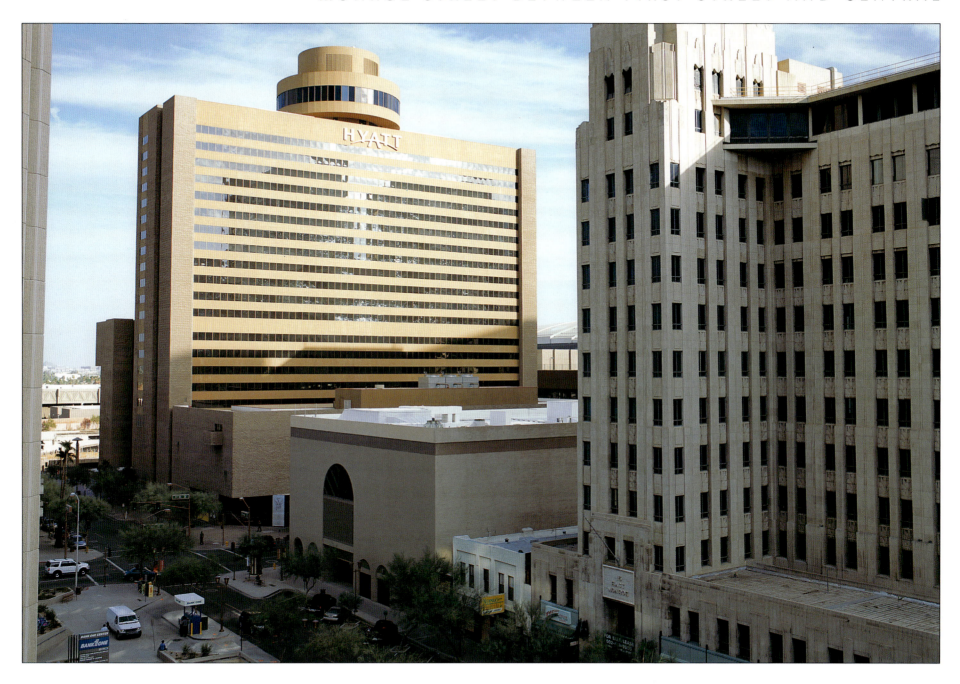

The Hyatt Regency Hotel, completed in 1976, now takes up the block where Montgomery Ward once stood. The department stores started leaving downtown in the mid-1950s and were all gone by 1969. To the left of the Hyatt is part of the Phoenix Civic Plaza. Finished in 1972, the plaza replaced Phoenix's skid row—a district of run-down boarding hotels known as the "Deuce." During the 1970s, Phoenix started to revitalize its downtown.

Phoenix is in the process of expanding the Civic Plaza, which will include a tower in the empty space between the convention center and the Hyatt. Lost in the canyon of the Hyatt, the back of the Wyndham Hotel to the left and the Professional Building, is the old Golden West Hotel. It's closed now, except for the bar on the first floor. The Golden West is the earliest remaining example of a once-common lodging building in downtown.

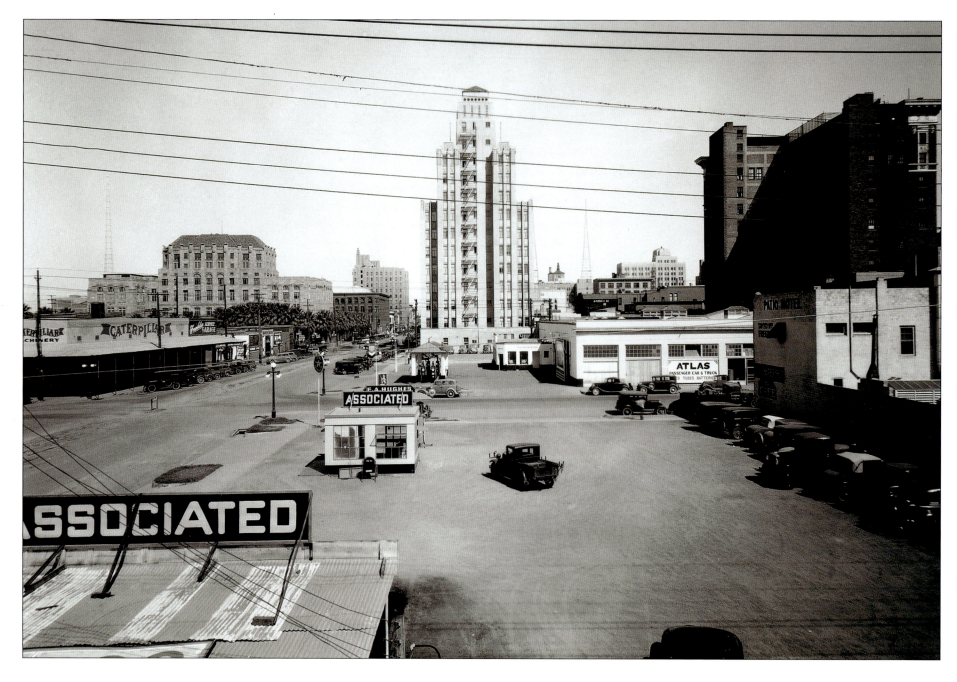

This view is looking north at downtown Phoenix about 1933. The photographer took this picture from where Jackson Street crosses over First Avenue. Phoenix's industrial and warehouse districts developed south of downtown. Warehouses clustered here because of the closeness of the railroad, which was just behind this building. The building near the upper left is the County-City Building, completed in 1929. The tall, art-deco skyscraper in the center is the Luhrs Tower. Its older sibling, the Luhrs Building, stands to the right edge.

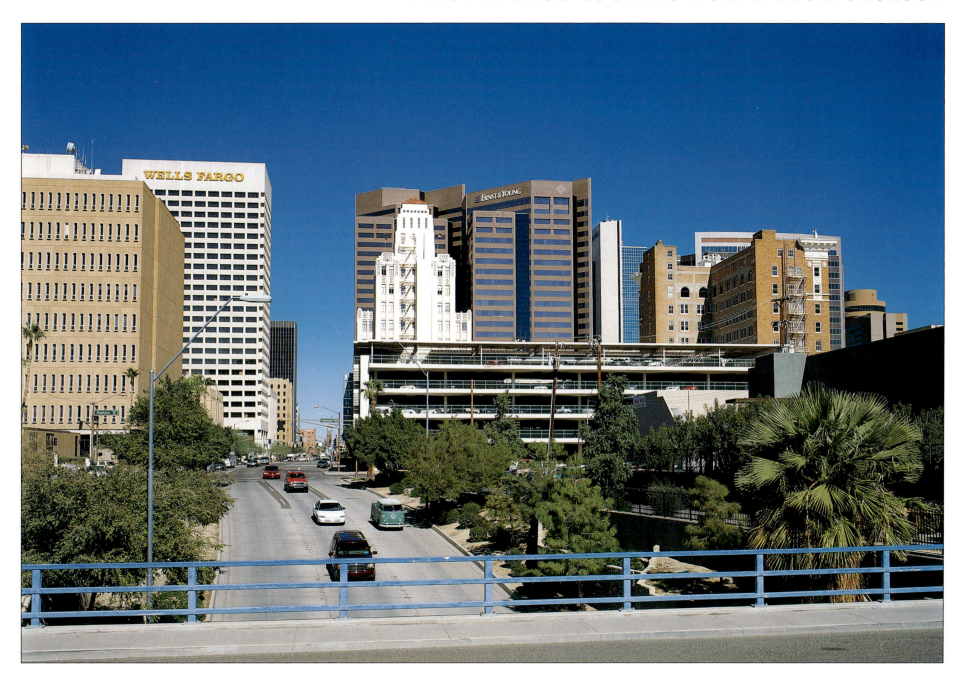

Some of the warehouses still stand on Jackson Street, although they are mostly located just to the right of this view. The County-City Building is almost entirely blocked by a parking garage and Maricopa County's Madison Street Jail. Other modern skyscrapers dwarf the two Luhrs buildings. Many of the surviving warehouses are being used as nightclubs and restaurants today, thanks to nearby sports venues. Bank One Ballpark's completion in 1998, the home of Major League Baseball's Arizona Diamondbacks, brought new interest to the buildings of this once remote industrial district. One of these restaurants in the revitalized Warehouse District is owned by rock star and Phoenix resident Alice Cooper.

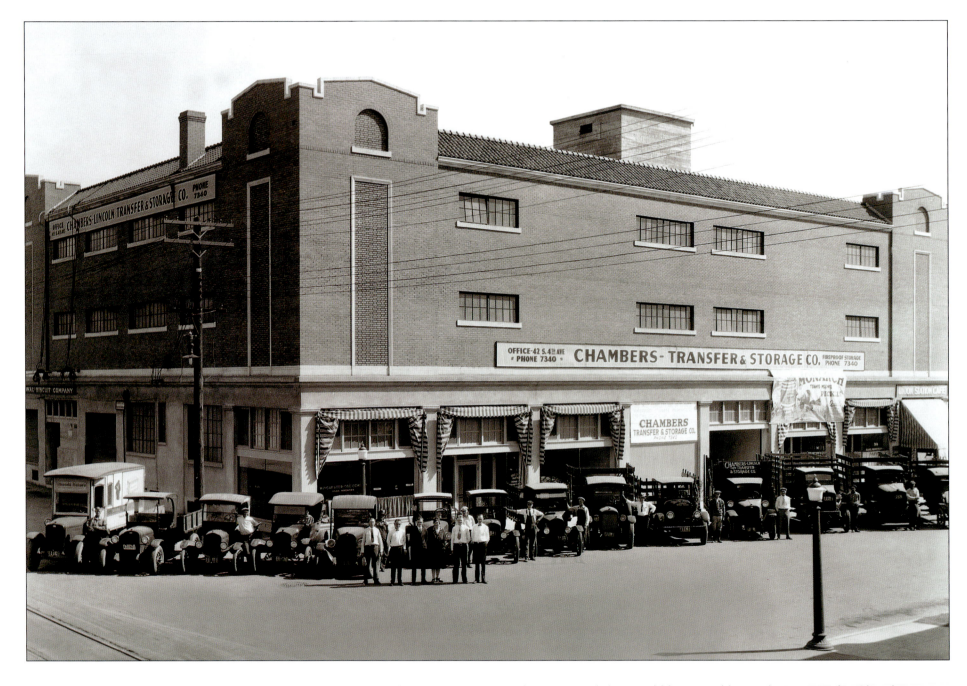

The Chambers Transfer & Storage Company warehouse at Fourth Avenue and Jackson Street, around 1930. The Chambers Building is one of dozens of warehouses that grew in the area near the railroad tracks from the 1880s until World War II. Chambers was a long-established Phoenix business when it opened this new warehouse in 1923, which stored shipments that came in on the train until they could be moved by truck. Because the Chambers Building is right next to Union Station (out of view to the right) and the traveling public, the Spanish Colonial Revival building also has stores and offices on the first floor.

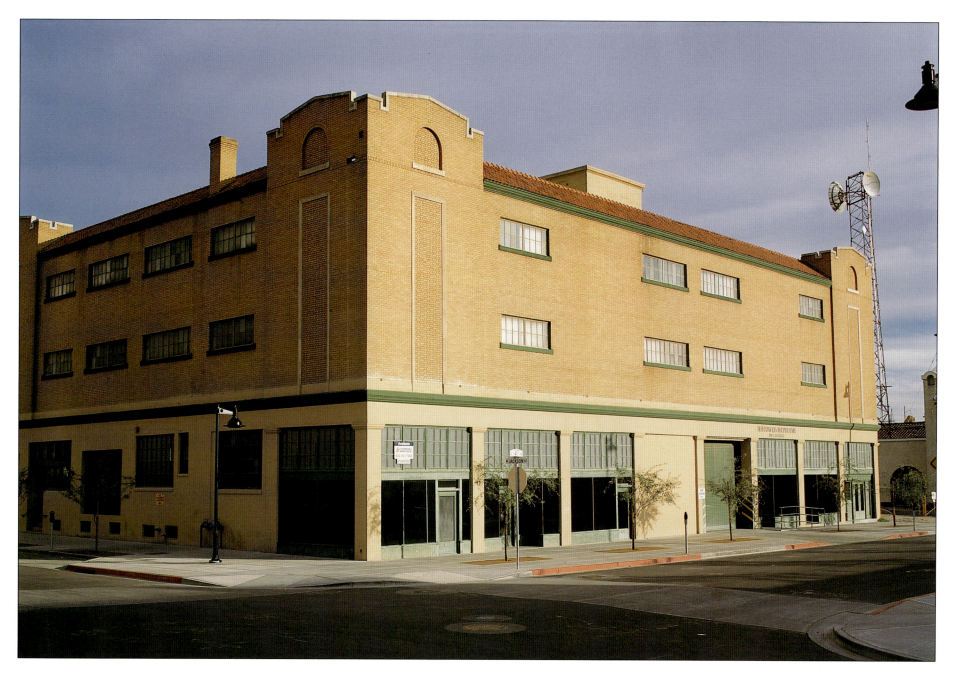

The Chambers Building is now a telephone switching station and offices for Maricopa County government, although the first-floor retail spaces still sit empty. Other former warehouses were knocked down in 1999 to make room for a new county jail, which is just across the street to the left, dashing the hopes of those who thought the "funky old" warehouses could anchor an arts district. The jail's construction set off a minor squabble between the City of Phoenix and Maricopa County, which, as a government entity, did not need to follow the zoning restrictions of another governmental entity. A public outcry got the county to promise not to destroy the Chambers Building or nearby Union Station. The Chambers Company continued to call this building home until 2000, when it moved its headquarters to Scottsdale.

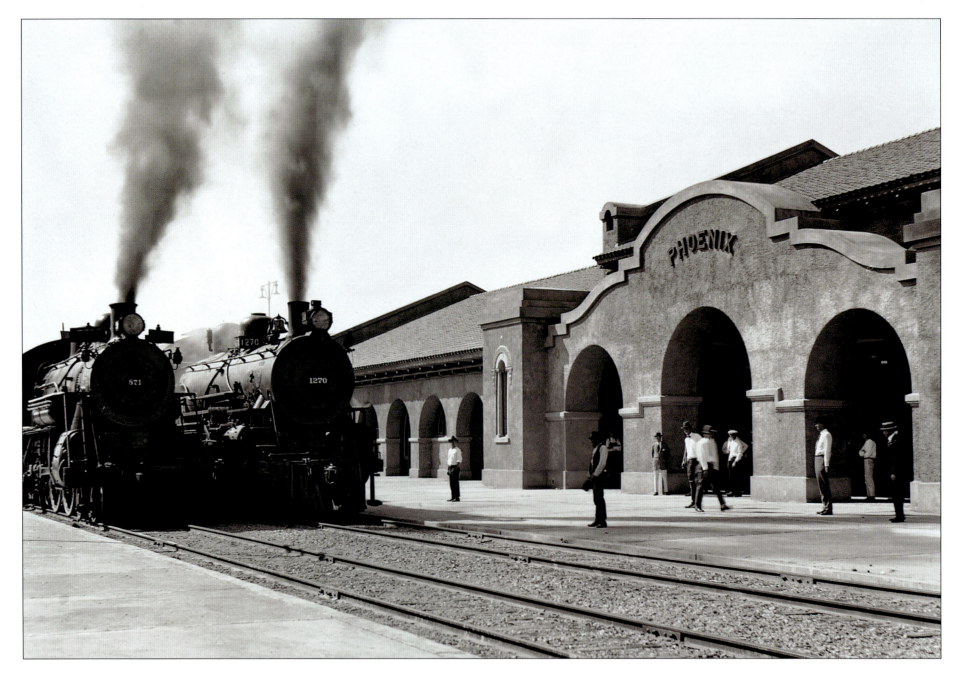

Phoenix Union Station was just a few years old when the photographer took this photograph in about 1926. These two trains belong to the Santa Fe Railroad, but it would have been possible to see a Southern Pacific train here as well—both lines used Union Station. Southern Pacific decided in 1926 to make Phoenix part of the main line and trains went directly to or from California. Opened in 1923, this Mission Revival station provided the look that tourists from the East expected, and many did come through as Phoenix's tourism industry took off in the 1920s.

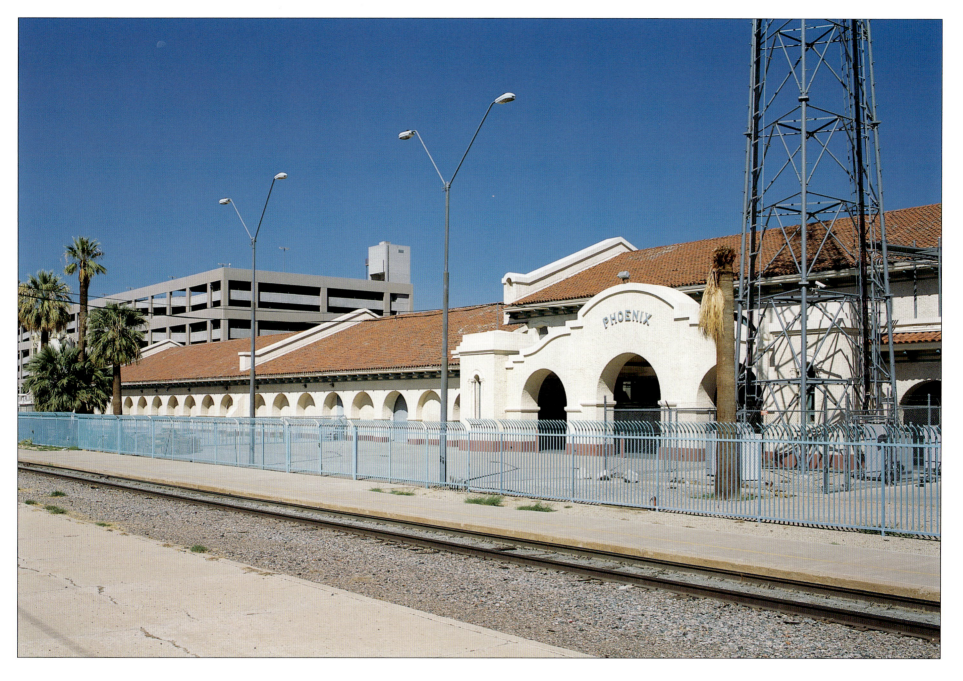

Don't show up at Union Station today expecting to catch a train. Amtrak—the government-sponsored provider of rail passenger service since the 1970s—stopped serving the station and Phoenix on June 2, 1996. Trains leave from Tucson or Flagstaff instead. The private railroad companies now move freight and still pass by Union Station, but their names have changed since the 1920s. Union Pacific took over the Southern Pacific in the 1990s.

Santa Fe merged with Burlington Northern about the same time, creating Burlington Northern Santa Fe. Union Station sits empty now, but it has not been forgotten by a vocal group of local railroad enthusiasts. They rallied in 1999 when they thought that Maricopa County was planning to tear it down (the County has since promised not to). This group also wants to return passenger rail service to Phoenix and new life to Union Station.

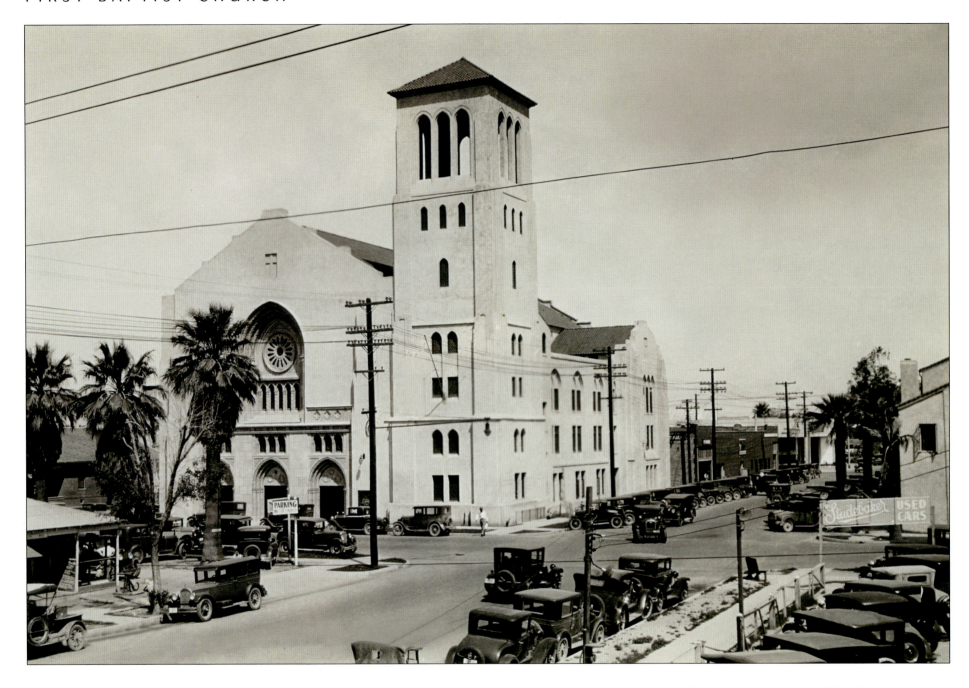

The First Baptist Church, Third Avenue and Monroe Street, about 1930. This was the congregation's third church building in Phoenix. This Spanish Colonial Revival structure, completed in 1929, sits on the site of the second church. George Merrill, an architect with the local firm of Fitzhugh and Byron, mixed a little of the Gothic Revival style from the previous church to create this distinctive house of worship. The four-story church included a rooftop garden, a seven-story bell tower, twenty-seven Bible school rooms, a 1,500-seat auditorium, and a 125-seat choir loft. It also has a small radio broadcasting studio. The church's contractor proclaimed the First Baptist Church to be "among the most complete, practical, and beautiful church buildings in the West."

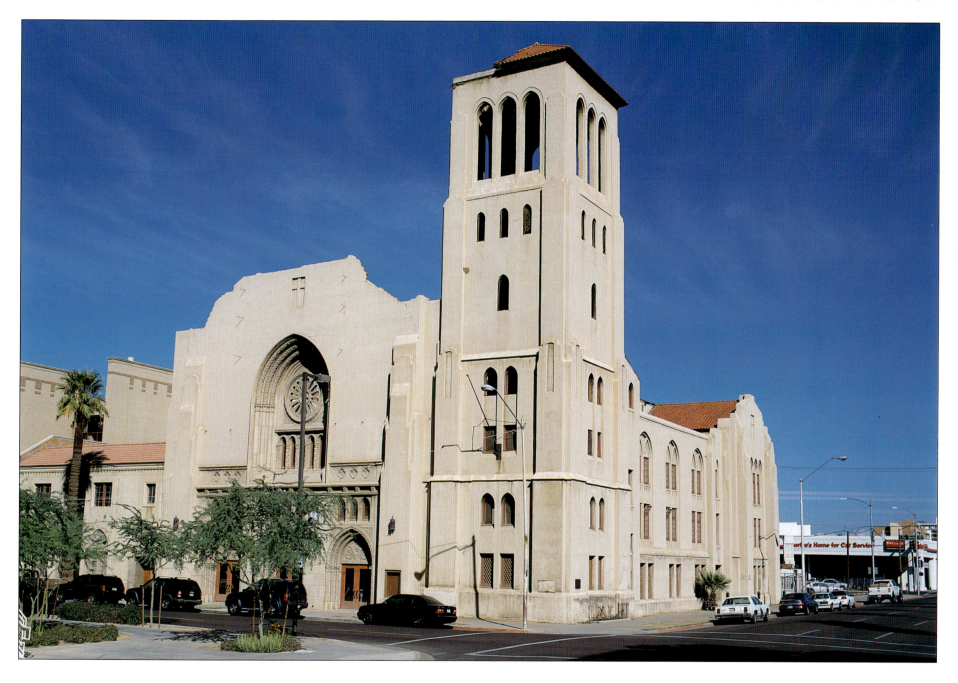

Today this once-grand church stands vacant and without a roof. The building was partially destroyed in a 1984 fire by transients who were camping inside. Like many of Phoenix's original churches, its congregation moved out of the downtown in the 1960s. The congregation actually tried to sell the building during the Great Depression when the church had trouble making its debt payments. They kept the building with the help of the local Mormon church.

Vacant and dilapidated, the building was almost demolished in 1992. A nonprofit group bought the old church with the aim of transforming it into affordable housing but was never able to raise enough money. Instead the group built a new apartment building in the church's parking lot. Concerned for the church, the Arizona Preservation Foundation listed the structure as one of Arizona's Most Endangered Historic Properties in 2004.

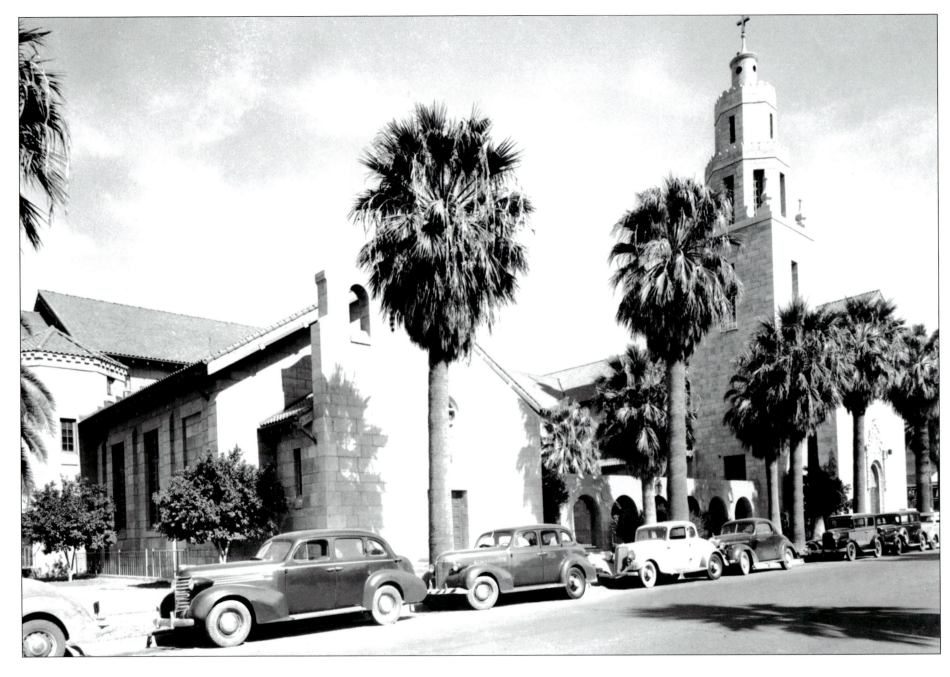

The First Presbyterian Church of Phoenix, around 1930, at Fourth Avenue and Monroe. The very first Presbyterian Church in Phoenix in the 1870s was actually a brush arbor. The congregation completed its first "real" church building in 1892 at the southeast corner of Adams and Third Avenue (which was then called Papago). They stayed in the redbrick church for forty years before moving into this new building in 1927. The church community wanted their new building to be "substantial, whose beauty could endure for at least a century to come." They hired Los Angeles architect Norman Foote Marsh, who designed this Spanish Colonial Revival building. The family of developer and town booster W. J. Murphy, founder of Glendale, donated the chimes for the building.

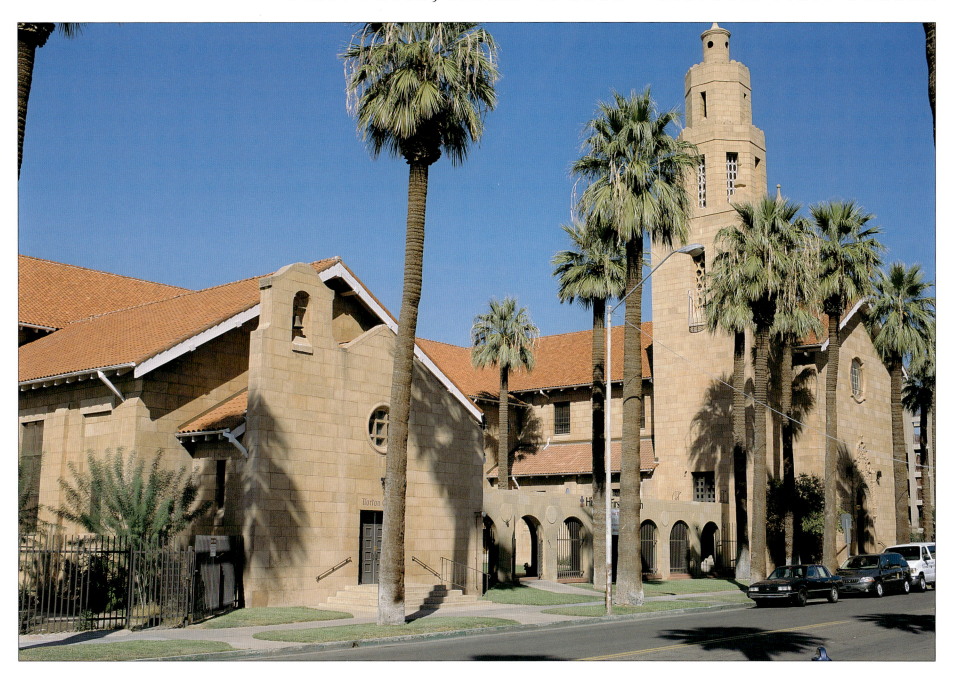

The beauty of the First Presbyterian Church does indeed endure today. Now called the Historic First Church by its congregation, it is still used by its founding community. Many of the other big Phoenix churches built at the same time have either changed hands or been abandoned or demolished—like the former First Baptist Church, which can be seen a block to the east.

The First Presbyterian Church weathered some tough years though. The congregation completed the church right before the Great Depression and almost lost the building in the mid-1930s, just like many other Phoenix churches at the time. Having regrouped and worked hard, they paid off the building in 1945.

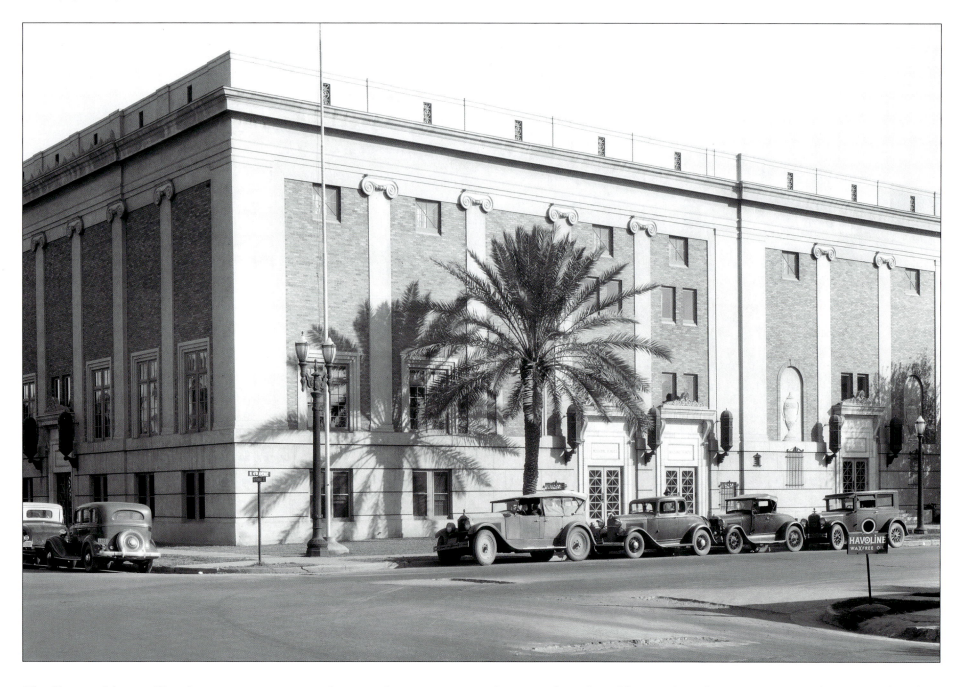

The Phoenix Masonic Temple, a structure meant to showcase the prominence of Masons in Phoenix, around 1930. F. C. Hurst designed the three-story, neoclassical building on the southeast corner of Monroe and Fourth Avenue. It became the first permanent home for Arizona Lodge #2—originally established in October 1879—which had been meeting in various locations throughout Phoenix. It took some time to get things started, and the lodge finally purchased land in 1923. Completed in 1926, the building cost $172,000—a staggering sum at the time. Seven different Masonic lodges eventually held meetings in the new temple.

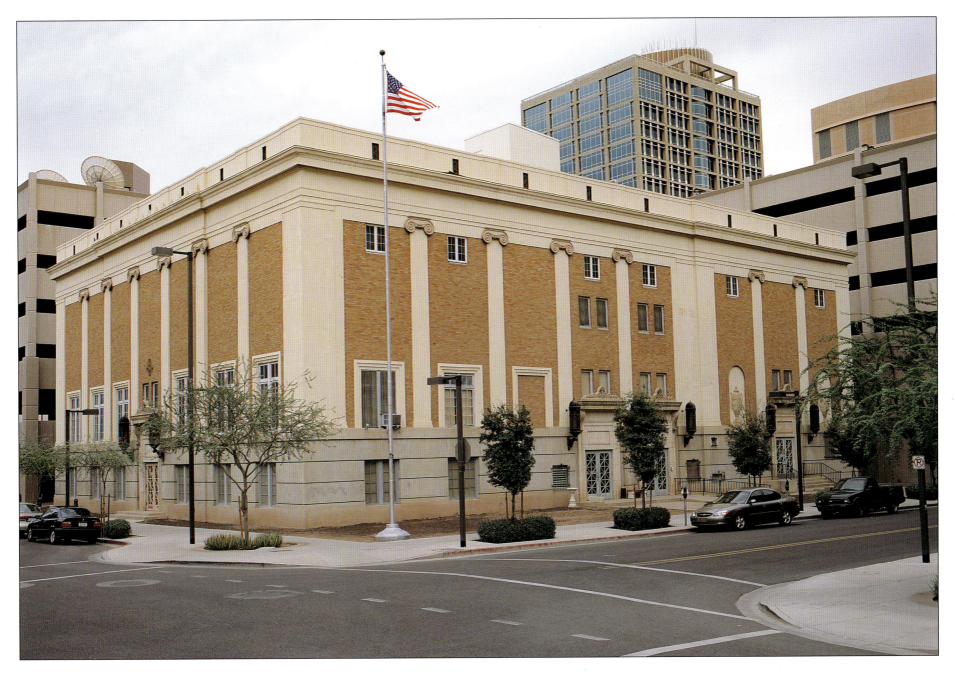

The Masonic Temple is still home to Arizona Lodge #2 and three other lodges. The residing lodges briefly lost control of the building during the Great Depression but were able to buy it back in 1941. By the 1990s, the structure was showing its age and needed repairs. The Masons considered selling the building and moving out. In 1996 they decided the building was a treasure to keep. As a sign of their commitment toward maintaining this historic structure, that same year the lodges applied for and received listing on the City of Phoenix's historic registry. The building underwent a major restoration between 1999 and 2001.

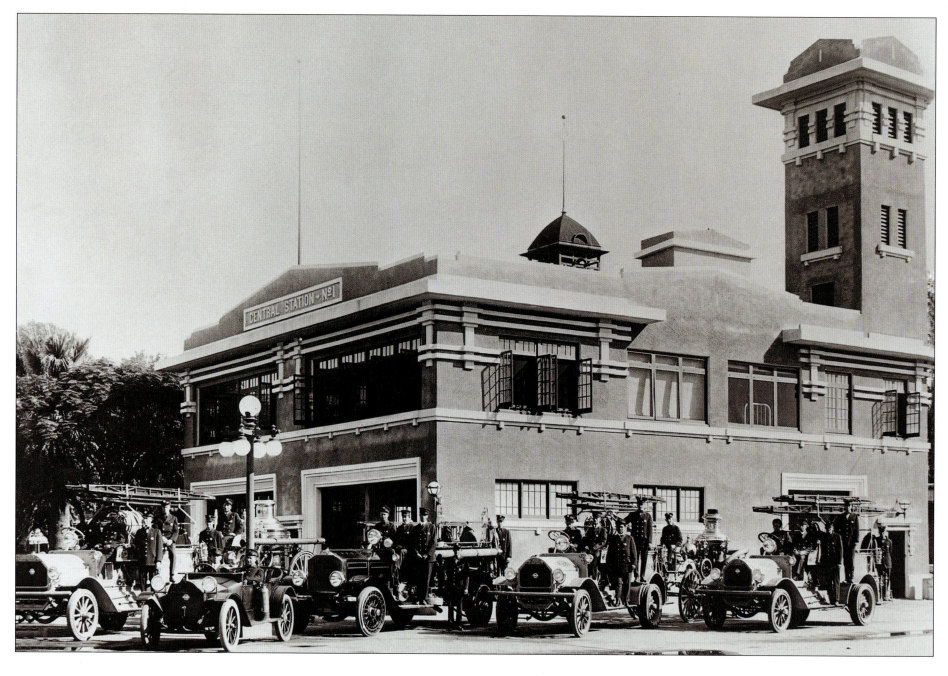

Phoenix Fire Department's Central Station Number 1, located at First and Jefferson streets, in 1916. Completed just two years earlier, this station sits on the same site as Phoenix's original fire station. The new station was one of two the city had at the time. Phoenix didn't even have an organized fire department until after several devastating fires forced the issue in 1886. Some of the firefighters pictured here were paid; others were volunteers. By 1922 the entire force was paid. These firefighters here are showing off their new 1914 Seagraves Type 19 fire trucks. The department only started phasing out fire horses when this station was completed.

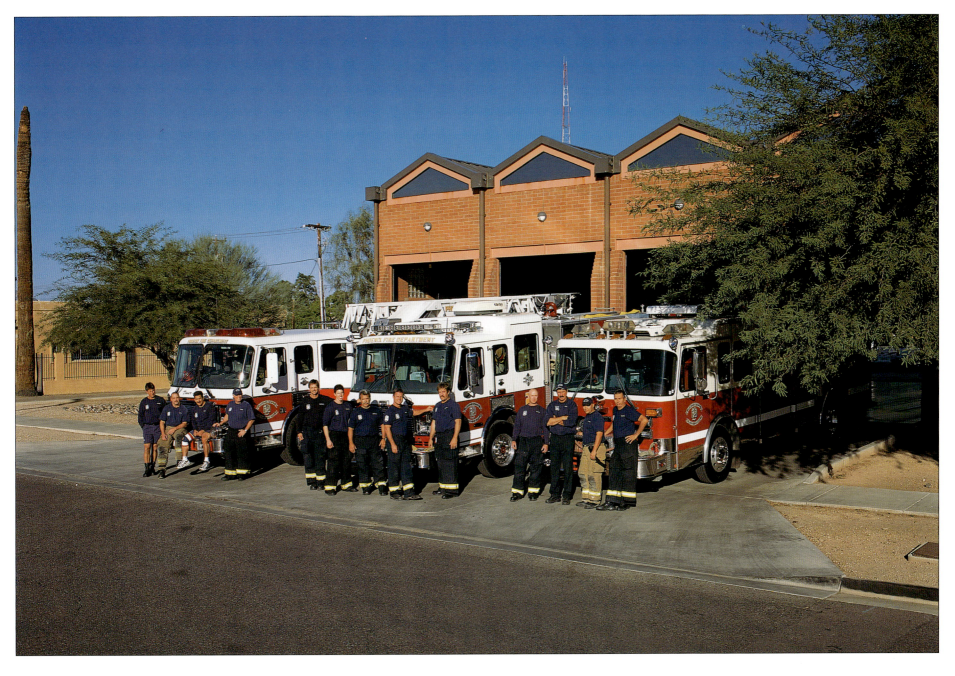

Though the City Fire Department's Central Station Number 1 no longer stands at First Street and Jefferson, Phoenix Fire Station Number 1 lives on in another structure, located near Fourth Avenue and Van Buren. Phoenix now has forty-nine fire stations, serving a city of nearly 1.4 million people spread out over 512 square miles of territory. The technology and practices of firefighting have changed quite a bit since 1916. Phoenix got its first ladder truck in 1921, which the department still has, but it is very different from the ones pictured here. Today firefighters do a lot more than just fight fires; they are also trained as emergency medical technicians. The overwhelming majority of calls that the fire department receives today are for medical emergencies.

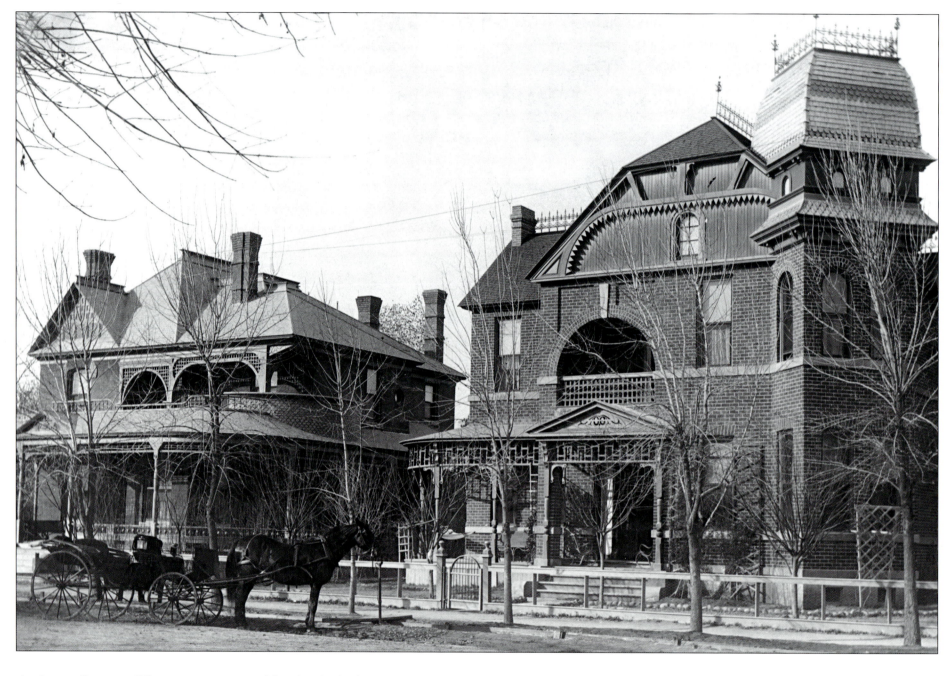

As the small town of Phoenix grew, its wealthy class looked for a place to build homes. As the Salt River sometimes flooded its banks and parts of Phoenix, the well-to-do selected home sites in the northeast corner of the original town site where the ground was higher. This part of town became Phoenix's Nob Hill, a name borrowed from the fancy Victorian neighborhood in San Francisco. Here are two Phoenix mansions in the 1890s, located between Second and Third streets on Monroe. The mansion to the left belonged to Marcus Jacobs. J. T. Dennis built the larger house on the right. The Queen Anne Victorian style was very popular at the time in a town that was trying to forget its desert origins.

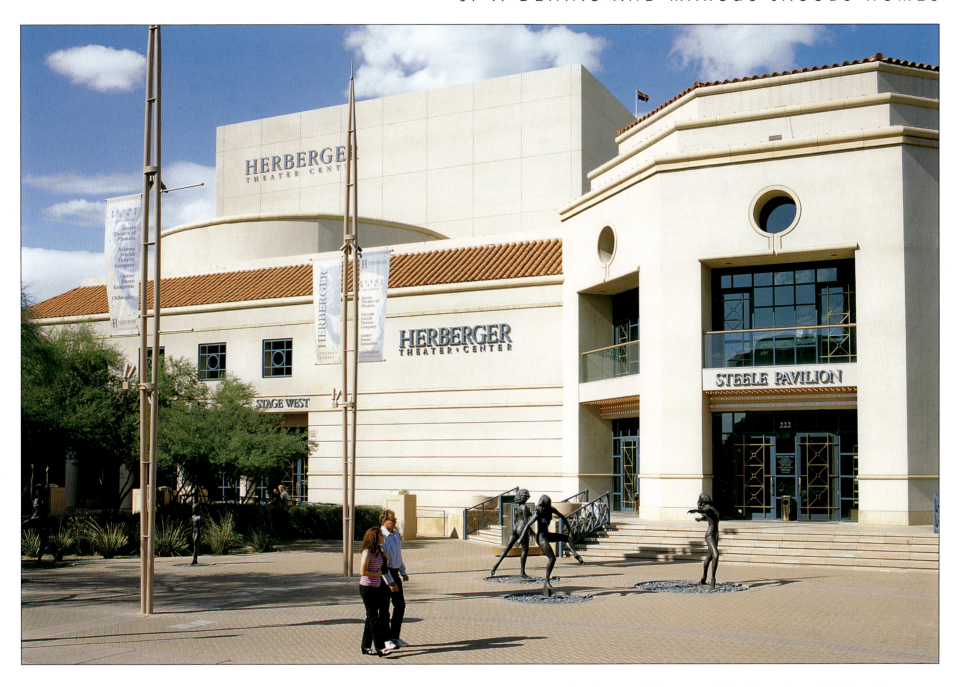

The Herberger Theater Center now sits where the two mansions once stood. Nob Hill's appeal faded as downtown encroached on the neighborhood. Over time, Phoenix's wealthier citizens abandoned their neighborhoods for homes farther north, especially along Central Avenue. The former Nob Hill mansions became rooming houses and slowly deteriorated. Some, like the Jacobs house, held on until the 1960s before being demolished. Built in 1989, the Herberger Center was part of Phoenix's effort to reinvigorate an abandoned downtown and to develop the arts locally. This performing-arts venue, home to four theater companies, is named for Robert and Katherine Herberger, who have supported many Phoenix-area arts organizations.

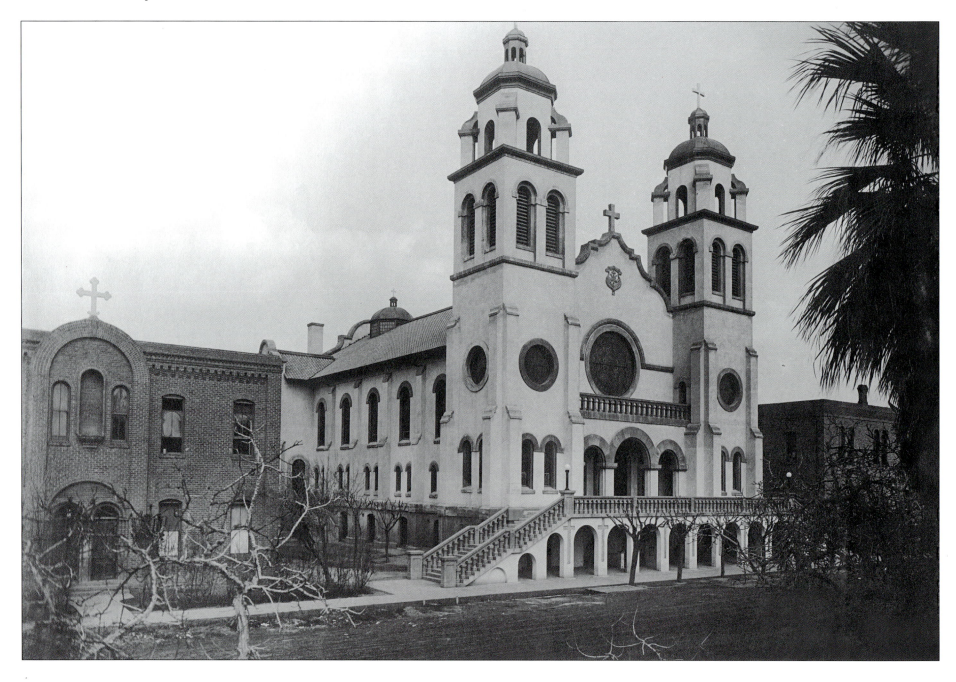

St. Mary's Catholic Church, about 1920. Located near the northeast corner of Third Street and Monroe, it sits on the site of Phoenix's first Catholic church, a small adobe structure built in 1881 and torn down in 1902 to make way for the new one. St. Mary's is the oldest Catholic presence in the Phoenix area, and the church has been staffed through most of its history by Franciscan priests. The church complex also included St. Mary's elementary school. Officials dedicated this Mission Revival church, designed by R. A. Gray and George Gallagher, in 1915. The completed church featured beautiful stained-glass windows created by the Munich School of Stained Glass Art.

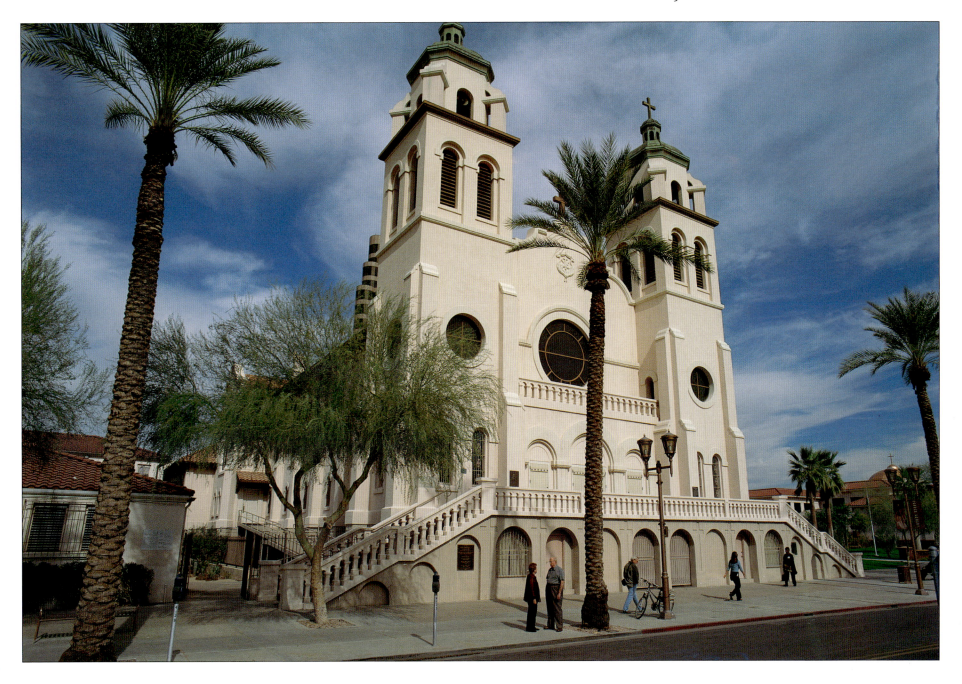

Since 1989, the church has been overwhelmed by new development in the downtown. The Arizona Center shopping complex stands to the north and Bank One Ballpark, home to Major League Baseball's Arizona Diamondbacks, to the south. The church will be further obscured by a seven-story addition to the Phoenix Civic Plaza, a convention center, just to the southwest. The Diocese of Phoenix has also changed the area, tearing down the parish's elementary school behind the church and replacing it with a new diocesan headquarters. In 1985, Pope John Paul II designated St. Mary's a minor basilica in honor of its contribution to the history of the region. He visited Phoenix and St. Mary's in September 1987.

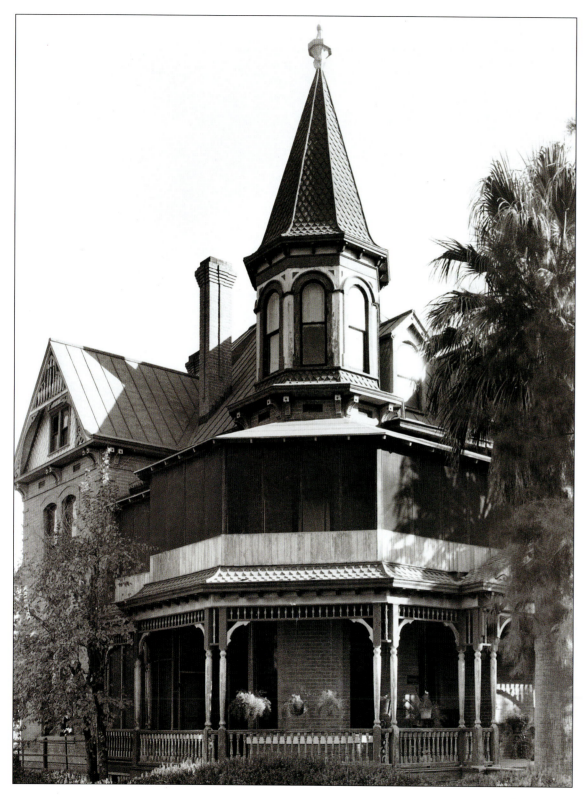

Dr. Roland Lee Rosson came to Arizona as an army surgeon at Camp McDowell. He married Flora B. Murray, member of a wealthy local family, and opened his own medical practice in Phoenix. Flora purchased an entire city block in the original Phoenix town site for $1,000, and, in 1895, on three of the lots, the Rossons hired local architect Alexander P. Petit to build them an Eastlake house. Petit moved his practice from San Francisco and introduced the use of brick for construction to Phoenix, where builders were accustomed to using adobe. The Rossons did not live in the house very long before they rented it to Whitlaw Reid, editor of the *New York Tribune* and future U.S. ambassador to Britain. Reid came out to Arizona because he hoped the dry air would ease his asthma. This photograph was taken around 1920.

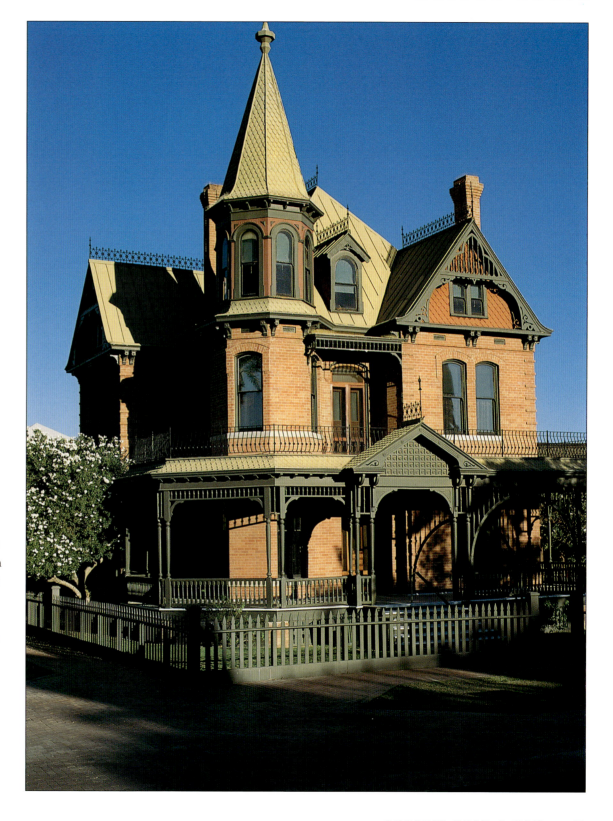

The house is now a museum that looks much the way it did when the Rossons first moved in. The couple sold the house in 1897 and moved to California, where Dr. Rosson died the following year. The house had many owners over the next seventy-five years or so, as many of the more wealthy residents left the downtown area and moved north. The Rosson's old home was a rooming house when the City of Phoenix bought it and the other structures on the block in 1974. Known as Block 14, it housed the last remaining houses in the original Phoenix town site. Phoenix restored the Rosson House as a museum and the centerpiece of the Heritage Square historic district. Restaurants and stores are in the other buildings.

Leon Bouvier, a cattleman and flour mill operator, built this house in 1899. Bouvier only lived here a short time before he rented it out. This is how the house appeared around 1902, based on the curved-dash car, the car's wooden spokes, and the family's clothing. This bungalow-style house is located on Adams Street, on the southern end of Block 14 of the original Phoenix town site. Edward Haustgen, an immigrant from Luxembourg, bought the house in 1911. His family owned a lot of real estate in the Phoenix area, and he later bought the Stevens house next door, to the west. One of the longtime residents of this house was Eliza Teeter from Tempe. She moved into the house in 1919.

The house is now part of Phoenix's Heritage Square, an area of restored historic houses and museums in downtown Phoenix. The square sits just across the street to the east of the Phoenix Civic Plaza convention center. Completed in 1972, Civic Plaza was the anchor of Phoenix's plans to revitalize the old downtown. Phoenix cleared a couple of blocks of old houses and cheap hotels to make way for Civic Plaza and the adjacent Phoenix Symphony Hall. These projects left Block 14 as the only remaining cluster of original homes from the old Phoenix town site. Then-mayor John Driggs proposed saving and transforming the block into Heritage Square. Today the Bouvier-Teeter Building is a popular tea house and restaurant called the Teeter House.

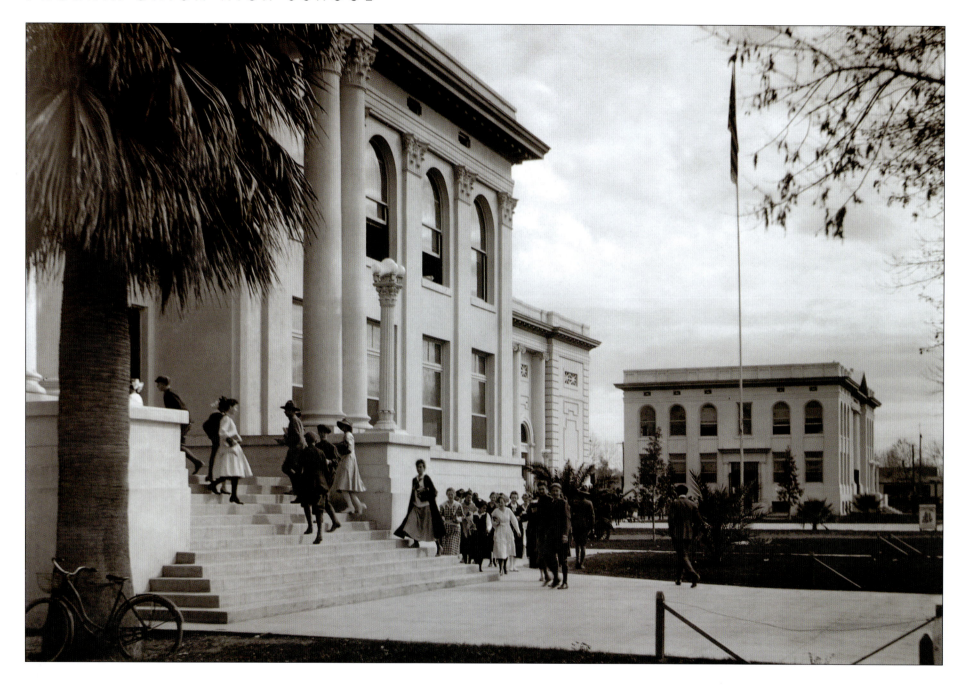

Phoenix Union High School, shown here around 1917, had a sprawling campus on the northwest corner of Seventh Street and Van Buren. The students are coming down the steps of the Domestic Arts and Sciences Building. Next door is the auditorium, and across the plaza is the Sciences Building. These three buildings were constructed between 1911 and 1912. The idea that several buildings could be used as a high school campus was a novelty. The other two contemporary examples of this concept in the Southwest were in California. Los Angeles architect Norman Foote Marsh designed all three! The campus, particularly the auditorium, which was entirely rebuilt in 1929, was the site of many cultural and social activities in Phoenix. This was the only high school in Phoenix for many years, and at its peak in the 1930s, the campus had eleven buildings and over 5,000 students.

These are the only buildings that remain on the former campus. The students left in 1982 when the district closed the school. The City of Phoenix now owns the property and is developing it as a center for biotechnology research. In 2002, the city convinced Dr. Jeffrey Trent, one of the scientists who led a successful effort to map the human genome, to move to Phoenix. Trent's Translational Genomics Research Institute (TGen) will use the science of genomics to research cures for diseases ranging from cancer to diabetes. TGen will take over the former high school campus, renovating the old buildings and constructing new facilities to support the research. Already one new building is nearing completion to the north of these buildings, and it is hoped that the campus will again become a regional center, one that further attracts much sought-after biotech research firms to the Phoenix area.

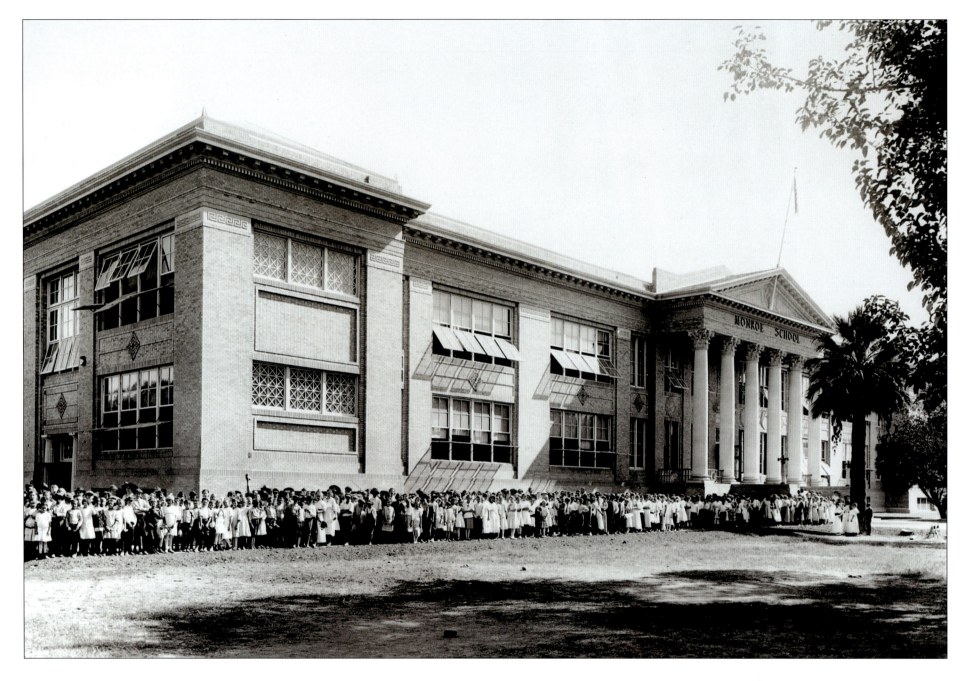

The student body of Monroe School posed for this photograph in front of their school in January 1916. The school opened near the heart of downtown Phoenix, near Seventh Street and Van Buren, in 1914. It was within walking distance of the Phoenix Union High School. Designed by Los Angeles architect Norman Foote Marsh, this was the first school in Phoenix to choose a design that was something other than a Victorian style. Students entered this three story, neoclassical-Revival school through an imposing portal of columns, which evoked the importance of education in the capital of a young state. Monroe School was the largest and grandest elementary school in the region, and it served students from a variety of social backgrounds. Although it was in the middle of the city, the school was surrounded by a large playground.

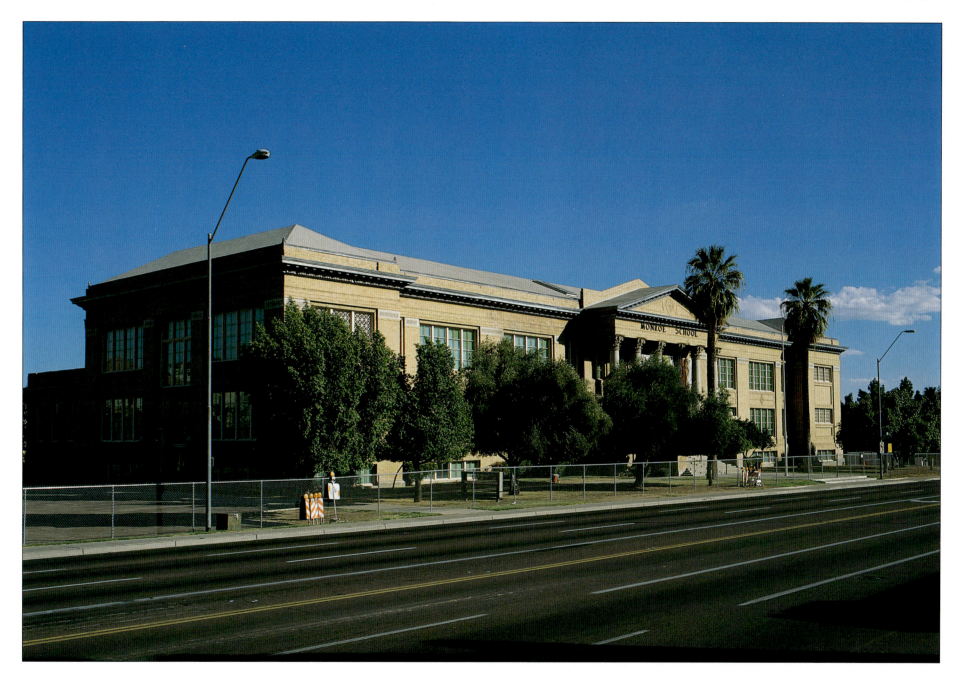

Monroe School will be the home of the Phoenix Family Museum, which plans to open in 2007. Started in 1998 by parents in central Phoenix, the Phoenix Family Museum got support from the City of Phoenix. The win-win partnership gave the museum a building and gave Phoenix a tenant for one of its most threatened historic buildings. The Monroe School closed in 1972 as much of the school-aged population moved away from the center-city. The federal government later purchased and renovated the building, using it for a military recruiting station. After the recruiting station moved out in 1998, the building sat vacant while new construction, including nearby Bank One Ballpark, abounded downtown. Worried about losing the school to demolition, Phoenix bought it in 2002 with bonds approved by Phoenix voters.

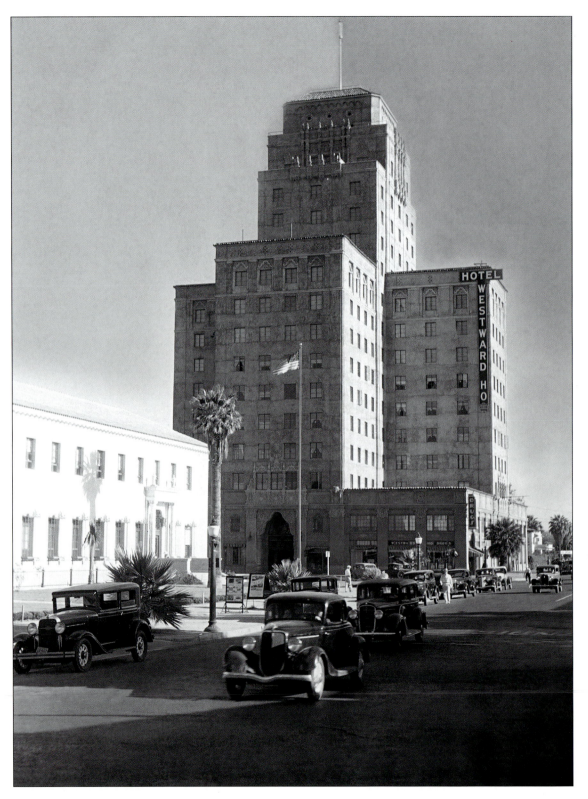

In this picture taken of Central Avenue in 1937, two important Phoenix buildings are visible. The smaller one to the left is the Phoenix Post Office. Opened in 1935, the federal government originally wanted the structure to have seven floors to house government offices. The Great Depression both delayed the building and forced the project to be scaled back significantly to only two floors. The towering building across the street is the Hotel Westward Ho. This sixteen-story building opened in 1929 and became one of the Phoenix area's most recognized landmarks. Its ballroom was a popular place for dances in the 1930s and during World War II, and the Thunderbird Dinner Theater was a great place for a date. The hotel also attracted the famous. Roy Rogers once got his horse Trigger to climb the stairs in the lobby. Elizabeth Taylor rented a suite on a year-round basis. The hotel also made an appearance in Marilyn Monroe's 1956 movie, *Bus Stop*.

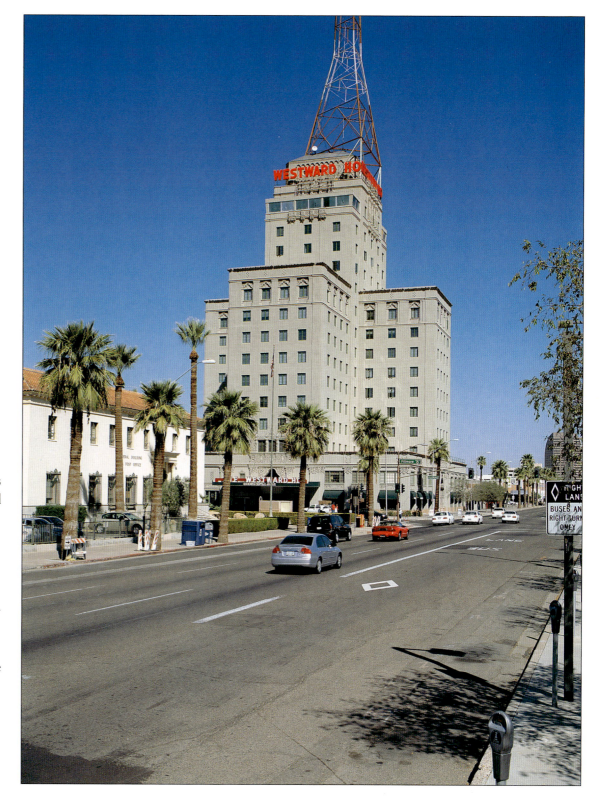

Both buildings are still there today. The Westward Ho, one of only two of Phoenix's major historic hotel buildings to survive (the San Carlos is the other), became subsidized housing for the elderly in 1981. A radio antenna now sits on top. A group called the Phoenix Preservation Partnership bought the structure in 2003 and completed a $9 million restoration in 2004. The theater and other spaces have been converted to apartments. The new owners painted the tower gray after learning that the color had graced the Westward Ho when it first opened; the building was white for years. As for the post office, it is still operated by the U.S. Postal Service, but Arizona State University is interested in acquiring it as part of a new Phoenix branch campus.

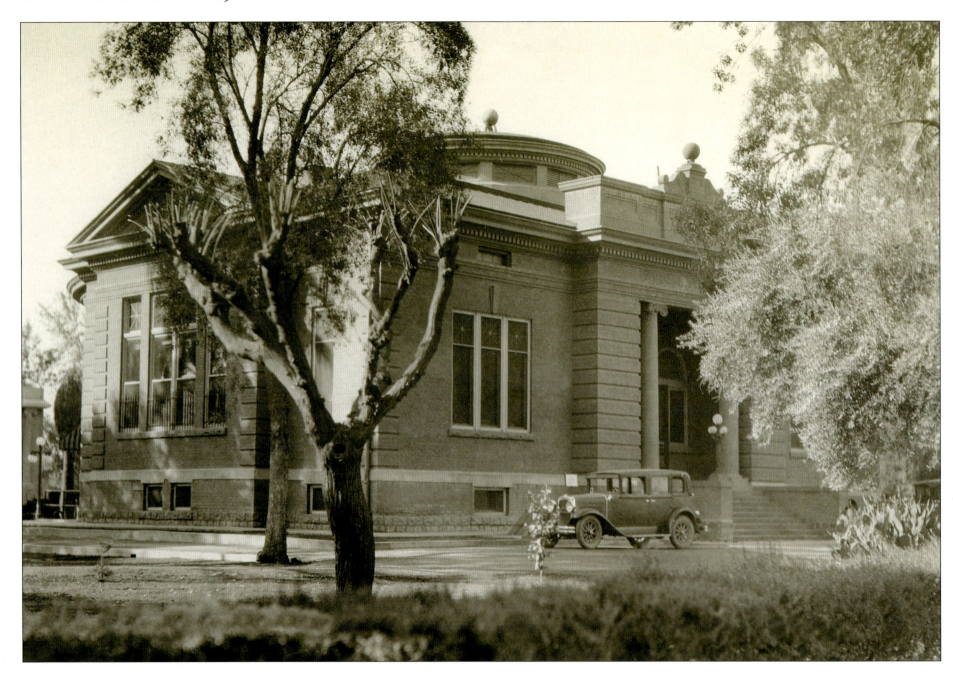

Shown here around 1930, the Phoenix Carnegie Library sits on a long block between Washington and Jefferson streets and Tenth and Twelfth avenues. This was the city's first free public library, and its construction was the result of ten years of effort by a group of volunteers who thought the young city needed such a place. The library is named for Andrew Carnegie, the wealthy businessman who helped build libraries throughout the United States.

He donated $25,000 for the construction of this building and the City of Phoenix donated the land. Designed by local architect W. R. Norton, with a few changes made at the City Council's request, the library opened in 1907. The library's grounds were also part of a city park that served the surrounding neighborhood between downtown Phoenix to the east and the State Capitol grounds to the west.

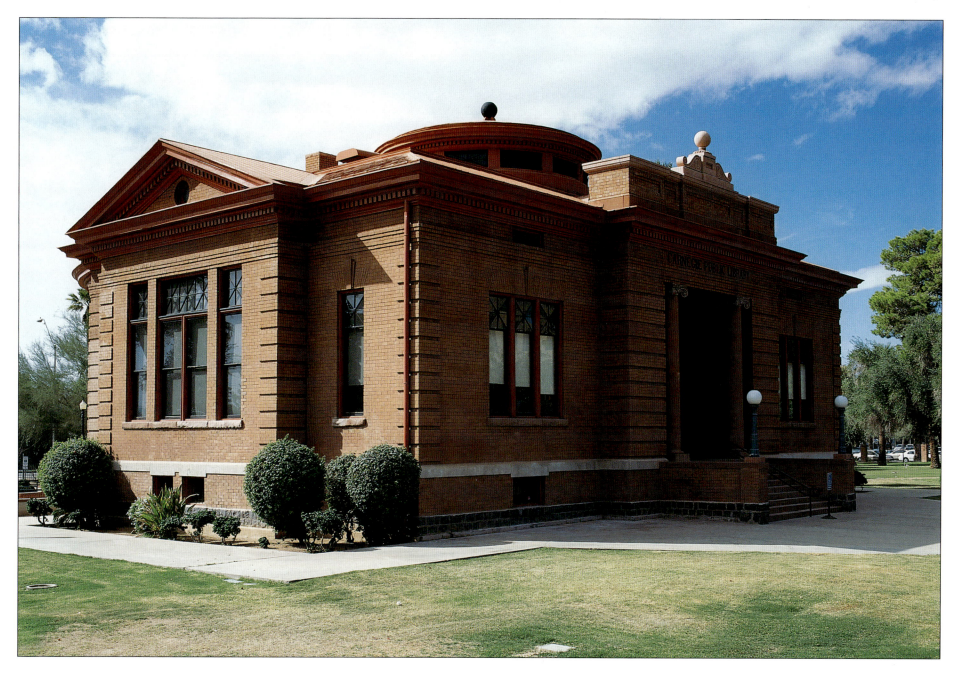

Today the Arizona Department of Libraries, Archives, and Public Records operates the building as the Carnegie Center, which offers a variety of electronic library resources and services. Phoenix kept the old Carnegie Library open until 1952, when the Phoenix Public Library moved to a new location at Central and McDowell Road. Following the move, the old library became an adult recreation center, a clothing distribution center, a reading room, and a warehouse. Meanwhile the surrounding neighborhood declined, many houses were demolished, and the library park became a refuge for the homeless. The State of Arizona took over the site in the mid-1980s, restored the library, and opened a museum within it. Since then, new government building projects are filling in the former neighborhoods between downtown Phoenix and the State Capitol.

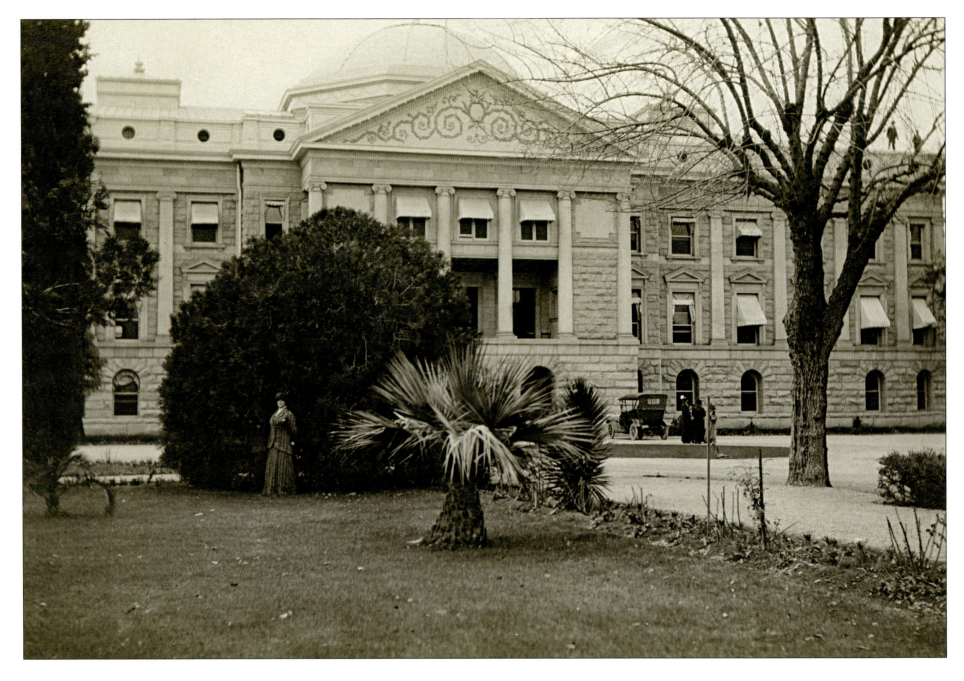

The Arizona State Capitol Building, at Seventeenth Avenue and Washington, about 1920. During its first thirty years, the Territory of Arizona had a "capital on wheels." The capital swung between the Arizona towns of Prescott and Tucson before Phoenix captured the prize in 1889. Constructed between 1898 and 1900, this capitol building ensured that Phoenix kept the capital for good. Phoenix remained the capital when Arizona became a state in 1912. James Riely Gordon won the national design competition by entering his rejected plan for the capitol building of Mississippi. Cash-strapped Arizona officials reduced the scale and cost of Gordon's design by eliminating a grand staircase to a planned second-floor entrance. They also passed on the suggestion to make the capitol dome from copper to recognize Arizona's dominant copper industry. They painted the dome copper instead.

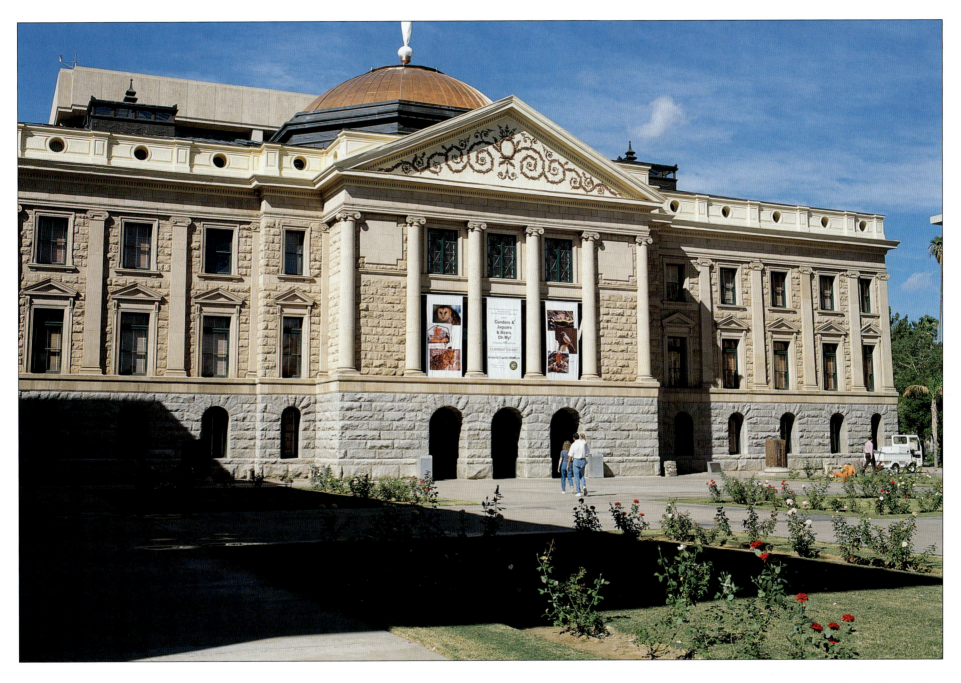

As the population of Arizona exploded during the post–World War II boom, so did the size of Arizona's government, and it quickly outgrew Gordon's building. Rejecting a fantastic proposal by famed architect Frank Lloyd Wright, Arizona instead built separate modern-looking buildings for the senate and house of representatives in 1956. In 1974, the governor moved into a new "executive tower" skyscraper right behind the capitol building.

Having lost its original government function, Arizona transformed the old capitol building into a museum in 1981 following a restoration that put real copper on the building's dome. The restoration also freed the "Winged Victory" weather vane that legislators in the 1950s had fixed in place so that her back would never face them.

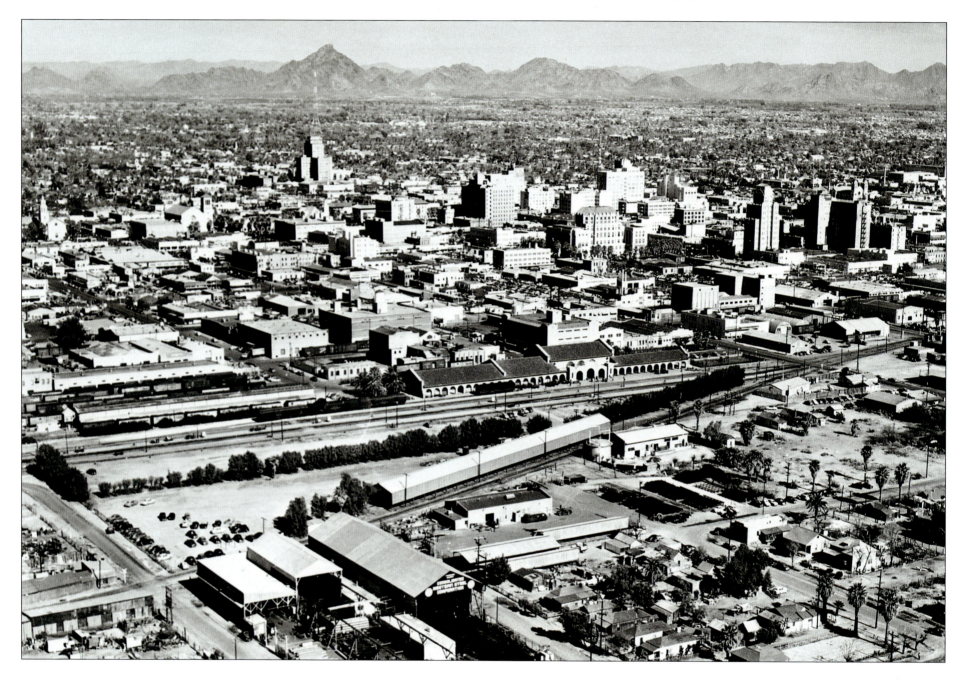

Downtown Phoenix, about 1940. Looking northeast, Phoenix's industrial district is near the bottom and is centered on Union Station in the middle. Beyond the central business district are many of Phoenix's residential neighborhoods. Open space separates Phoenix from the mountains on the horizon, such as the McDowells to the far right. Prominently featured at the top left is one of Phoenix's notable mountains, Squaw Peak. All of the skyscrapers seen in this view were built or started during the prosperous times of the 1920s. Commercial building largely came to a halt during the Great Depression, and in a sense, the downtown was "frozen" until after World War II.

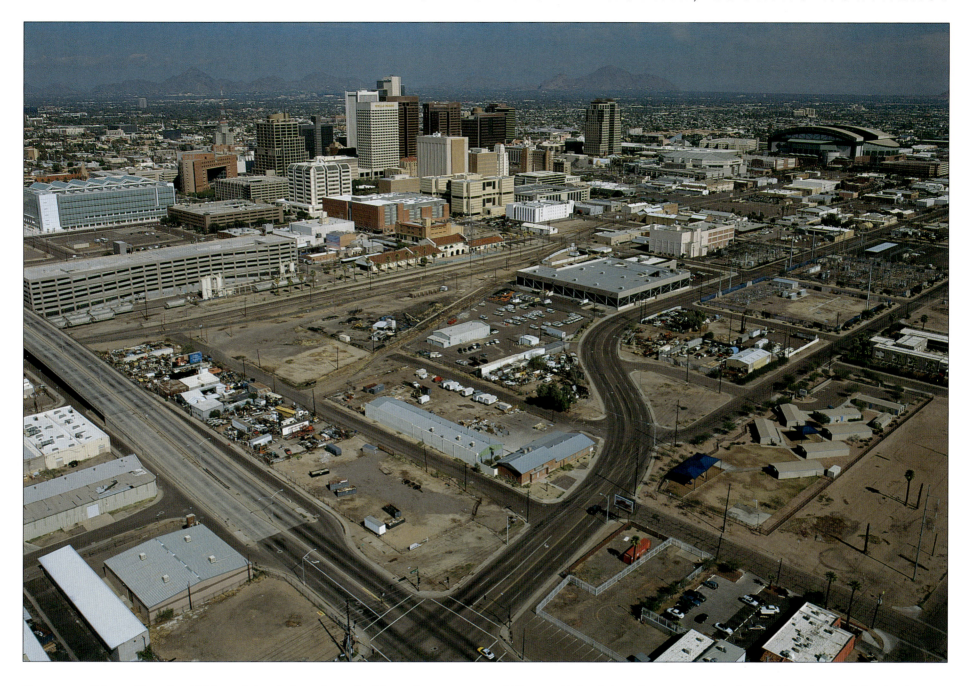

Downtown "thawed" in the 1950s and the skyline shows buildings from every decade since then. Some of the major recent projects include the Bank of America Tower, center right, completed in 2000. The larger, hangarlike building to the far right is Bank One Ballpark, completed in 1998. The Arizona Diamondbacks baseball team won a world championship there in 2001. The big rectangular building to the far left is the new Sandra Day O'Connor Federal Courthouse, completed in 2002 and named for the first woman on the U.S. Supreme Court. The former Squaw Peak, a name considered offensive by many, was renamed Piestewa Peak in 2003 by the State of Arizona. Army Pfc. Lori Ann Piestewa, a member of the Hopi tribe in northeastern Arizona, died in the War in Iraq in 2003. She was the first Native American woman in the U.S. armed forces to die in combat.

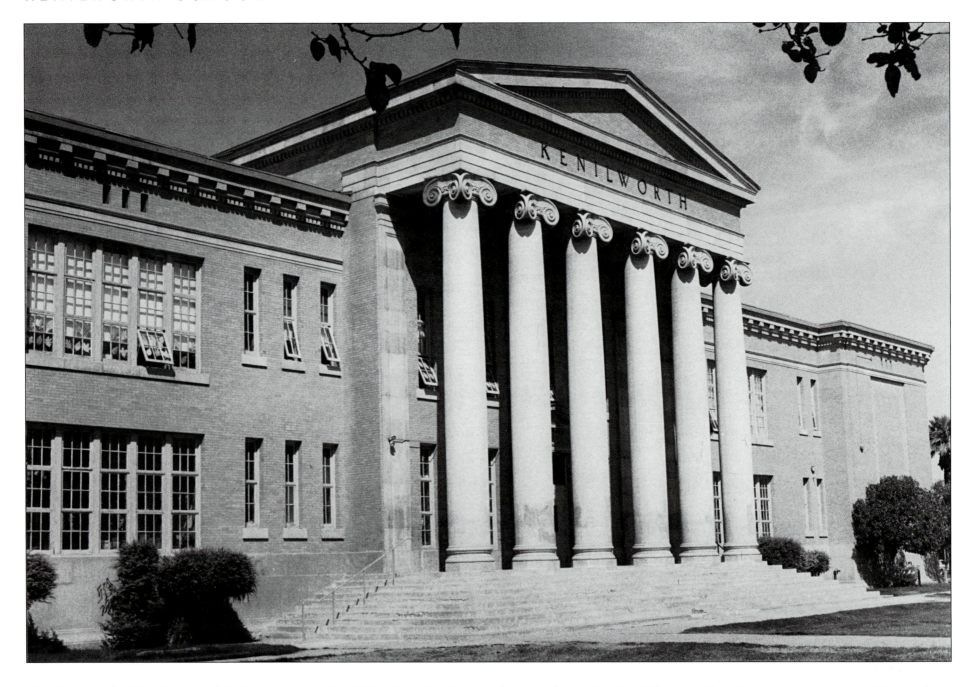

The Kenilworth School, on north Fifth Avenue, in the 1920s. Completed in 1920, the imposing neoclassical building, designed by Norman Foote Marsh, was one of the first schools built outside of Phoenix's original town site. Phoenix had a population of 29,000 in 1920 and was starting to expand north from the historic town center. More schools were needed, and the district built Kenilworth Elementary to meet the demand. Because it was built on the north side of Phoenix, the school catered to some of the city's more prominent families. Arizona Senator Barry Goldwater graduated from here, as did Arizona governor and senator Paul Fannin. Margaret T. Hance, a former mayor of Phoenix, also went to the school. Today a park nearby bears her name.

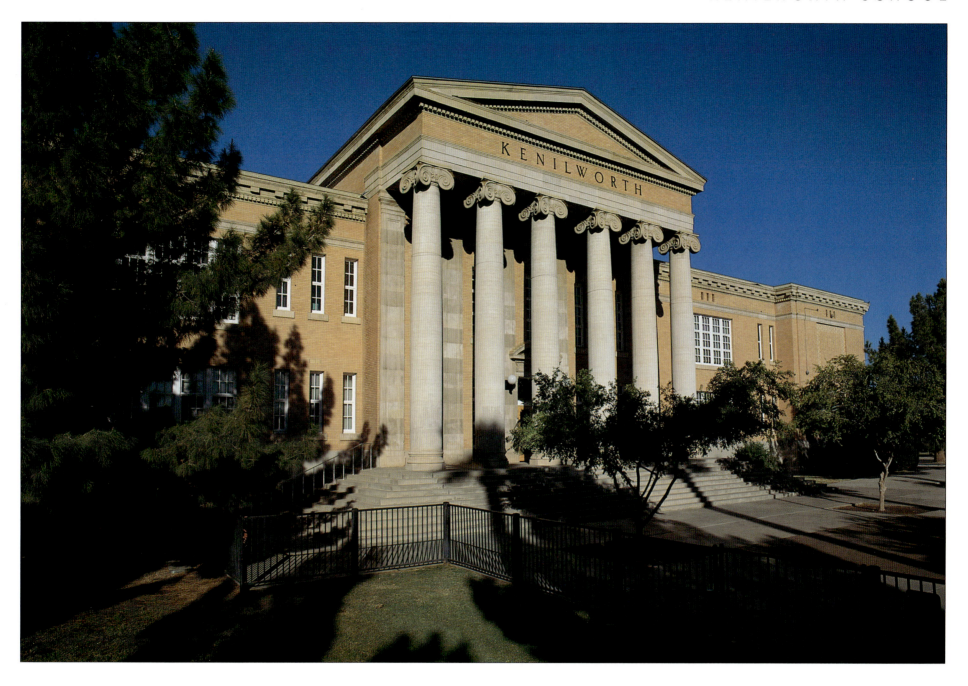

Kenilworth is still a school today, although its surrounding neighborhood was demolished to make room for the Interstate 10 freeway, or Inner Loop. The freeway is within sight of the school to the south, but transportation planners changed the freeway alignment slightly in the 1980s to save this historic structure. With 650 students today, this public school is the oldest still operating in Maricopa County. Kenilworth's Montessori program also attracts students from around the valley and has a waiting list. The district rehabilitated the structure in the early 1980s and added a new annex in the 1990s. The school celebrated its eightieth anniversary in 2000 by restoring one of the classrooms to the way it looked in the 1920s.

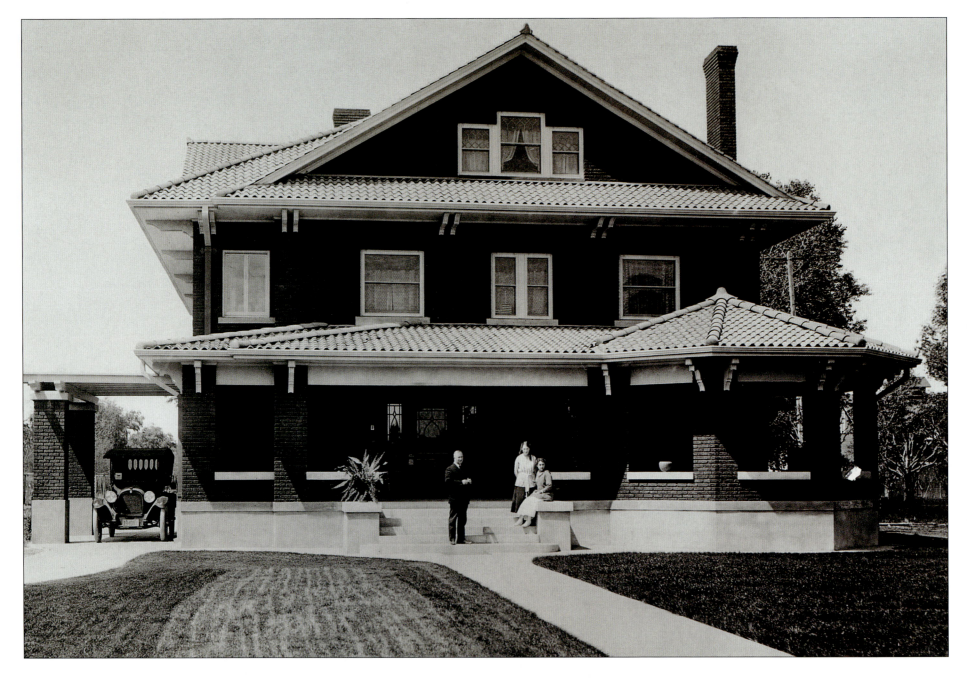

Dr. William C. Ellis's house, on north Central Avenue, about 1920. Moving to Phoenix from Ohio in 1907, Ellis helped organize the Arizona Deaconess Hospital (now the Good Samaritan Medical Center) and was the head of its medical staff. From the 1890s to the 1930s, Central Avenue's rural feel attracted many of the Phoenix wealthy who wanted to live in the country and yet be close to the city. Their large homes lined the sides of Central Avenue, earning neighborhood the nickname of "Millionaires' Row." Local architect R. A. Gray designed the house at a time when the Craftsman Bungalow style was very popular in Arizona, and the house is a blend of the Prairie and Bungalow styles. Completed in 1917, the house featured three stories, a basement, hardwood floors, mahogany trim and banisters, hand-painted globe-style chandeliers, and wire-cut bricks from Colorado.

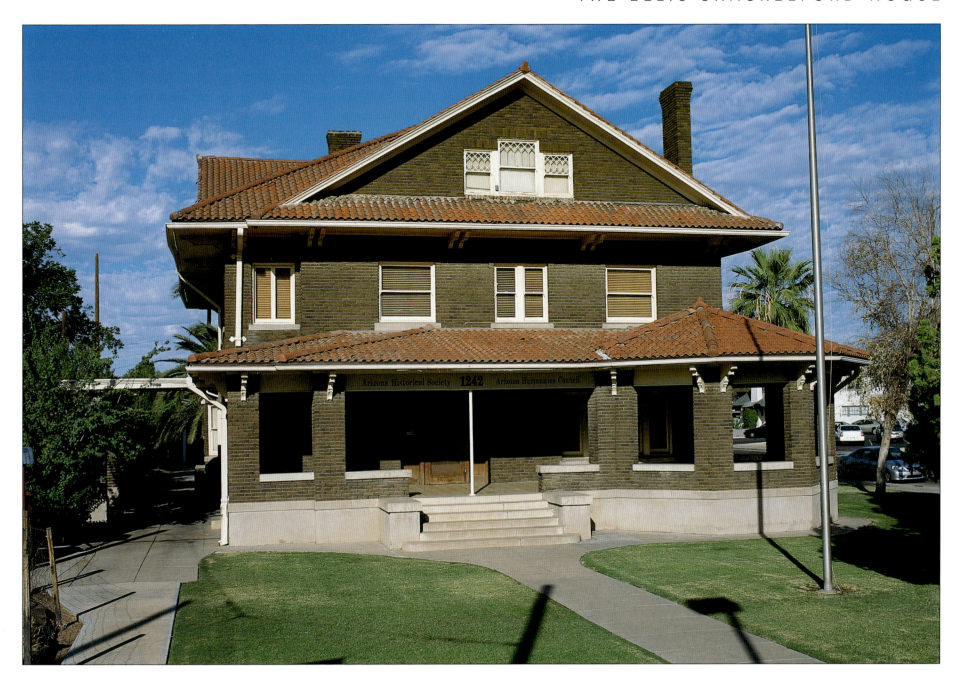

Today the house is the only intact mansion left along the downtown section of Central Avenue. The house now sits on the north side of the Interstate 10 freeway, which cuts right through the center of Phoenix. The Phoenix Burton Barr Central Library, with its desert climate–sensitive design by William Bruder, sits across the street. Dr. Ellis's daughter and her husband, J. Gordon Shackelford, inherited the house and lived there until 1964. The house was used as a boys' home and as a museum of the Arizona Historical Society. The Arizona Department of Transportation acquired the house during the construction of the freeway. The Arizona Humanities Council now occupies the house and is raising money to restore it as a combination museum and office.

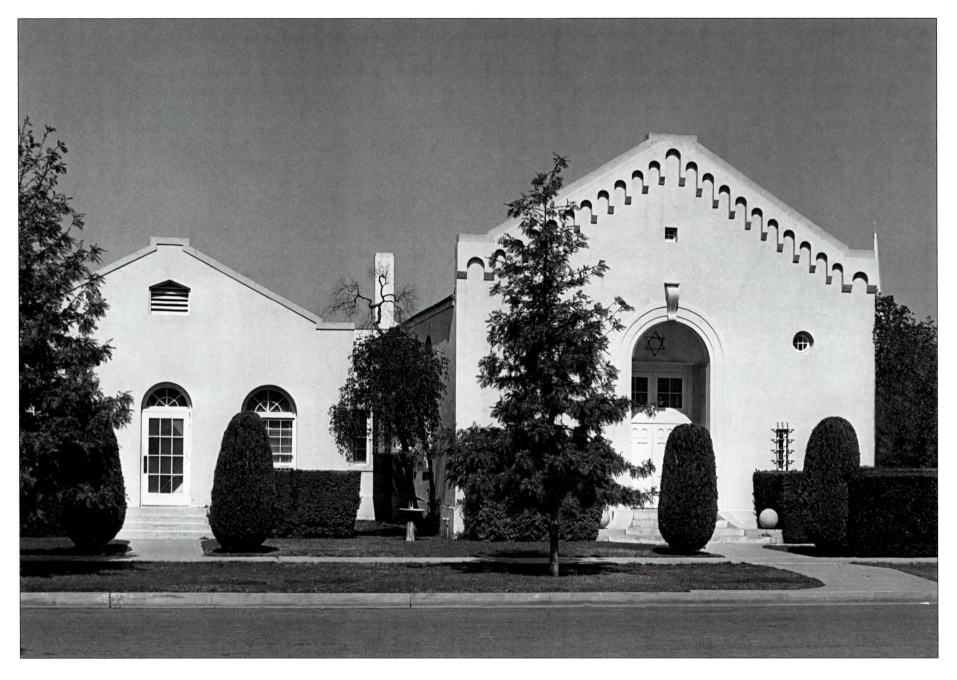

Phoenix had 29,000 people in 1920 and had just become Arizona's largest city when Temple Beth Israel, a Reform congregation, organized. Jewish Americans started arriving in Phoenix in the 1870s, but it took a while until this community could support a synagogue. This congregation built the first synagogue in Phoenix around 1921. Several prominent local businessmen, including Isaac Diamond, David Goldberg, and David Grunow, helped lead the effort. Located at 122 East Culver, a few blocks south of McDowell Road, the building was a place of worship, a community center, and a gathering place. Here is the synagogue complex in about 1930. The building to the left was a classroom, completed in 1924. The synagogue, just a few blocks east of Central Avenue, was centrally located for Phoenix's Jewish community.

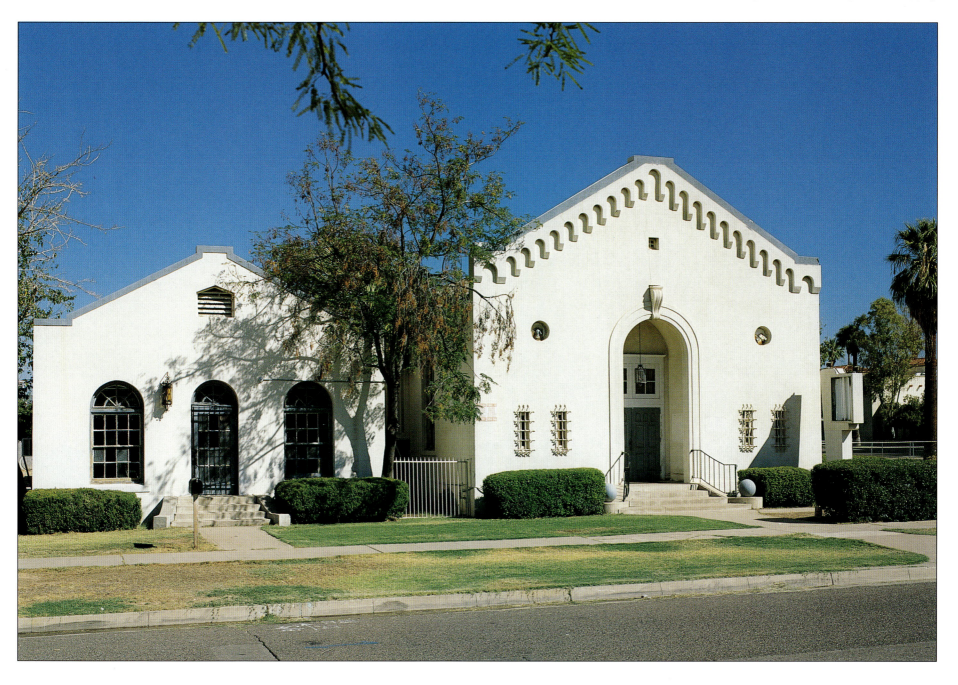

Today the Arizona Jewish Historical Society (AJHS) owns the building, though the building has not been associated with the Phoenix Jewish community for nearly fifty years. Following World War II, Phoenix started to grow north and many Jewish Americans moved out of the downtown area. Temple Beth Israel relocated in 1949 to better serve its congregation. The Chinese Baptist Church purchased the building and called it home until

1959. Because of the Phoenix area's growing Hispanic population, the former synagogue eventually became the Iglesia Bautista, a Mexican Baptist Church. The AJHS purchased the building from the church in 2003 and plans to restore it as a Jewish heritage center. The building now also stands literally in the shadow of the Phoenix Burton Barr Central Library, built in 1995.

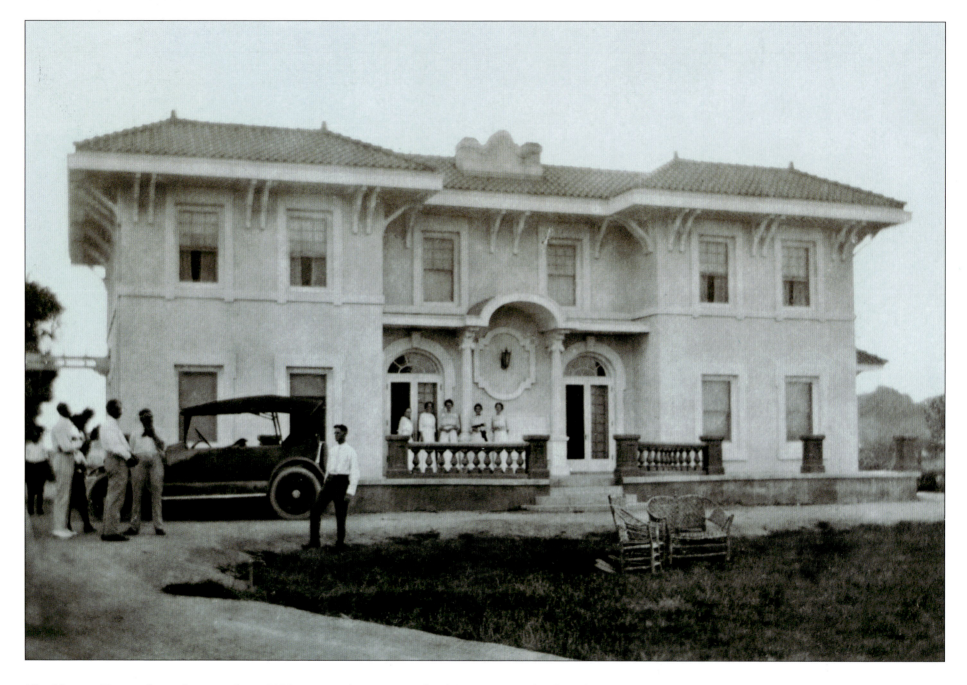

The Norton House, shown here in about 1920, was, at the time, north of Phoenix, located on Fifteenth Avenue between McDowell and Thomas roads. Dr. James C. Norton was a veterinarian and former Iowa college professor who moved to Arizona for health reasons. In 1893 he became the territorial veterinarian and was responsible for keeping Arizona's cattle herds healthy. He left that job in 1912, bought 200 acres in the country, and started a dairy farm. Dr. Norton also founded a local YMCA and was active in the First Presbyterian Church of Phoenix. He had this Renaissance Revival house built and moved his family into it in 1913. The house had two sleeping porches along the back of the house for keeping cool during warmer weather. The family loved to play croquet on the large lawn in the front.

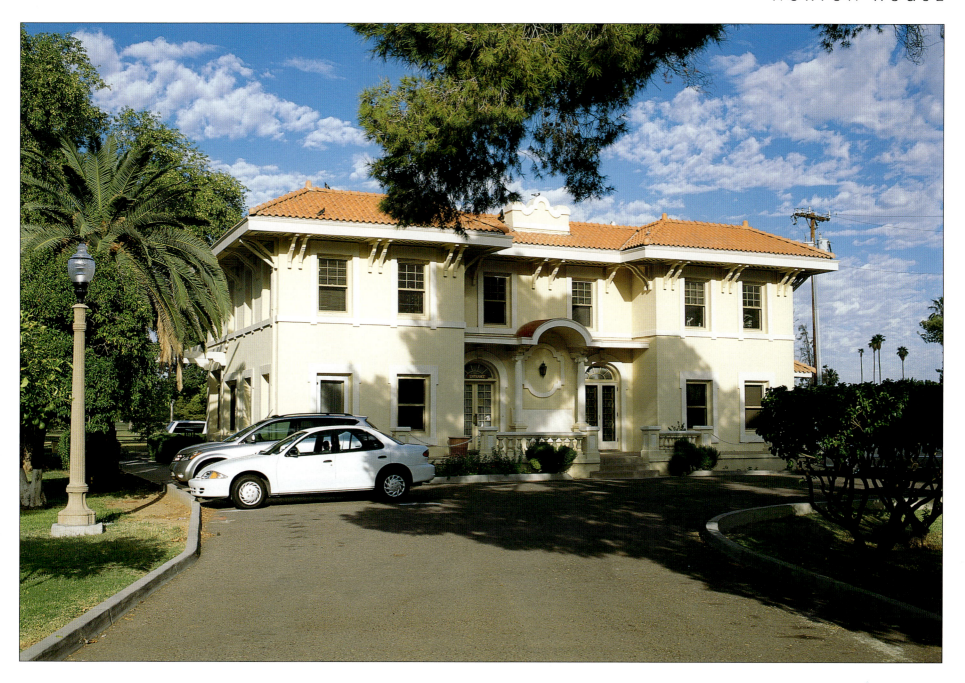

The Phoenix Parks and Recreation Department maintains its headquarters in the house, as it has since 1935. The screened sleeping porch has been filled in and the rooms have been converted into offices. The City of Phoenix bought the house from Dr. Norton, along with half of Norton's 200-acre property, in the early 1930s. Phoenix then launched an ambitious program to develop new parks. The City transformed its portion of Norton's land into Encanto Park, which included a lagoon, boathouse, and golf course. Norton, who lived until 1954, developed the rest of his property as the Del Norte Estates neighborhood.

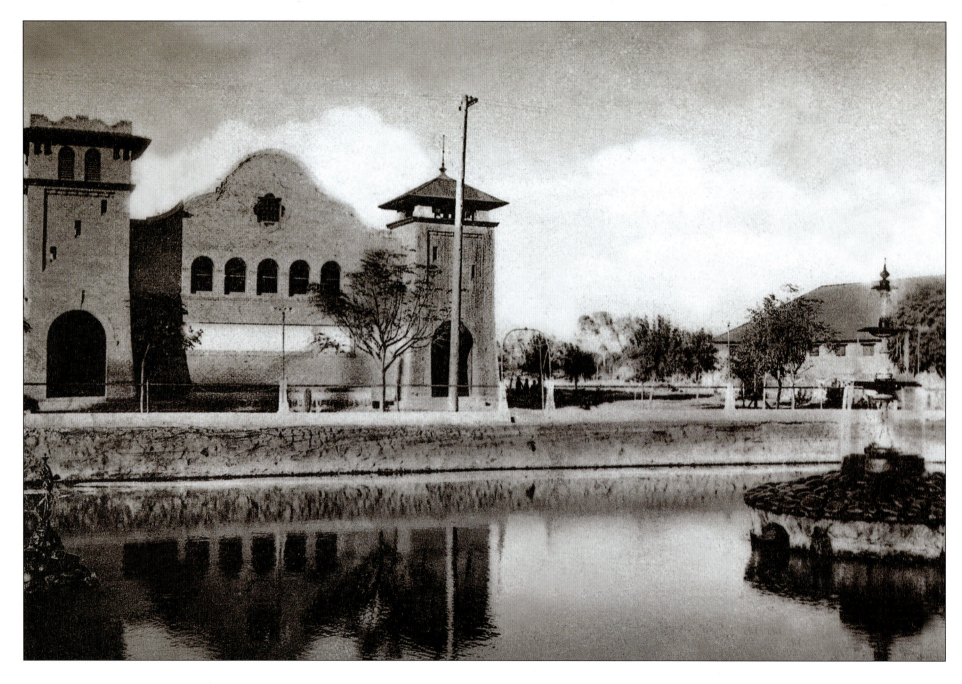

Memorial Hall stands behind the lagoon on the 160-acre campus of the Phoenix Indian School. The school opened to the northeast of Phoenix in 1891. Indian School Road runs along the school's southern boundary. Named in honor of the Native American students who fought in World War I, this school's auditorium opened in 1922. This picture shows the hall within a year or so of its completion. The school, one in a national system of schools, was part of the federal government's plan to assimilate Native Americans by teaching them English and manual and domestic labor skills. The government forcibly took Native American children from their parents, cut their hair, put them in military uniforms, and punished them for speaking native languages. The campus also included a dining hall, dormitories, a band field, a farm, and related buildings.

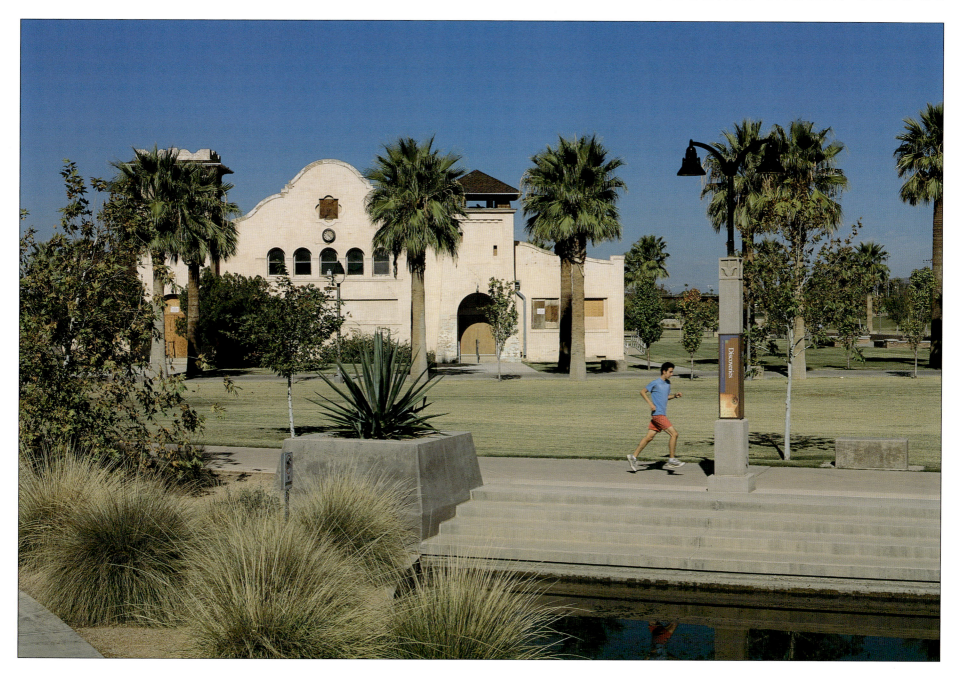

Memorial Hall is one of only three buildings from the Indian School that remains today after the campus closed in 1990. A federal policy change emphasizing reservation schools over boarding schools eventually led to the closing of this ninety-nine-year-old institution. The federal government, which owned the school, divided the 160-acre property three ways in the mid-1990s: it traded the valuable Central Avenue portion to a developer, gave some of it to the Veterans Administration Hospital on the east end of the property, and let the City of Phoenix have the middle portion. The developer has not started on its share of the land, but the City has. Phoenix's Steele Indian School Park opened in 2001. The City is currently restoring Memorial Hall as a performance venue, the dining hall as a Native American cultural center, and the band building as a veterans' museum.

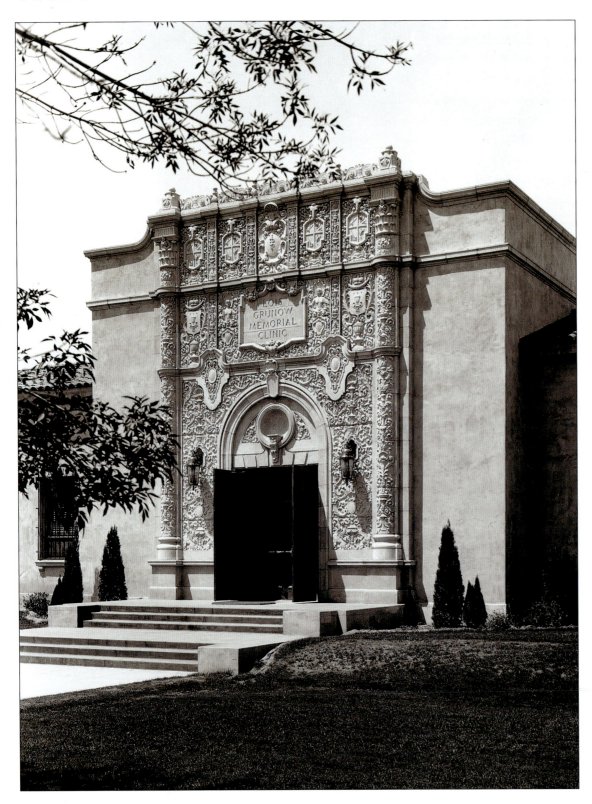

Shown here in 1931, the Grunow Memorial Clinic, at 926 E. McDowell Road, was named for Lois Anita Grunow, who died in 1929 when she was seven. Her parents, owners of a successful manufacturing company, donated the money to build the clinic. Designed by L. M. Fitzhugh and Lester Byron, this Spanish Colonial Revival building has one of the more distinctive entrances in Phoenix. The entrance facade and building windows have Churrigueresque detailing (elaborate stone carvings). Inside the entrance, in the Renaissance room, are murals of early physicians painted by local Lon Megargee, who later gained some fame as a cowboy artist. This medical office is right across the street from the Good Samaritan Hospital, one of the largest hospitals in the Phoenix area at the time. The hospital opened here in 1923 and attracted other medical businesses and buildings to the area.

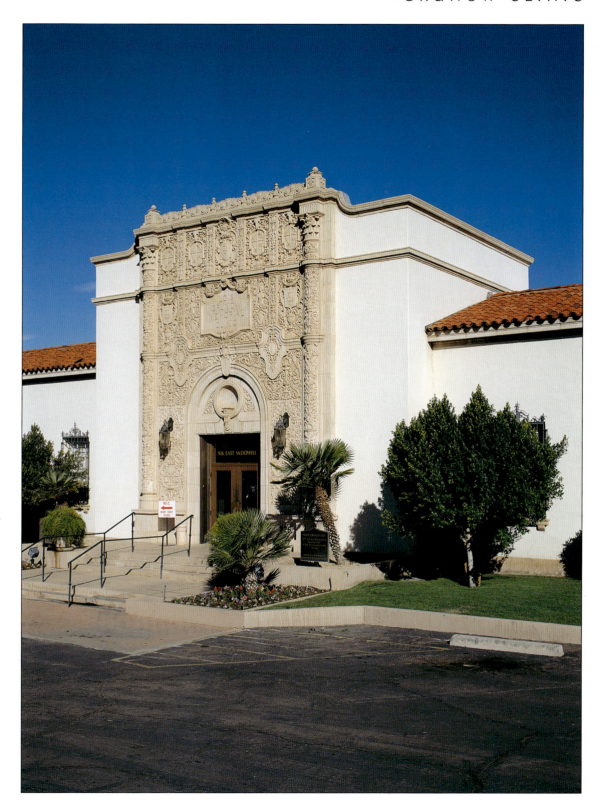

The Grunow Clinic still stands on McDowell Road and the building is still used for medical offices. Most Phoenix-area residents know about the Grunow Clinic from one of Arizona's most spectacular and grisly murders. Winnie Ruth Judd, dubbed the "trunk murderess" by the press, worked as a secretary in the building. Judd was accused of killing her two roommates in 1931, dismembering the bodies, and shipping them in trunks to Los Angeles. The Hearst newspapers in California sensationalized the case, and Judd was convicted and spent much of her life in the Arizona State Hospital. Most Phoenix residents thought she took the blame for a crime committed by a prominent businessman, who they believed was protected by the Phoenix business establishment. Across the street, the original Good Samaritan building has been replaced by a large, modern hospital.

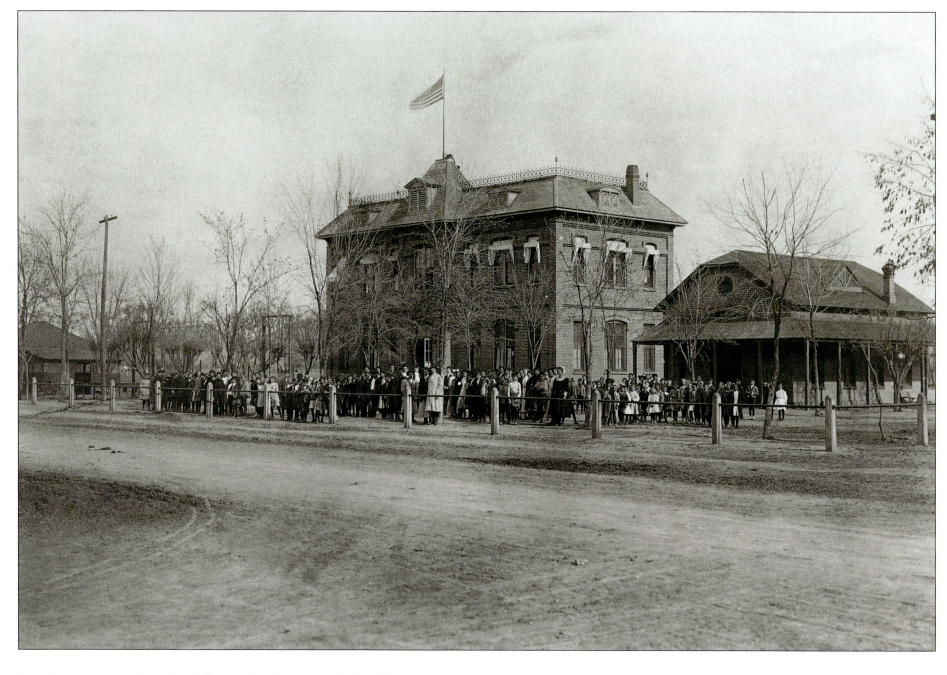

Seen here in about 1900, the Osborn School was a rural school located far to the north of Phoenix on Central Avenue and what is today the northeast corner of Central and Osborn Road. It was established in the early 1880s, and the original two-story building was completed in 1892. James A. Creighton was the architect, and he gained a prominent reputation for designing this school and numerous other buildings in the Phoenix area in the 1880s and 1890s. His best-known structure today is Old Main on the campus of the University of Arizona in Tucson. Osborn School was named for one of the school's founding board members, John P. Osborn.

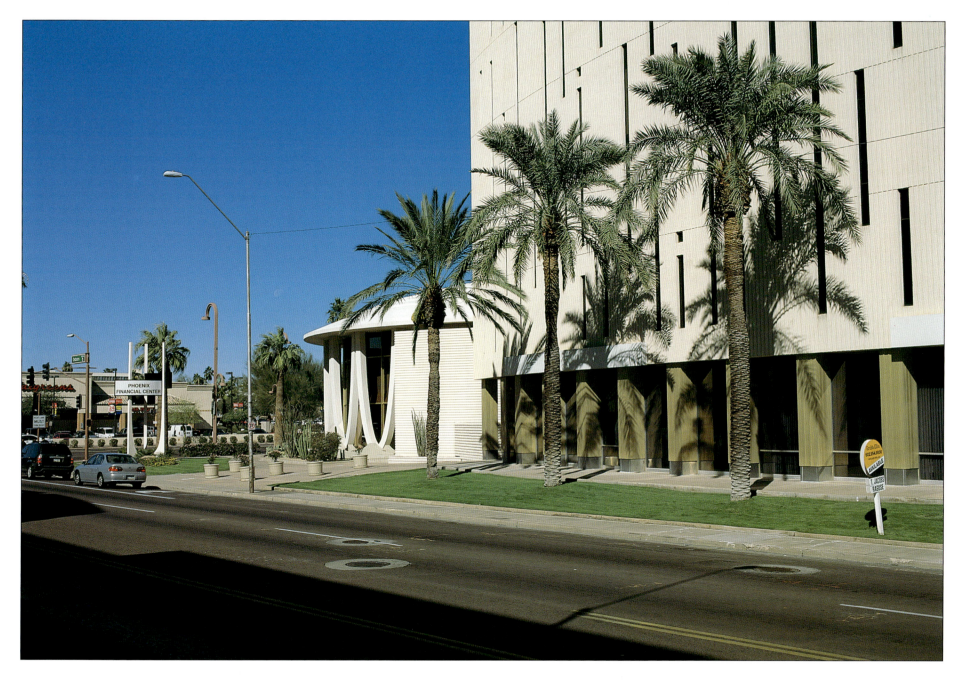

The corner is now host to the Financial Center, designed by St. Louis architect W. A. Sarmiento and built around 1965. This intersection lies in the heart of the uptown district of Central Avenue. Uptown is generally that portion of Central north of McDowell Road. Many Phoenix offices started to leave the downtown for this area in the 1950s, paralleling the departure of private homes and retail businesses. Occupying what had become valuable real estate, the Osborn School closed down and was demolished in 1963. In the years prior to the school's destruction, the school district made several changes to the historic structure, including flattening the roof and expanding the campus.

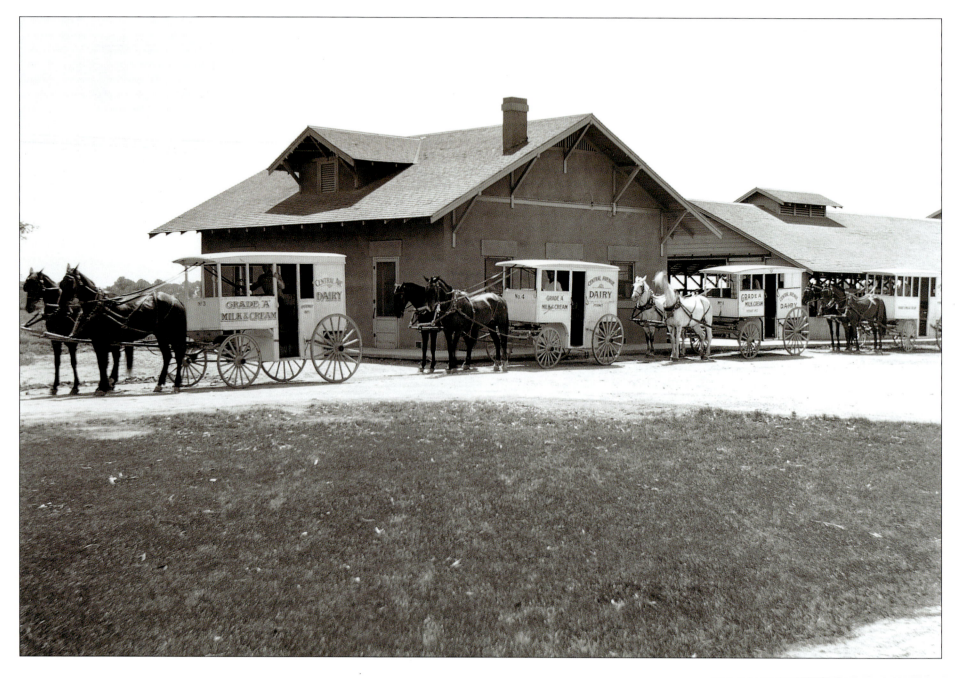

In 1937, the Central Avenue Dairy was located north of town in the country. The dairy was about a mile north of some of the fancier homes south of McDowell Road and Central Avenue. The population of Phoenix totaled about 60,000 people at the time. This building was located near the present-day alignment of Earl Drive, and on the west side of Central Avenue. This photograph shows the dependable form of transportation that delivery drivers relied on each morning as they traveled to points throughout Phoenix. The large dairy, owned by the Geare family, remained in operation right up until the early 1950s.

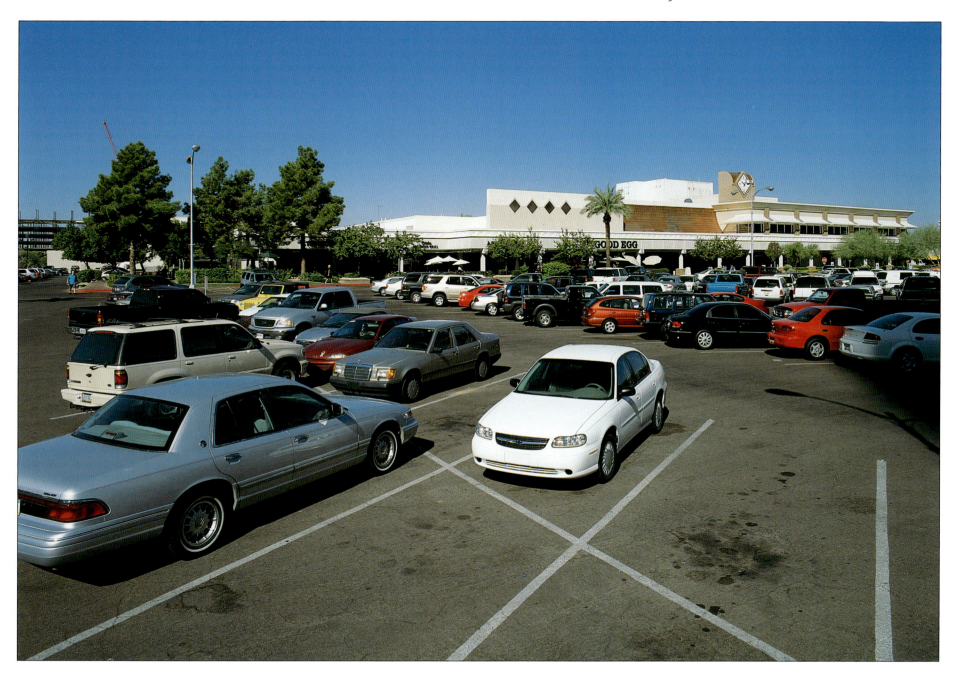

The site of the old dairy is now part of a sprawling, mixed-use office center called Park Central. Park Central was once an open-air shopping mall, the first mall in Phoenix, opened in 1957. The mall was closer to Phoenix's new suburban neighborhoods. This same trend led to the mall's demise in the early 1990s. The city kept moving north and new malls opened. Dillard's department store, the last of the mall's major tenants, closed in 1995. New owners transformed the mall into office space. Taking advantage of Park Central's location near St. Joseph's Hospital, several health care businesses moved in. Park Central still includes a few small businesses that cater to the office workers from the nearby office tower–lined section of Central Avenue known as uptown. One of these is the Miracle Mile Deli, which was one of the mall's first tenants.

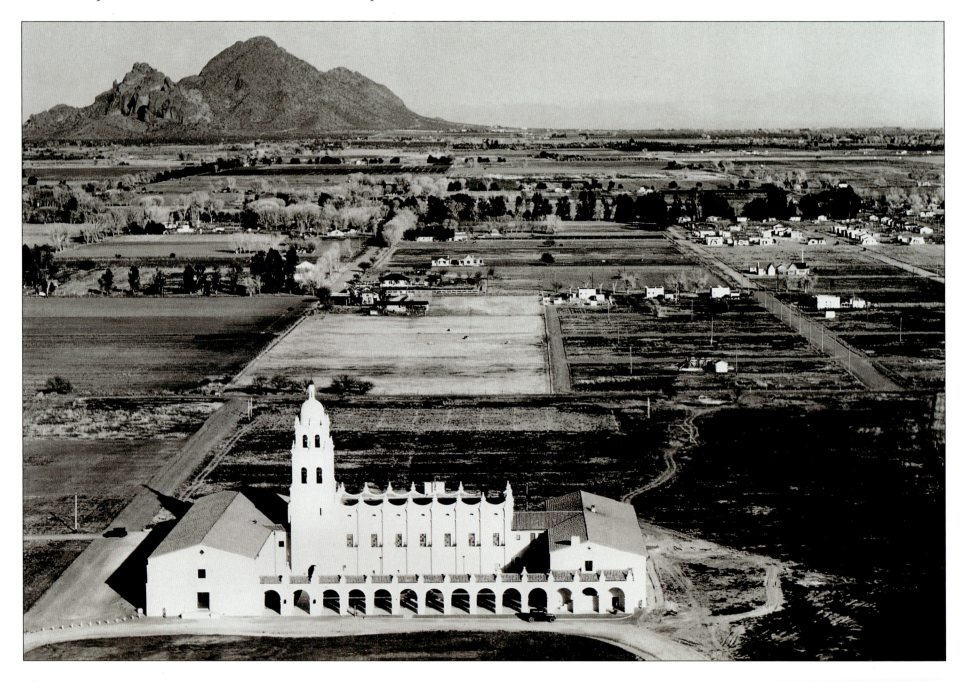

Brophy College Preparatory School, with Camelback Mountain in the background, in 1928. Ellen Amelia Goodbody Brophy established this Catholic school in honor of her late husband, William Henry Brophy. The Jesuits, a religious order, operated the school. The Spanish Colonial Regis Hall, which contained a chapel and the Jesuits' residence, sits just east of Central Avenue on nineteen acres that were once part of the Brophy estate.

Part of the meandering Arizona Canal is to the right. The chapel also served as St. Francis Xavier Parish, the second Catholic parish in Phoenix. Ellen came to Arizona in the 1890s with her husband, a successful mining company executive and banker. A devoted Catholic, she helped establish several churches and schools. Pope Pius XI honored Mrs. Brophy for her work in 1931. She died in 1934.

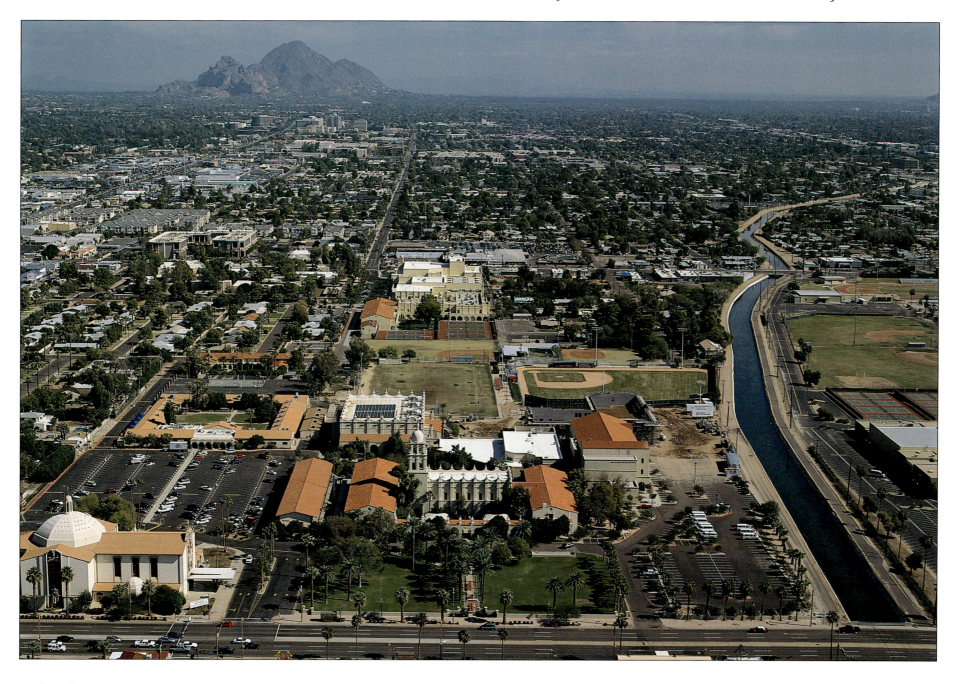

Today urban Phoenix surrounds the once-isolated campus, including the adjacent grounds of Phoenix Central High School across the canal to the right. Developers are interested in this section of Central Avenue, as new office and apartment buildings have been built from the right, or south, of this view and the lot across the street awaits a new project. With the onset of the Great Depression just a year after opening, Brophy College Preparatory struggled through hard economic times. The financially strapped school limped along before closing in 1935. The all-male high school reopened in 1952. It added several buildings to its once-rural site, including the Spanish Revival Saint Francis Xavier Church (1959), Loyola Hall (1959), Robson Gymnasium (1967)—one of the state's largest gyms, and the Steele Library (1986). About 1,200 students now attend the nationally recognized school.

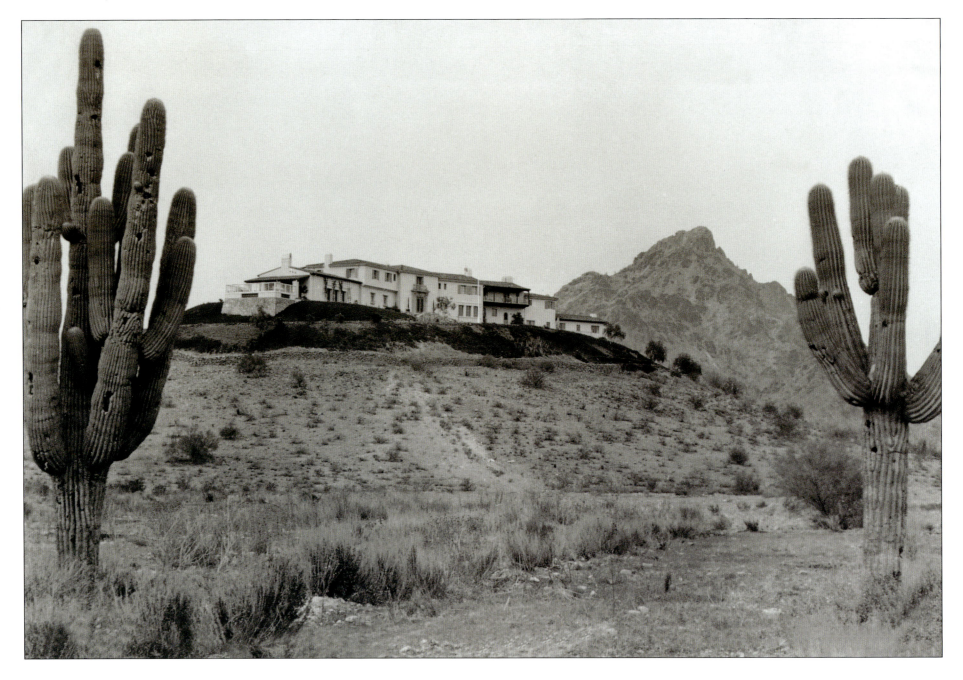

William Wrigley Jr., who made his fortune selling chewing gum, built the Wrigley Mansion as a fiftieth-wedding-anniversary gift for his wife, Ada. Constructed between 1929 and 1931, it was the largest private residence in the state at the time. Here it is in the 1930s. The 17,000-square-foot house had twenty-four bedrooms, twelve bathrooms, and eleven fireplaces, yet the Wrigleys only used it as a winter cottage during their four-to eight-week visits from Chicago each year. The house was one of five that they owned. Los Angeles architect Earl Heitschmidt included elements of the California Monterey, Mediterranean, and Spanish Colonial Revival styles in the design of the mansion, which the Wrigleys called La Colina Solana, or "the Sunny Hill." At the time, there were no other buildings within ten miles of the mansion.

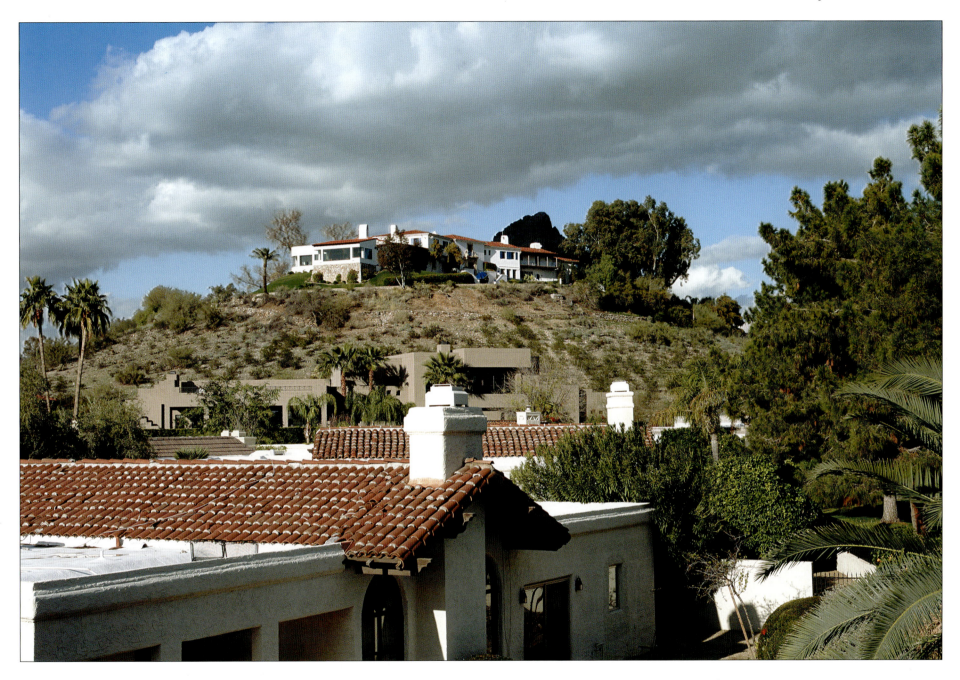

William Wrigley Jr. died in 1932 and Ada died in 1958. The Wrigley family, which also purchased the nearby Arizona Biltmore Resort, continued to own the mansion for many years. They had the house included in the zoning for the resort in the 1960s. In 1973, the family sold the mansion, the resort, and an adjacent golf course to Tally Industries. Tally used the mansion as a public function facility and as an extra guest lodge for the hotel. Western Savings purchased the mansion in 1979 and turned it into the Mansion Club, a private club and corporate resort. Interested in preserving the landmark mansion, George A. Hormel—an heir to the meatpacking family—purchased the house in 1992. He restored the house and grounds to their 1930s appearance, and the complex is now available for corporate meetings, weddings, and other events.

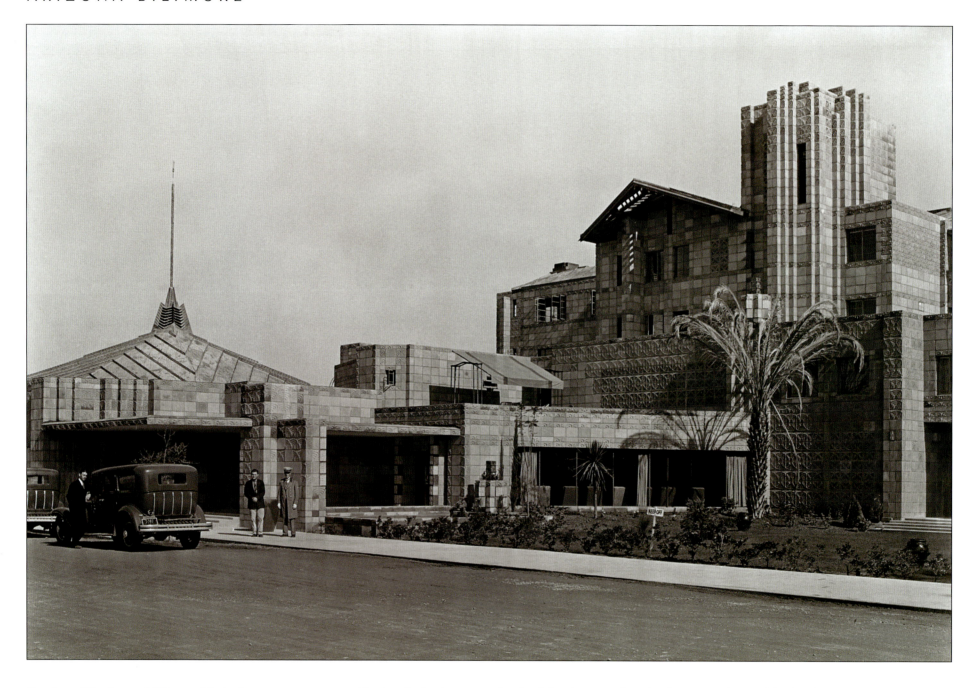

Brothers Charles and Warren McArthur were operating a Dodge dealership in Phoenix when they got a brainstorm to build a resort. Having escaped their hometown Chicago winters, they thought that Arizona would make a popular destination when the rest of the country was snowed in. Their idea blossomed into the Arizona Biltmore, shown here about 1940. At the time the resort was located about eight miles to the northeast of Phoenix, on the bank of the Arizona Canal. The McArthurs' older brother, Albert, a commercial architect who once worked for famed architect Frank Lloyd Wright, designed the building. In developing the hotel's distinctive "Biltmore Block," Albert consulted with Wright about using a type of cast–concrete block technique, which Albert mistakenly thought Wright had developed. The Prairie-style hotel opened on February 23, 1929.

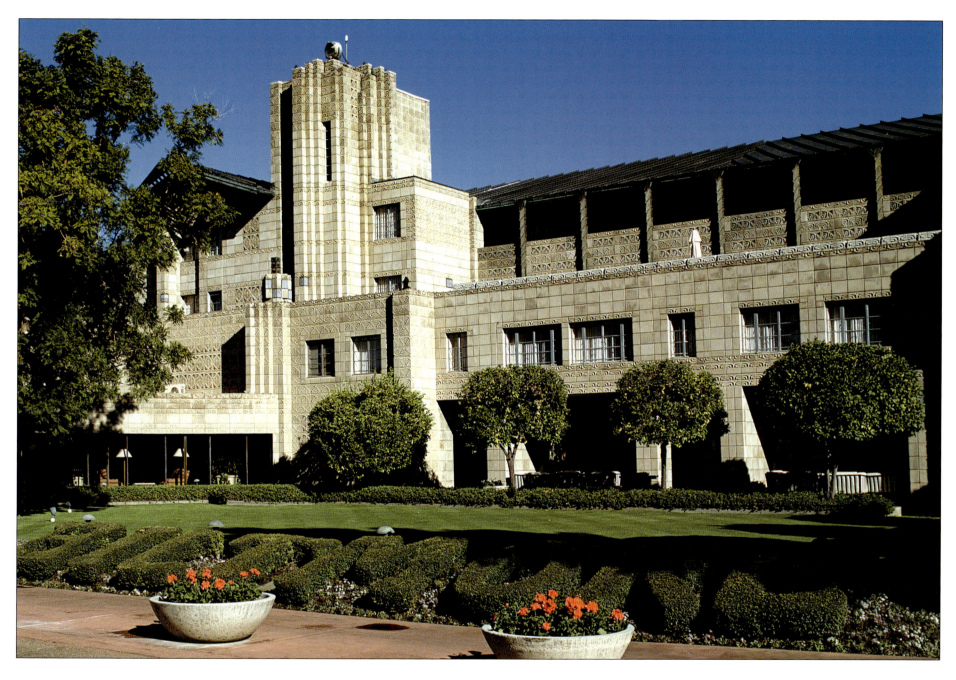

The resort now sits in the middle of the prestigious Biltmore neighborhood in Phoenix, northeast of Camelback Road and Twenty-fourth Street. The original hotel and complex of fifteen cottages has since expanded to include a conference center, seven tennis courts, eight swimming pools, several restaurants and stores, and condominiums. The hotel continues to attract a high-end clientele, including every president since Herbert Hoover.

Unfortunately the McArthurs did not share in its success. Charles and Warren lost the resort to chewing gum entrepreneur William Wrigley Jr. following the 1929 stock market crash. Albert lost credit for designing the resort after a 1973 fire severely damaged the hotel; the owners at the time turned to Wright's Taliesin West architectural school to repair the damage, which led to the common misconception that Wright designed the resort.

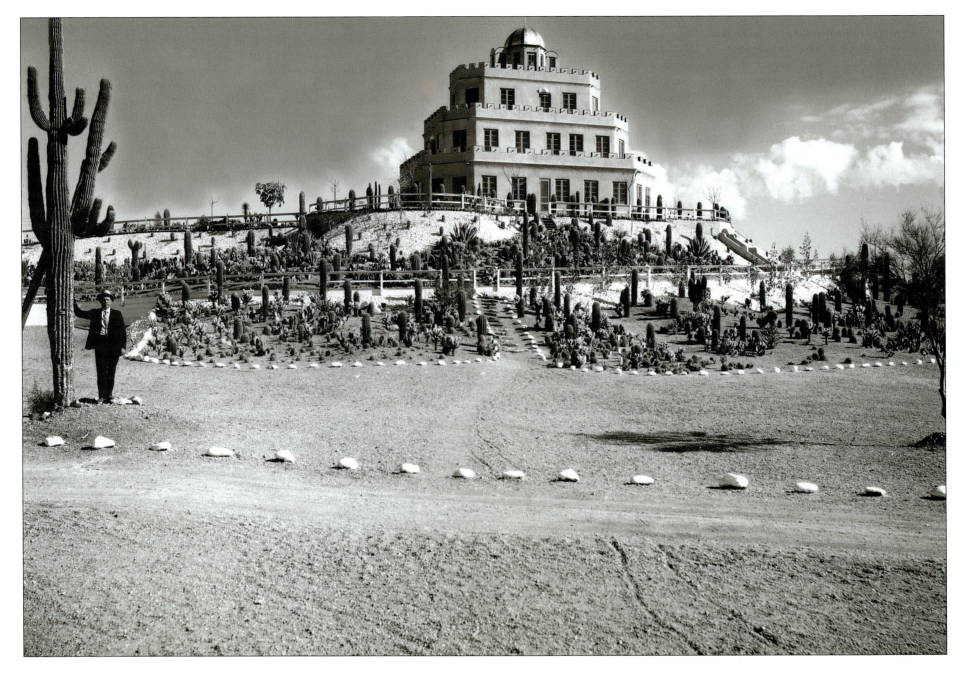

Alessio Carraro finished building this wedding cake–style house—shown here in the 1930s—in 1930. Carraro was an Italian immigrant who found financial success with a San Francisco sheet-metal business. He wanted to use this house as a hotel and the centerpiece for Carraro Heights, an upscale residential development he planned to build. Carraro based the design on his vision of a medieval Italian castle and built the house himself with the help of his son and some hired laborers. M. Moktatchev, a traveling Russian author and gardener, landscaped the grounds with hundreds of species of cacti from around the world. The project was finished in late 1930, and Carraro celebrated by outlining the building with hundreds of painted lightbulbs.

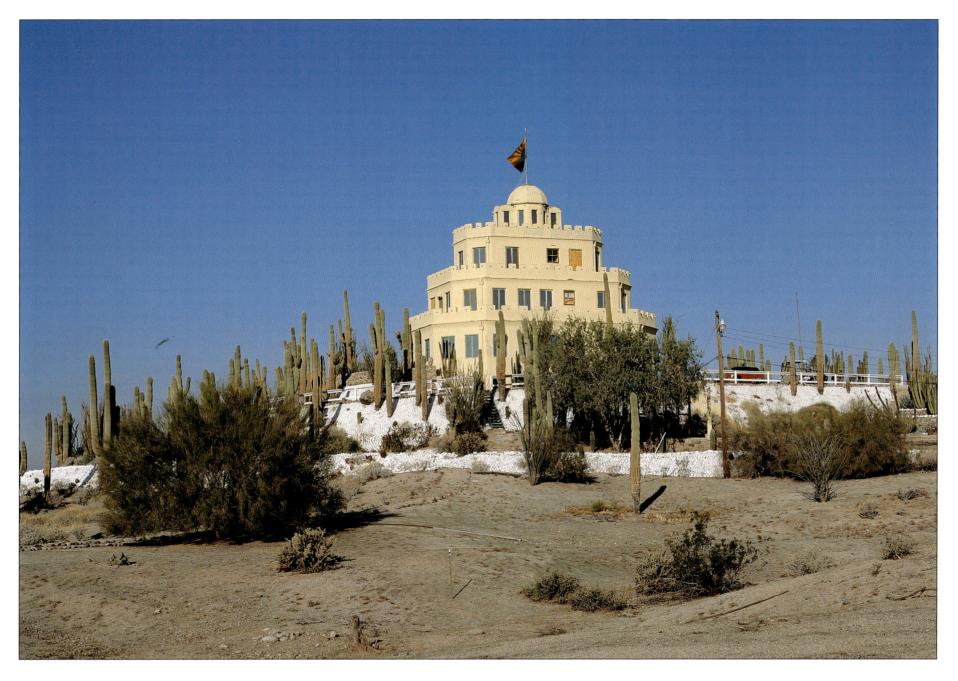

Tovrea Castle, as it is now known, is no longer as remote as it once was and can easily be seen from the nearby 202 freeway. Carraro's plans for his plush resort crashed when Edward Tovrea bought land nearby for a slaughterhouse and sheep pens. Realizing that no one would want to build a fancy house next to sheep, Carraro sold the property to an anonymous buyer. That buyer was Della Tovrea, Edward's wife. Edward died and Della eventually married

William Plato Stuart. The couple wintered in the house until Stuart died in 1960. Burglars robbed the house in 1969, injuring Della, and she later died from her injuries. The family kept the house but did not live there; it suffered from neglect and many of the cacti died. The City of Phoenix bought the house in 1993. Since then the City has been working on purchasing the rest of the hill around the house and plans a major restoration of the house.

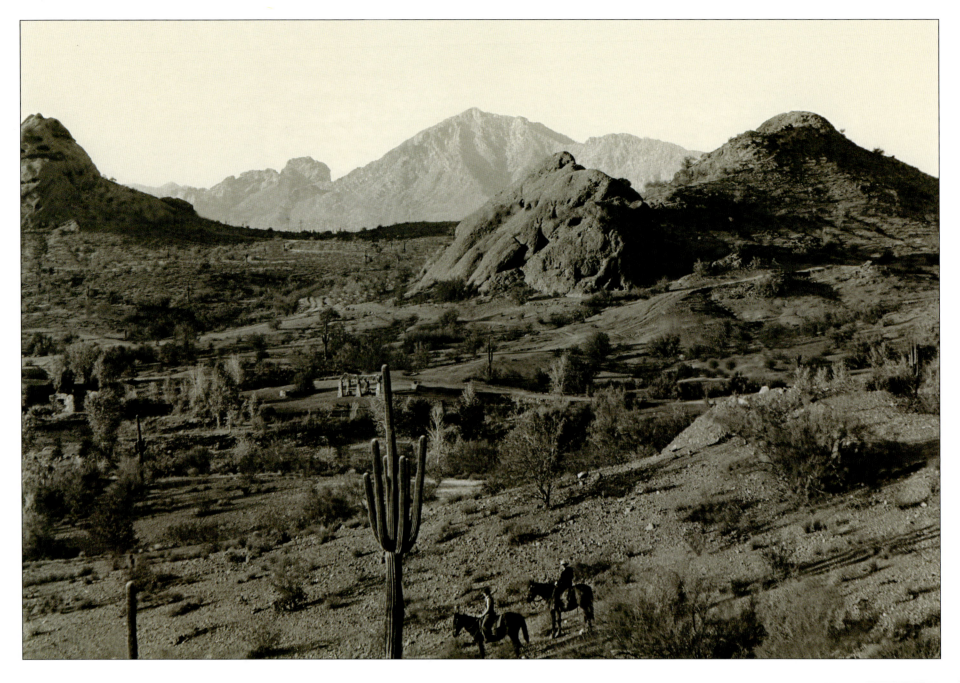

The red-hued Papago Buttes are probably the most stunning land feature in the region, aside from Camelback Mountain. Early on, the Buttes became a popular place for picnicking and horseback riding, as shown in this photograph from around 1930. Just out of view is the Buttes' most-recognized feature, Hole-in-the-Rock. The beauty of the area and threats from population growth led the federal government to establish Papago-Saguaro National Monument in 1914, only to withdraw the designation in 1930 at the insistence of Arizona's congressional delegation. The government subsequently divided the land among the State of Arizona, Phoenix, Tempe, and others.

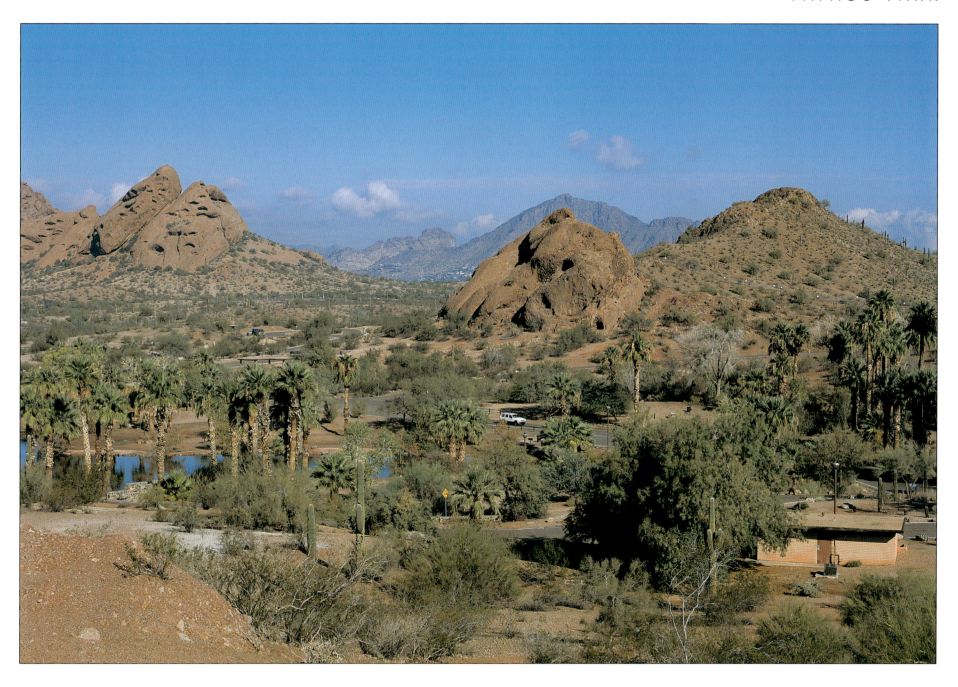

Today the area is called Papago Park and is shared by three cities: Phoenix, Scottsdale, and Tempe. The area remained popular over the years and the Civilian Conservation Corps built trails and picnic ramadas there in the 1930s. Urban growth has somewhat infringed on the area—several roads, power lines, and canals go through and around the park. A couple of golf courses, a baseball stadium, and small patches of grass now surround the more natural desert terrain of the Buttes. Today the park includes a branch museum of the Arizona Historical Society, the Desert Botanical Garden, and the Phoenix Zoo, which is built around former fish hatchery ponds, seen here, that the state built in the 1930s. The park has paid the price for its popularity over the years, however; much of the cacti and other vegetation have been destroyed by visitors.

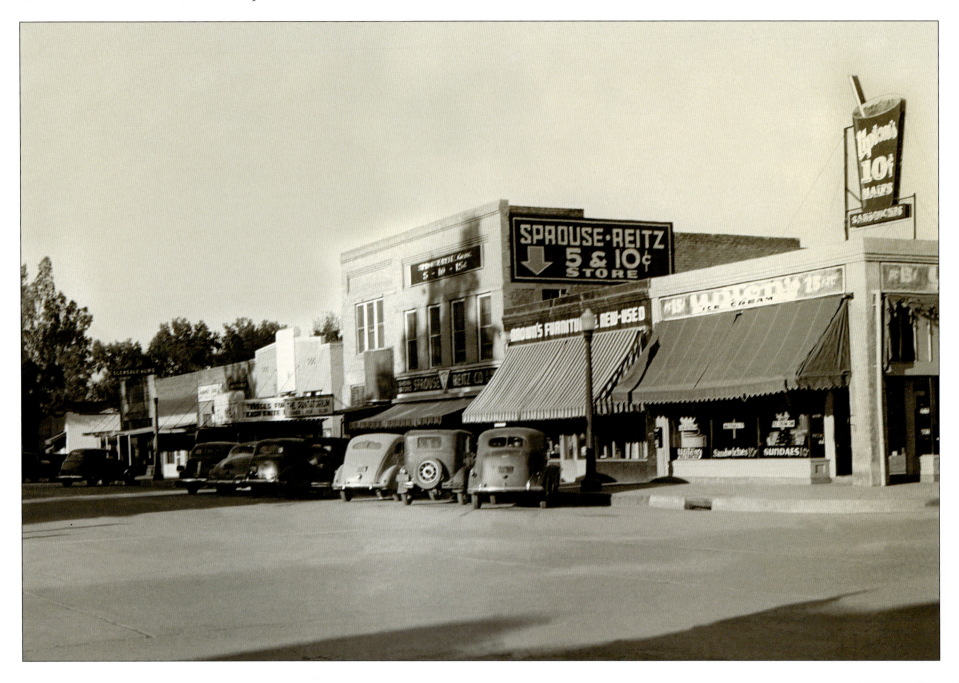

The northeast corner of Glendale and Fifty-eighth avenues, around 1945. These buildings, all constructed at different times in the previous twenty or so years, look out on Fifty-eighth Avenue. The Glendale City Park is across the street just outside of view. The trees in the background are the beginning of Catlin Court, a neighborhood full of bungalows built in the late 1910s and 1920s. The two-story Sprouse-Reitz Building was the first on this block and was owned by Robert W. Cole. He purchased three lots to build his general store and completed it in 1919. Other businesses soon filled in the block, including the popular Upton's Ice Cream Parlor on the corner. With about nine miles of open space between Glendale and Phoenix at the time, many farmers in the surrounding countryside went into Glendale on Saturdays to patronize these establishments.

Today Fifty-eighth Avenue is home to restaurants and stores that cater to antique hunters and tourists. The City of Glendale stretches far to the north and west and counts over 220,000 residents. Glendale's downtown fell out of favor with shoppers as newer malls with lots of parking opened up nearby. In an effort to bring shoppers back, the downtown had a modern facelift in the 1960s, but most businesses closed by the early 1970s. In the 1980s, Catlin Court started to transform into a district of teahouses and antique stores. That trend spread to downtown and the city returned the streetscape to its 1900s look. Kathy Munninger opened her apparel business in the corner building long owned by her family. The old Sprouse-Reitz Building is also an antique store. It recently replaced Larry Glazman's Bootbarn, which had attracted customers from as far away as Europe for its popular boots.

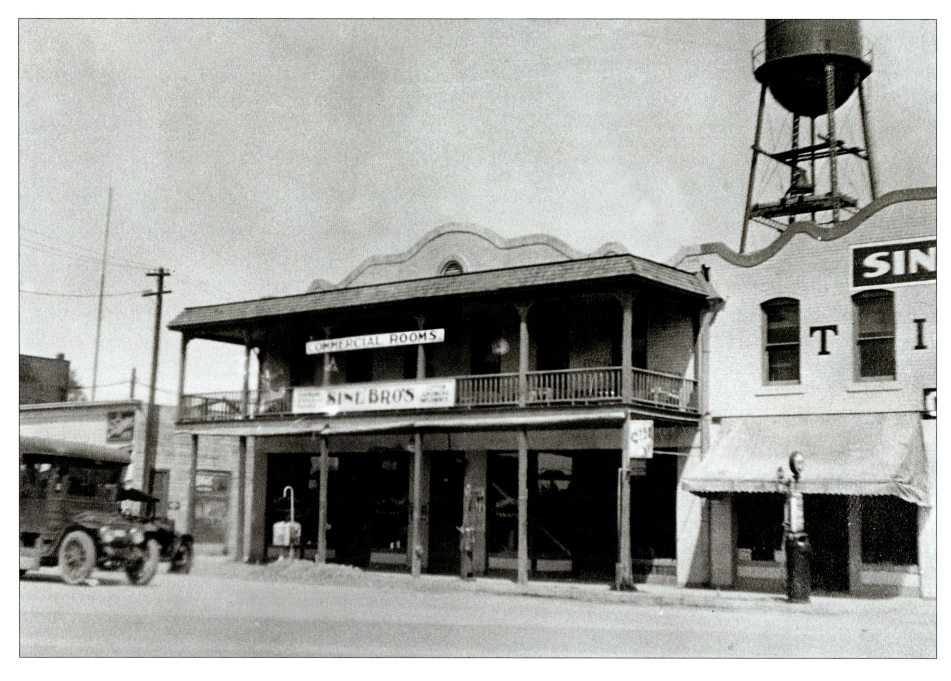

This is the east side of First Avenue (Fifty-eighth Drive) in Glendale, between Glendale and Grand avenues, about 1920. The Mission-style buildings house brothers Tuck and Van Sine's hardware store and their garage. The second floor of the hardware store was a rooming house. Their brother Floyd started hardware building in 1911. He also purchased the large water tower, built by A. W. Bennett, and expanded what was Glendale's first water system before selling it to the town in 1915. The bus belonged to the private Menderson Bus Lines, which provided service to the towns outside Phoenix. Behind the Glendale State Bank, to the left, is a flagpole, which stands in the Glendale City Park. At 125 feet, it was Arizona's largest when residents installed it in 1916 as a demonstration of patriotism.

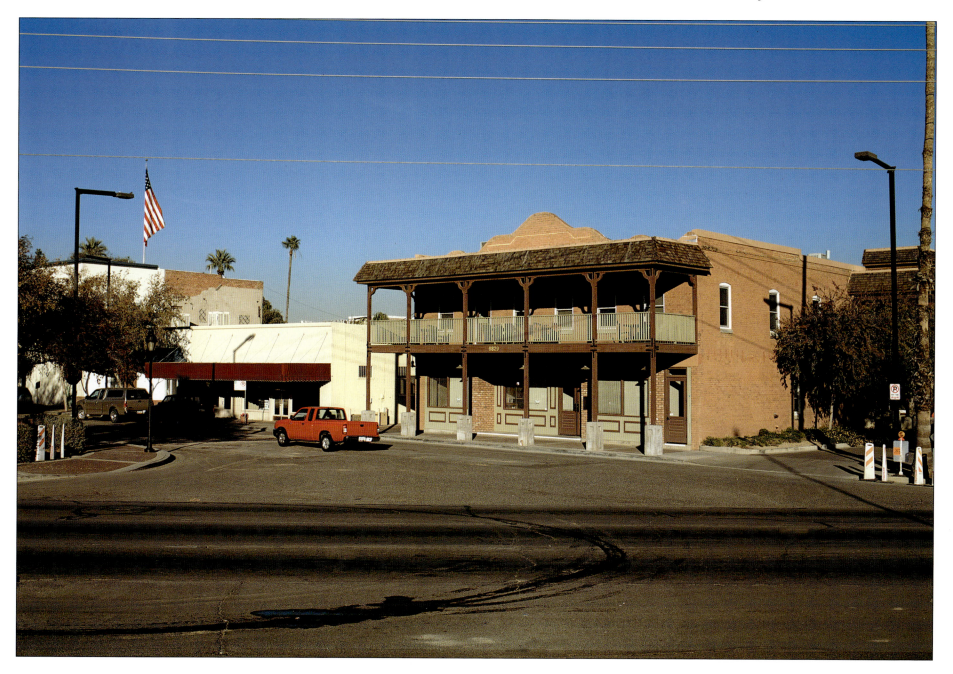

Glendale changed its street names in 1963 to match those of Phoenix. First Avenue is now Fifty-eighth Drive and now it stops at Glendale Avenue. The six-story building at the end of Fifty-eighth Drive is the Glendale Municipal Complex, finished in 1984. The complex now touches the edge of Murphy Park, formerly known as the Glendale City Park. The Velma Teague Library, which opened in 1971, sits in the middle of the park. The city removed the flagpole in 1960 and replaced it with a one-hundred-foot one. The expansion and reconstruction of Grand Avenue changed the makeup of the street. Sine's hardware store building is still there, though the business moved about a mile away in 1991. The City of Glendale bought the Sine Building, took off the 1960s facade, and restored it for use as city offices in 1998.

The Glendale State Bank in the Gillett Block, located today on the southeast corner of Fifty-eighth Drive and Glendale, about 1910. Glendale was a small town northwest of Phoenix that started in 1891 as a temperance colony. The developer who established Glendale, W. J. Murphy, wanted to attract dependable farmers to the area. He formulated deed restrictions that banned alcohol in town, and in 1891 a group of settlers who belonged to the German Baptist Brethren Church—and whose members were also known as "Dunkards," for their preferred form of baptism—came to the town. The men pictured here are Dunkards; sweaters were common business clothing for the men of this church at the time. The Glendale State Bank opened in this building, built by longtime local businessman Charles L. Gillett, in 1909. Gillett (second from left) stands in front of his grocery store on the first floor.

Today an antique store occupies the first floor of the Gillett Block. In addition to the bank, the building was the longtime home of Wood's Pharmacy. The building is now part of Arizona's largest antique district. Glendale's downtown contains some ninety antique stores and restaurants, all within walking distance of the park named after the city's founder. By the early 1970s, downtown had lost its traditional service role because of competition with new shopping malls. Glendale's leaders hoped to transform the declining district into a financial hub in the early 1980s. Instead, by the late 1980s, the area's historic buildings and the nearby historic neighborhood of Catlin Court started to attract people with a different vision of what downtown Glendale could be.

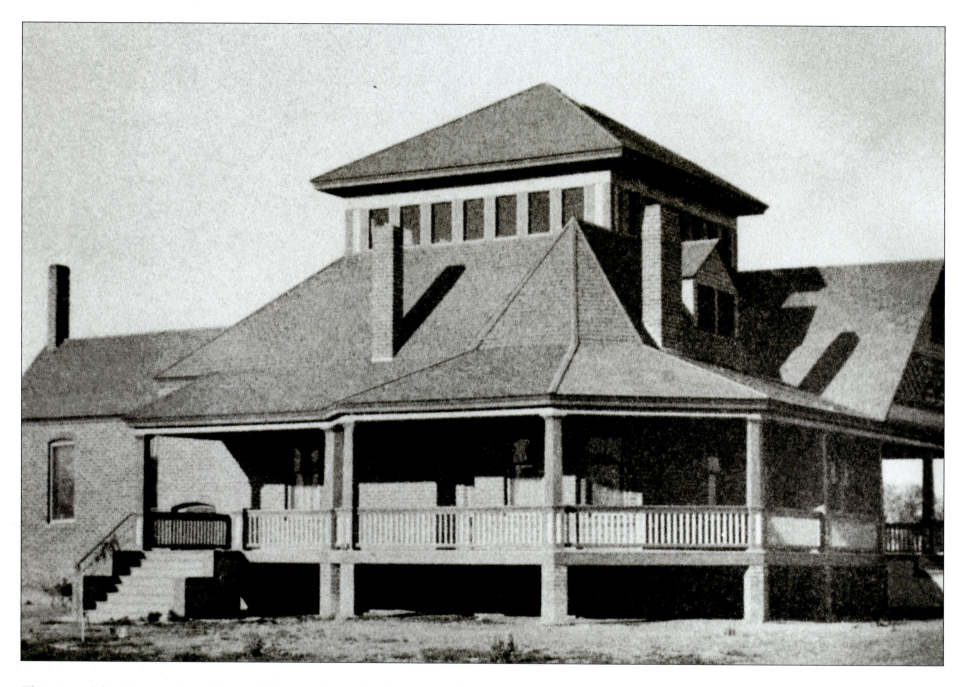

This view of the Manistee Ranch, located about a mile north of the original Glendale town site, was taken around 1900. Wisconsin native Herbert Hamilton developed a ranch here in the 1890s and hired Glendale carpenter William Weigold to build this house for the family. Weigold completed this Queen Anne Victorian house in 1897. It featured three stories, a basement, a sleeping porch, and a veranda around the front three sides. Hamilton sold the house and the 320-acre ranch to Louis Sands, a successful lumberman and rancher, in 1907. Sands renamed the property Manistee Ranch after his hometown in Michigan. The ranch was a combination cattle-feeding operation, farm, citrus orchard, and palm grove.

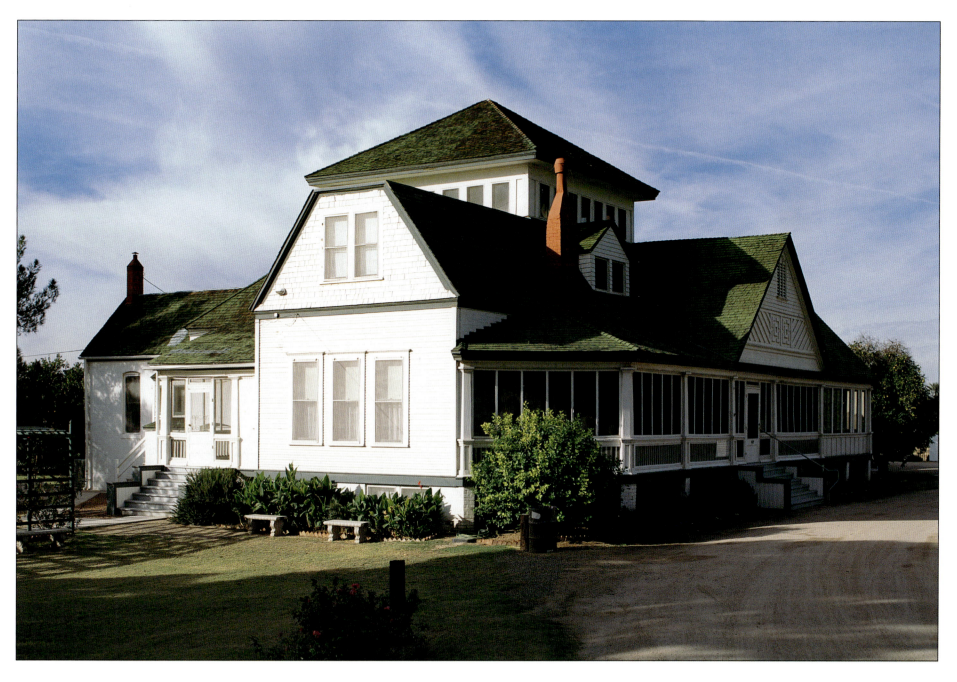

Manistee Ranch is now a public park near the southwest corner of Northern and Fifty-first avenues. The Glendale Historical Society cares for the house and provides tours. John Sands inherited the house from his father and lived here until his death in 1993. A couple years later, the Sands family decided to develop the ranch, including the 1897 house, for residential, commercial, and retail uses. Manistee was one of the last remaining cattle ranches in the

Phoenix area. Responding to an outpouring of public support to save the ranch house, a special landmark for many residents, Glendale organized a task force to save this significant property. Using state grants, the City purchased the 4.3-acre park in front of the house, and the society bought the house and another 2.2 acres. The Sands family donated $140,000 to assist the effort. The restoration of the house was completed in 2004.

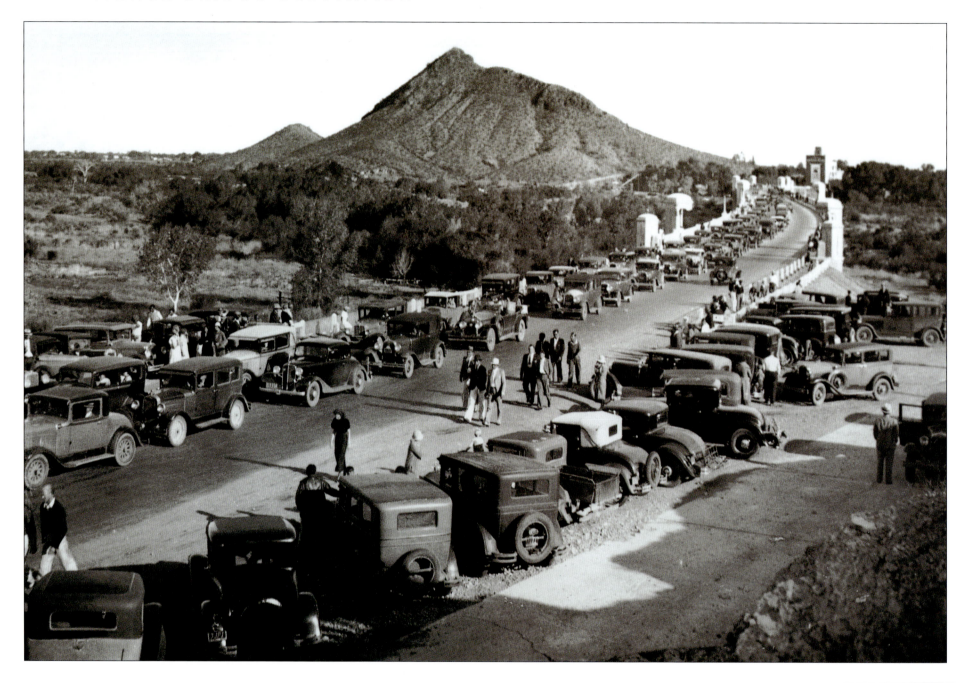

Ecstatic over finally having a dependable automobile bridge over the Salt River, Phoenix-area residents celebrated the dedication of the Mill Avenue Bridge for two days. Tempe photographer Stan Schirmacher probably caught this view of the festivities, looking south toward the bridge, downtown Tempe, and Tempe Butte, on May 1, 1933. The Hayden Flour Mill is visible to the upper right of the bridge. Presiding at the dedication was B. B. Moeur, a former Tempe doctor and the current governor of Arizona. The bridge actually opened to traffic in August 1931 but was not dedicated until much later. The Mill Avenue Bridge replaced Tempe's Ash Avenue Bridge, a smaller, damaged wagon bridge located a little to the west.

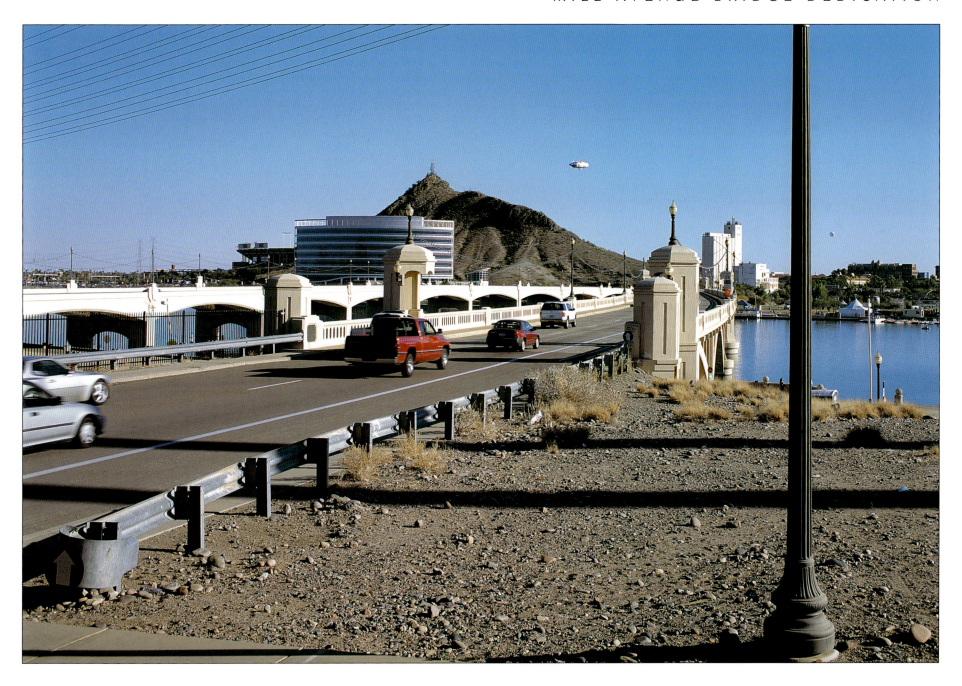

The Mill Avenue Bridge has remained open continuously since its completion in 1931. For many years it was the only crossing over the Salt River anywhere in the Phoenix area. Massive floods raged down the river in 1980, closing all the bridges except for Mill Avenue and one in Phoenix. Over 92,000 cars crossed the Mill Avenue Bridge in one twenty-four-hour period during that flood. The water hit the bridge at 200,000 cubic feet per second and far exceeded what the bridge was designed for, but it held. The river has not flowed in years, and today the Tempe Town Lake, part of a development project, sits below the bridge. The New Mill Avenue Bridge, to the left, opened in 1994 to take some of the traffic off the old bridge. State Route 202, or Red Mountain Highway, skirts the south end of the bridge today.

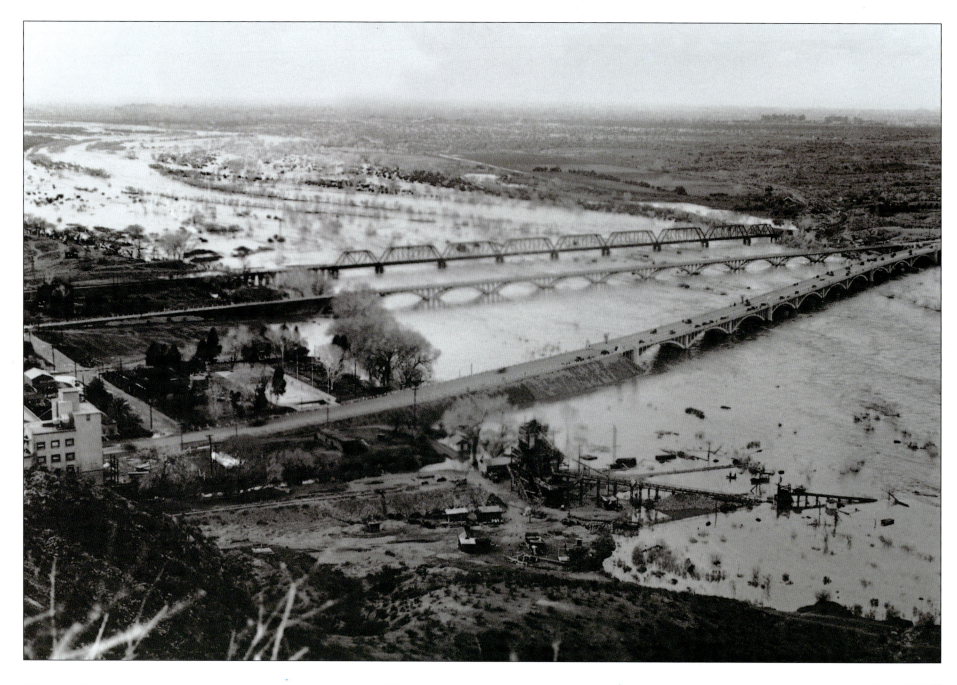

The Salt River is overflowing its banks, as seen from the top of Tempe Butte in Tempe, about 1931. Looking a little to the northwest, one can see Tempe's three important bridges. The bridge at the top is for the railroad, and it was rebuilt in 1909 to replace one lost in a flood. The Ash Avenue Bridge in the middle was the first wagon bridge over the Salt River in the Phoenix area. The newly completed Mill Avenue Bridge is the last of the three. The remains of a second railroad bridge can be seen below that. The Hayden Flour Mill is the tall building to the far left. Just above the left edge of Mill Avenue, Tempe Beach Swimming Pool, the largest pool in Arizona for many years, is visible. The Salt River continued to have water in it on an annual basis until the last of the upstream dams was completed in the 1940s.

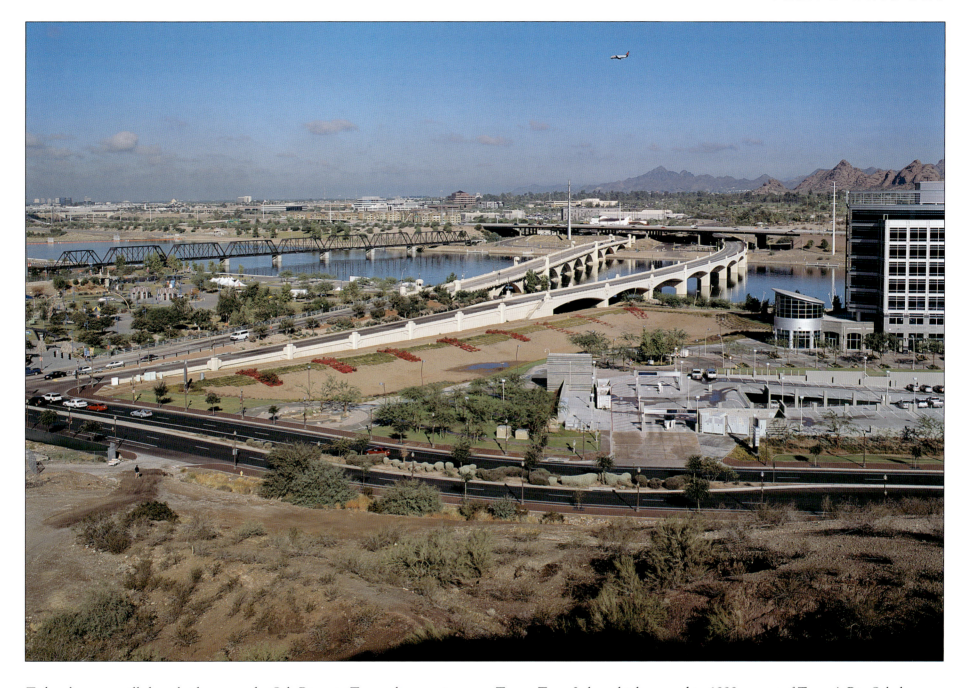

Today there are still three bridges over the Salt River in Tempe, but one is new. The 1909 railroad bridge is still there. The old Ash Avenue Bridge had been damaged in floods and was finally demolished in 1991. The New Mill Avenue Bridge, completed in 1994, now sits to the right of the Old Mill Avenue Bridge. There is water in the riverbed, but it's actually the new Tempe Town Lake, which opened in 1999 as part of Tempe's Rio Salado Project, an ambitious plan to "return water to the Salt River" and to develop the land-locked city's last piece of open space. The pool is gone, replaced by the rebuilt Tempe Beach Park.

The second Hayden Flour Mill in Tempe, around 1890. Charles Hayden, a former school teacher who became a freighter and a merchant, built the original mill in Tempe in 1874. Local farmers needed the mill to grind their grain into flour. The original mill was partially burned and was rebuilt as the one seen here. The white-haired man in the center of the photograph is Charles Hayden. The mill was the most important building in Tempe. Tempe's business district grew up along the road, which became known as Mill Avenue, leading to the processing plant. Both this mill and the earlier one were water powered. A small ditch brought water to the mill, which passed through it and returned to the nearby Salt River.

The second mill burned in 1918 and was replaced by the one seen here. The grain silos in the background were added in 1951. The Hayden family continued to operate the mill until the 1980s. This mill operated on electricity and continued to grind flour until 1997. At the time, it was the oldest, continuously operated industrial building in the entire Phoenix area. The building hasn't done so well since then. It burned in 2002, destroying several of the additions made to the mill over the years. Recently a private developer wanted to transform the mill and silos into a mixed-use building that would include condominiums, restaurants, and stores, but that project fell through and the City of Tempe now owns this historic site. City officials still hope to develop the mill into something that will link the Tempe Town Lake to the north to the Mill Avenue shopping district to the south.

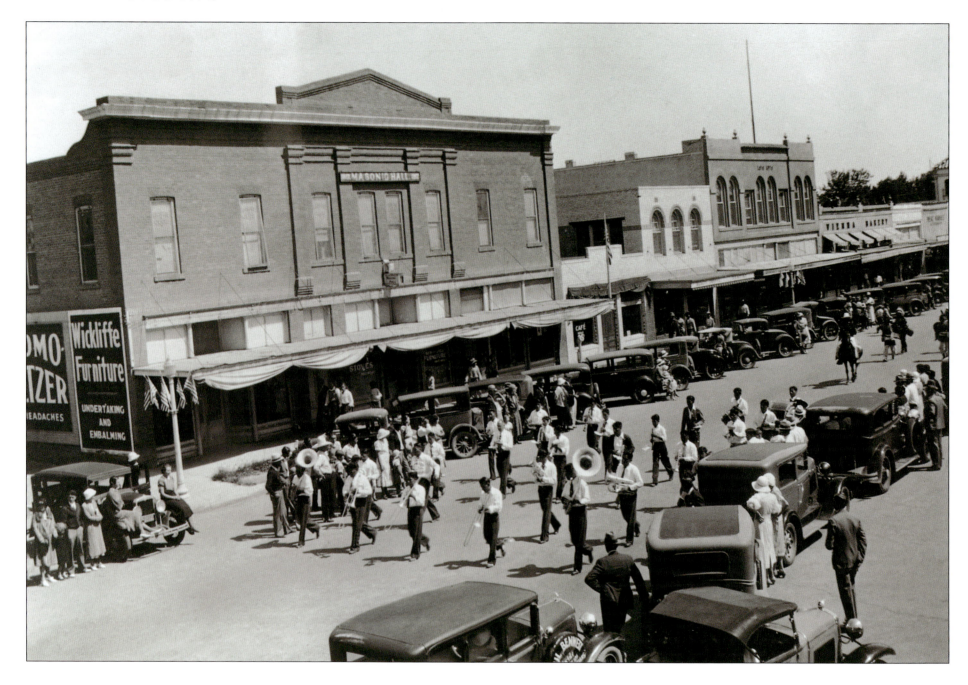

Mill Avenue, Tempe's main street, around 1931. The parade is proof of the street's importance. The structure to the left is the Andre Building, once owned by local saddle maker and notorious crank Captain R. G. Andre. At this point the Masons had taken over the upper story as their meeting hall. The ground floor hosts Price Wickliffe and his furniture and undertaking business, an interesting combination. The other large building on the block is the Chipman-Petersen Building, one of the business operations of successful Danish immigrant Niels Petersen. To the right of that is the Vienna Bakery, a business started by German immigrant Charles Bauer. His family operated the bakery until the 1960s.

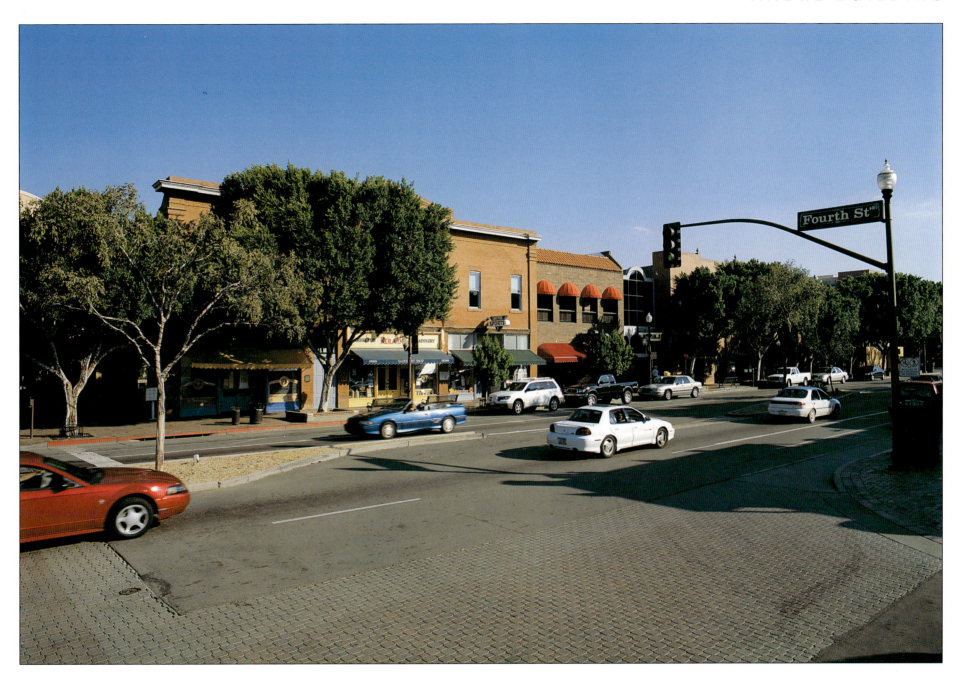

Only a few of the same buildings still stand on the block. The Andre Building is now home to Rúla Búla, an Irish pub operated by the Guinness beer company. The pub's interior was built in Ireland and shipped over in 2000. Fire took many of the historic structures that once stood on this street and also threatened the Andre Building as workers prepared for the new tenant in 1999. Most of the buildings to the right end of the block burned in the 1940s. A 1990 fire destroyed the Chipman-Petersen Building. The owner replaced it with a new building that vaguely resembles the old. Today half of the original Vienna Bakery building is still here. Mill Avenue is still a big part of community life, however. Tempe frequently closes the street to host large block parties for New Year's celebrations and art festivals.

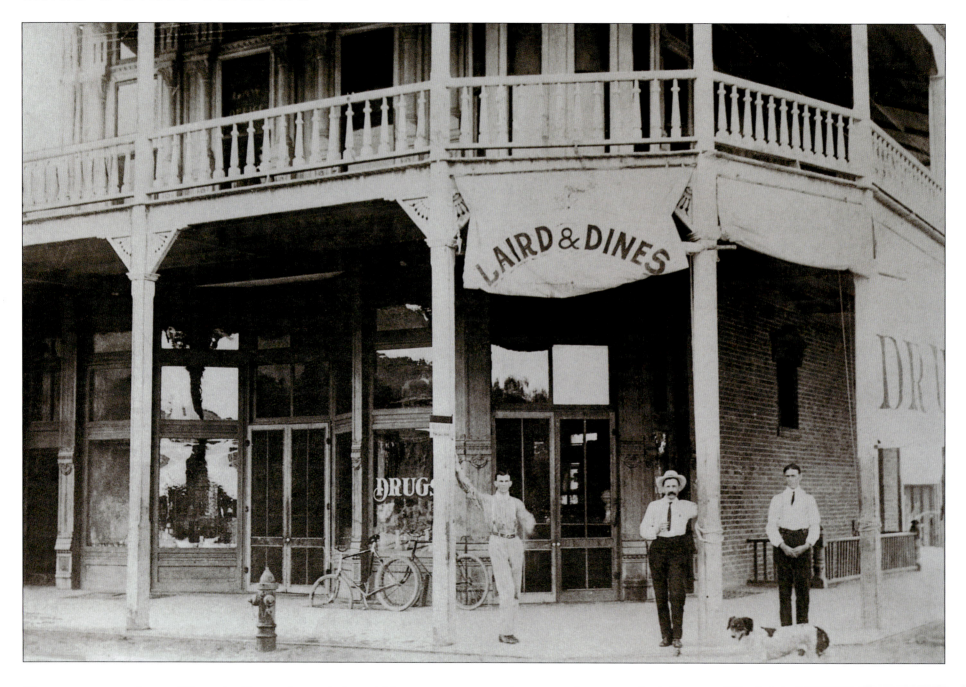

Three men operated one of Tempe's oldest and most influential businesses. Shown here around 1901, Dr. J. A. Dines, Hugh Laird, and Laird's brother Bill are standing in front of their business on the northeast corner of Fifth Street and Mill Avenue. Dr. Dines and the Lairds opened their drugstore in 1901 in this building, which was built in 1893. Hugh trained under Dr. Dines to become a pharmacist. Both Dines and Hugh Laird served as mayor of Tempe, with a combined twenty-five years of service. Because of this, the drugstore was Tempe's unofficial city hall and many decisions were made here. The business remained open until 1964. The Laird's transformed their Victorian building to the Spanish Colonial style in 1929.

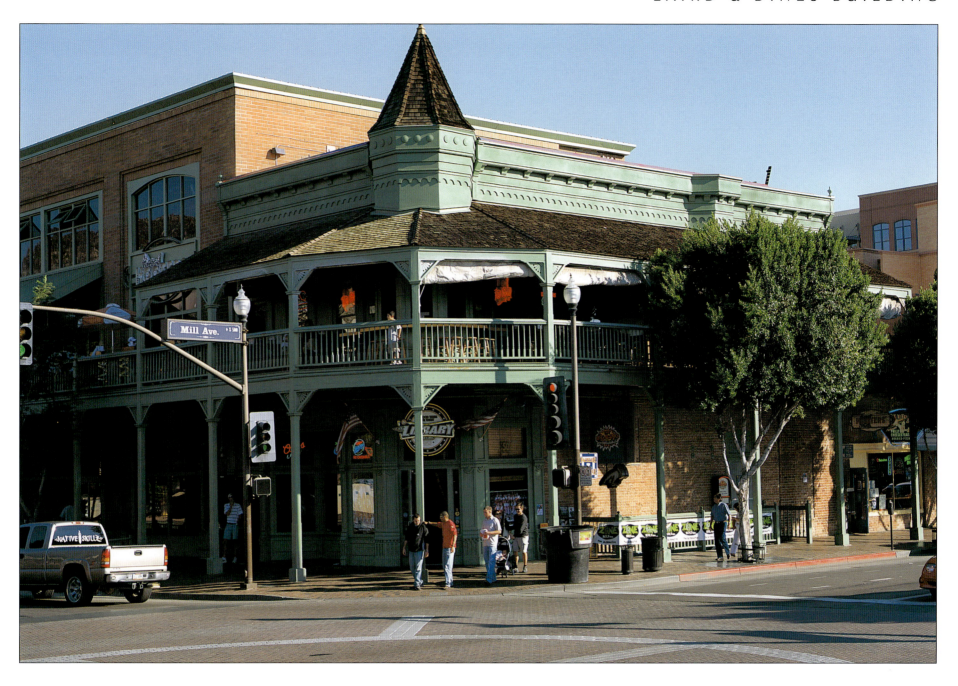

Today the building again resembles the Victorian structure it was a hundred years ago. Not only did the Lairds change the building in the 1920s, the state highway department expanded Mill Avenue in the early 1960s and took off the west veranda. Tempe's downtown became a low-rent district for many years until the City and private developers transformed the area into an entertainment district in the 1980s. New owners rehabilitated the Laird & Dines Building in 1994, reconstructing the veranda and corner turret. The two-story building with a basement is now home to several bars and nightclubs. Tempe renamed the intersection in front of the building Fackler Square in 2003, in honor of one of the chief planners behind Mill Avenue's renewal.

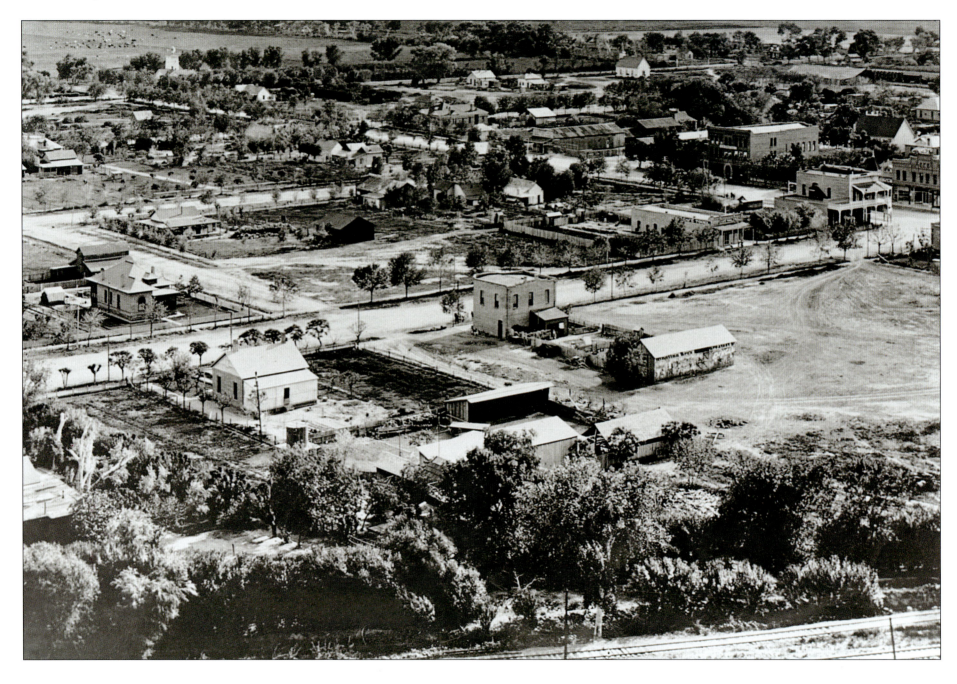

Here is the town of Tempe on April 9, 1905. The view is looking southwest, and it was taken from Tempe Butte. The big road running from left to right is Fifth Street. On the right end of Fifth Street, Mill Avenue can be seen running to the south. Fifth and Mill was the heart of Tempe's business district, as evidenced by the large buildings on the corners. Tempe had a population of a little over 1,000 people in 1905.

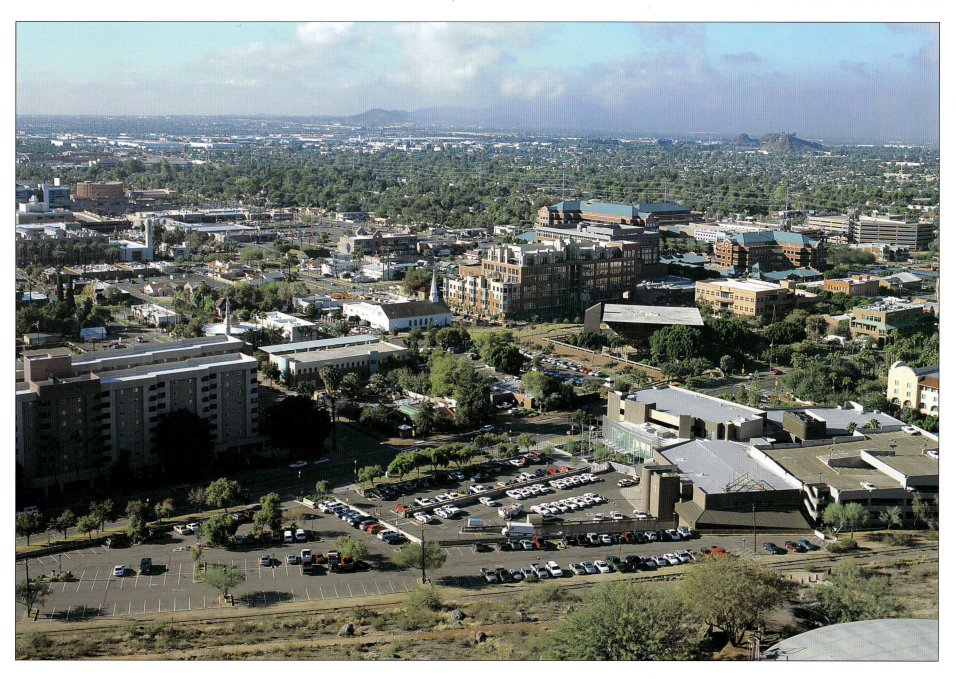

Tempe has a population of over 160,000 people today, and it doesn't have a single farm within its boundaries. The upside-down pyramid on Fifth Street is Tempe's City Hall, built in 1970. City Hall's construction led to a renewed interest in developing the "old town" area of Tempe. A lot of that redevelopment occurred along Mill Avenue in the last thirty years. A few of the original buildings are still there, but today these house restaurants, bars, bookstores, and other retail stores. Mill Avenue has become a popular destination for students from nearby Arizona State University. Some of Tempe's oldest remaining neighborhoods, such as the Maple-Ash neighborhood, are visible in the upper center of the photograph.

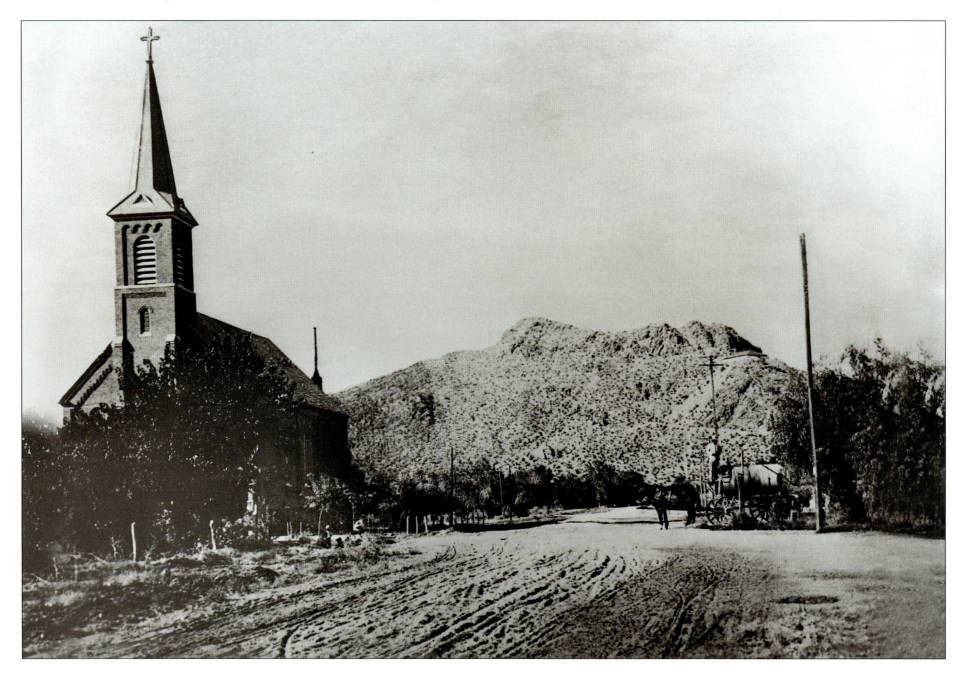

The intersection of Normal Avenue and Eighth Street (College and University today) in Tempe in 1915. The view is looking directly north along Normal Avenue at Tempe Butte. To the left stands St. Mary's/Our Lady of Mount Carmel church. Tempe's first water reservoir, added in 1903, is visible on the upper right of the butte. On the right side of the street sits a sprinkler wagon that would spray water on the streets to keep dust down.

Normal Avenue was the boundary between Tempe's Mexican American neighborhoods, or barrios, and white Tempe. The barrio next to the church was called San Pablo, or sometimes Barrio el Centro. Father Severinus Westhoff, the Franciscan priest assigned to Tempe in 1895, wanted to unite his white and Hispanic parishioners by constructing this church between the two communities. It was completed in 1903.

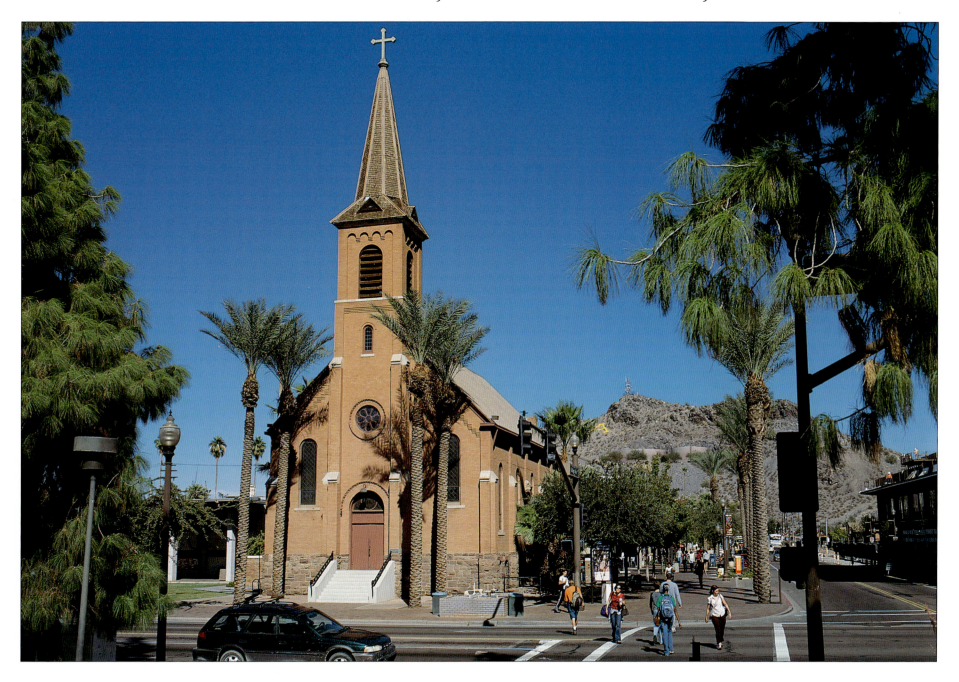

The church and the butte remain today, but there has been a lot of change around and between them. The former barrio is now part of the Arizona State University campus. In the early 1950s, the school used eminent domain to buy the barrio. With its parish community dispersed, the Catholic church moved to a new location further south. In 1962 the parish gave the 1903 church building to the Newman Club, a Catholic organization serving college students. The Newman Center restored the church and still uses it today. The letter A, for Arizona State University, is visible on Tempe Butte (also now called "A Mountain"). The large water tanks went on the butte in the 1950s. To the right is the new ASU Foundation building.

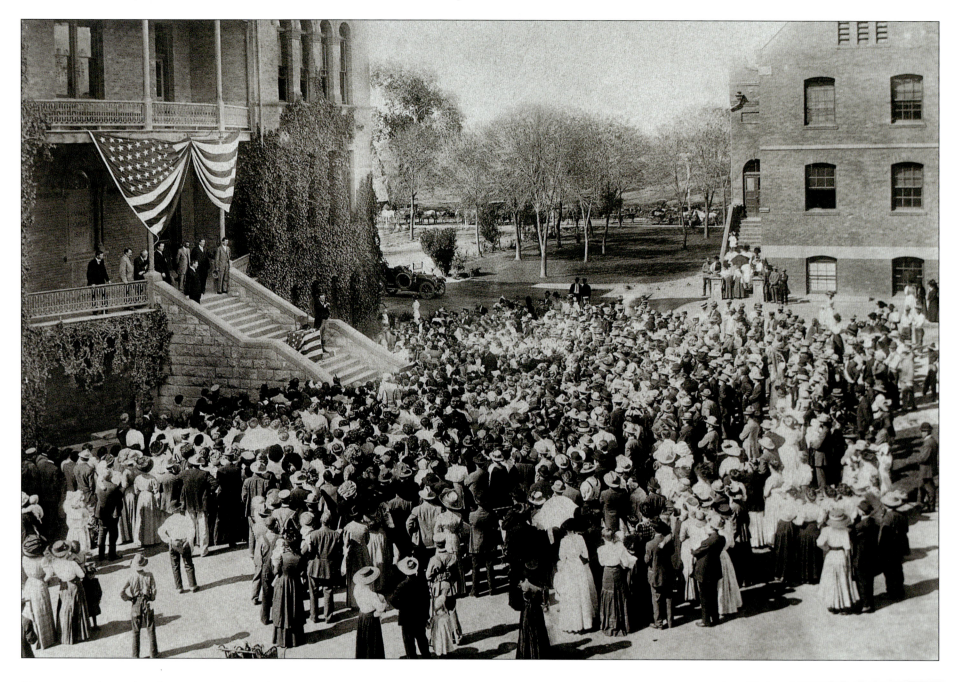

Former president Theodore Roosevelt speaks on the steps of the Old Main on the campus of Tempe's Normal School in 1898. Roosevelt's March 1911 visit to Arizona was to dedicate a large dam. In fact, the car that would take him to the dedication site is parked just to the right of Old Main. During his thirteen-minute speech Roosevelt proclaimed, "I believe as your irrigation projects are established, we will see 75 to 100 thousand people here."

Roosevelt had long supported spending federal money in the dry West to build dams for irrigation projects, and he signed the National Reclamation Act of 1902 to make that possible. Phoenix residents showed their appreciation of his efforts by naming their dam after him. Located east of the Phoenix area, Roosevelt Dam stored Salt River water for farmers to use during the dry years, and its completion sparked a local growth spurt.

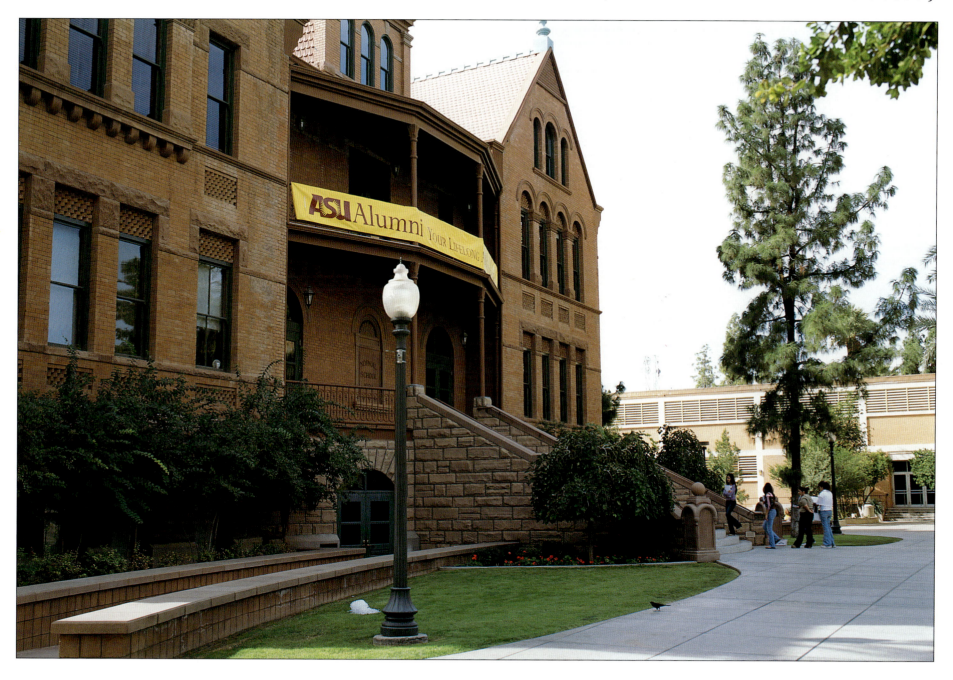

Roosevelt's prediction turned out to be a bit of an understatement. Today there are 160,000 people in Tempe alone, not counting the rest of the Phoenix area. Old Main is one of the most distinctive buildings on the campus of Arizona State University (what the little Normal School became by 1958). Over the years the building was used for classrooms and offices. In the 1950s, a modern, boxy-looking addition replaced the front steps. When

the ASU Alumni Association completed a restoration of the building in 2000, they returned the front steps. Ironically the architect who designed the 1950s addition was one of the first to donate money toward removing it in the late 1990s. Old Main is now home to the Alumni Association and hosts numerous events in a large ballroom on the third floor.

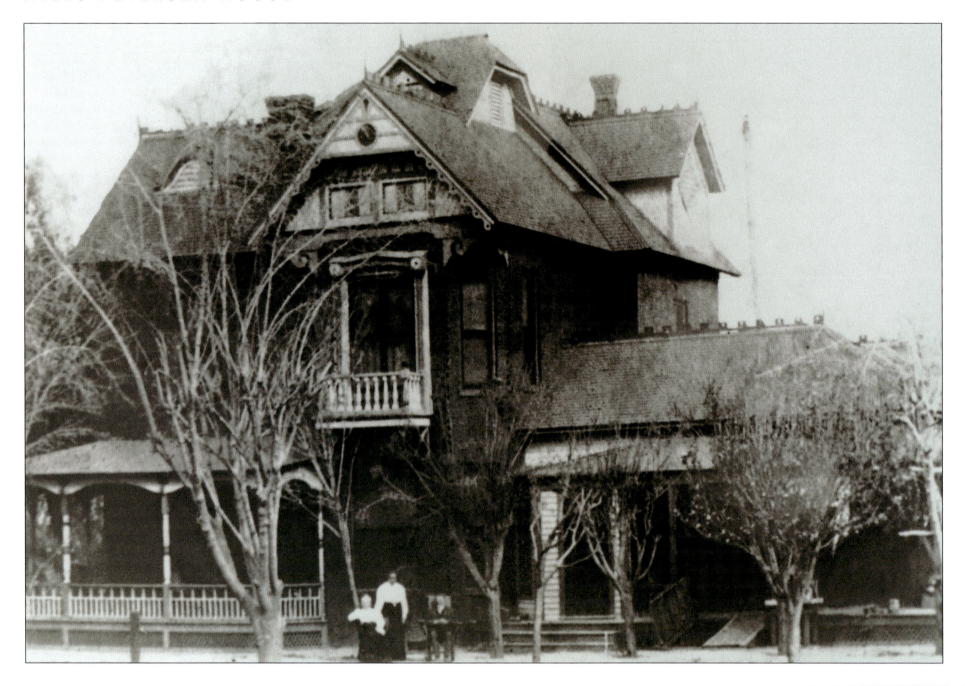

Susana Petersen, standing in the middle, entertains winter guests in front of the Petersen House near Tempe, in around 1900. Susana's husband, Niels, was a Danish immigrant who arrived in Tempe in 1871. He built a large cattle ranch and farm and owned over 2,000 acres of land by the time he died in 1923. Niels hired a well-known local architect named James Creighton to build this Queen Anne Victorian house in 1892. Niels married Susana Decker in Pennsylvania, and he wanted her new house to be built in a style that was more familiar to her. This house replaced one made out of adobe or mud bricks and was one of the fanciest in the Salt River valley; it could easily hold its own against some of the extravagant houses in Phoenix.

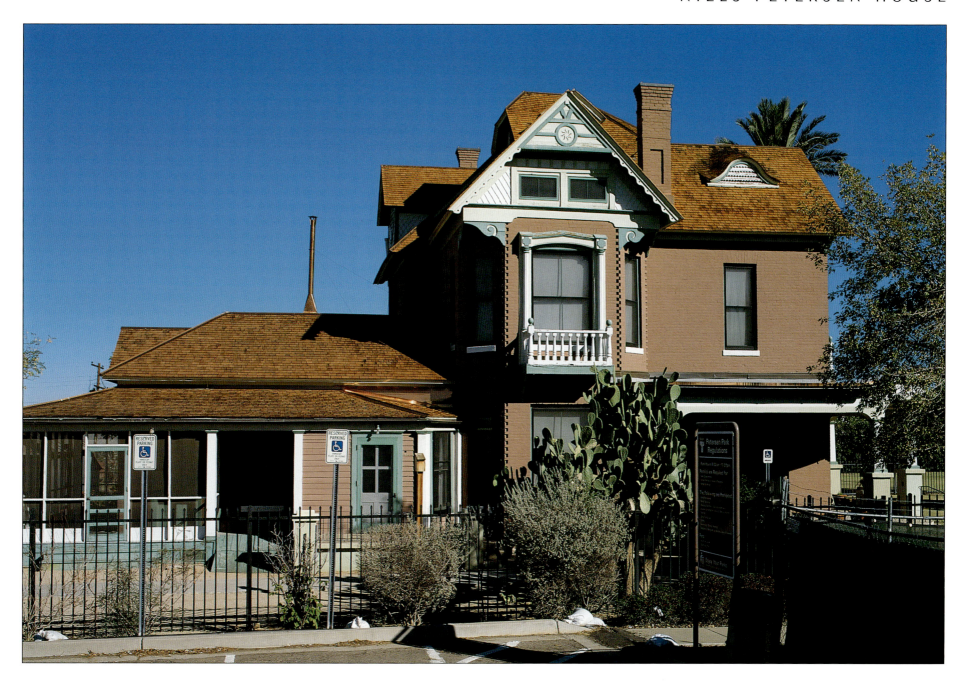

Today the Petersen House is a historic house museum operated by the Tempe Historical Museum. The Petersens did not have children, and the house passed to Susana's nephew, Edwin Decker, when she died in 1927. Edwin and his wife, Una Belle, refurbished the house and replaced the old Victorian-style porch with a Craftsman Bungalow–style one in 1930. Decker died in 1947 and Una Belle rented the house to the family of Arizona State College art professor Tom Harter. She sold off most of the ranch by the time she died in 1968. The land became neighborhoods, strip malls, and industrial parks. Since the Deckers, too, were without heirs, the old Petersen will required the house to pass to a fraternal lodge called the International Order of Odd Fellows. The lodge gave the house to the City of Tempe in the 1980s, and the Tempe Historical Society restored it as a museum.

The campus of the Arizona State Teachers College, Tempe, in 1928. Tempe was a small town to the east of Phoenix with a population of around 2,400 at the time. The road running from the middle left to the bottom is Mill Avenue, which leads to Tempe's business district to the left. The tall building near the center of the photograph is Old Main, and it is the heart of the college campus. Originally begun as Normal School, which trained school teachers, it became a college in 1925. The change of status allowed the school to grant four-year college degrees.

The college is now Arizona State University, the fourth-largest university in the United States. It brings about 45,000 students to Tempe, which now has about 160,000 people. In 1958 Arizona voters approved changing the college to a university, which can grant advanced degrees. The university has grown north, crossing University Drive (near the center middle of the photo). Mill Avenue now joins Apache Road in the curve at the bottom.

Grady Gammage Auditorium is the circular building inside the curve. Named for the college president who led the effort to make Arizona State a university, the auditorium was one of the last buildings designed by famous architect Frank Lloyd Wright. Gammage Auditorium hosted the last debate during the 2004 presidential campaign.

This is Camelback Mountain, one of the Phoenix area's most distinctive and intriguing landmarks. The mountain got the name Camelback, for obvious reasons, as early as 1903, but it was also called Camelsback until the 1930s. Early on, this 2,700-foot-tall mountain became a popular place for picnicking and horseback riding. Camelback was probably the most photographed landmark in the Phoenix area's early history. Shown here in 1932, the base of the Camelback attracted farms and later citrus orchards. Farmers often planted their orchards near the base of the area's mountains. In winter, cold air rolled down the slope of the base and away from the trees, protecting the trees and their fruit from frost. At the bottom is the Arizona Canal, which provided water, the other important ingredient for growing citrus fruit.

The citrus orchards are basically gone now, replaced by homes and residents attracted by Camelback Mountain's beauty. Some of these neighborhoods were built in the midst of the old orchards. Arcadia, a neighborhood started in the 1920s, encouraged homeowners to plant citrus trees on their large lots. A few of these trees survive today, although the trend lately has been to knock down the original houses and to build something much larger on the lot. The road in the middle running toward the mountain and north of the canal is Arcadia Road. Arcadia is such a desirable area in which to live that Realtors have attached the name to places outside the boundaries of the original neighborhood. On the immediate base of the mountain sit homes for some of the Phoenix area's wealthiest and most famous residents.

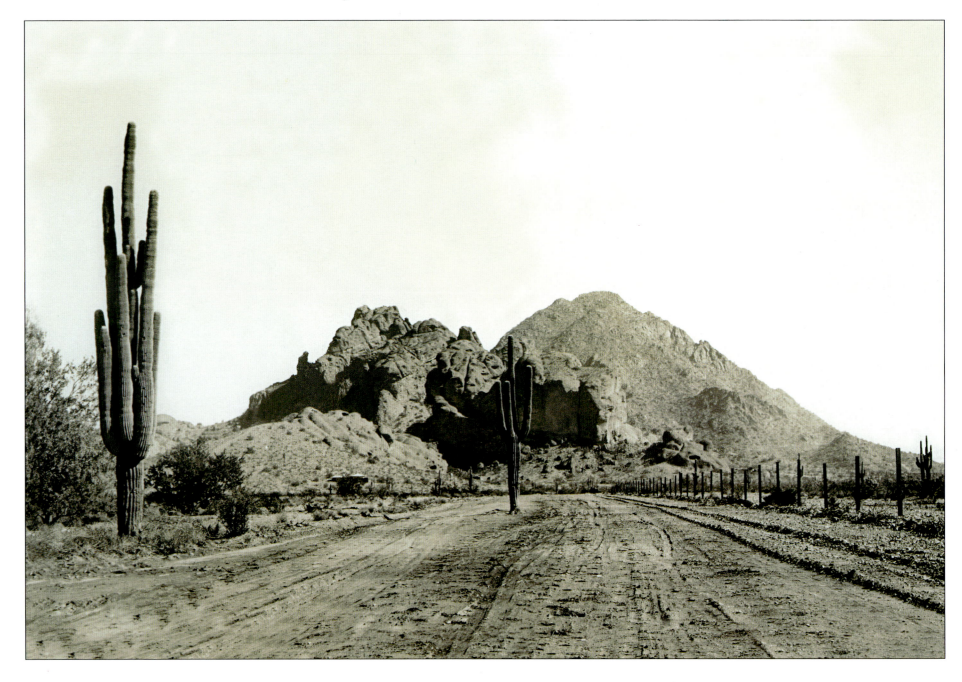

This is a side view of Camelback Mountain, looking east, taken sometime around 1930. The mountain doesn't look very much like a camel from this vantage point, but the mountain's other famous feature is visible. A small jut of stone is visible near the midway point on the left of the mountain. This is the Praying Monk, which actually does look like a kneeling person. Hikers who get closer to the feature come across a rectangular boulder balancing on one of its corners. The legend is that the monk was told not to drop his Bible or he would be turned to stone. Farms are starting to creep up to the mountain in this view, a newly cleared road runs right toward the landmark, and a wire fence stands to the right.

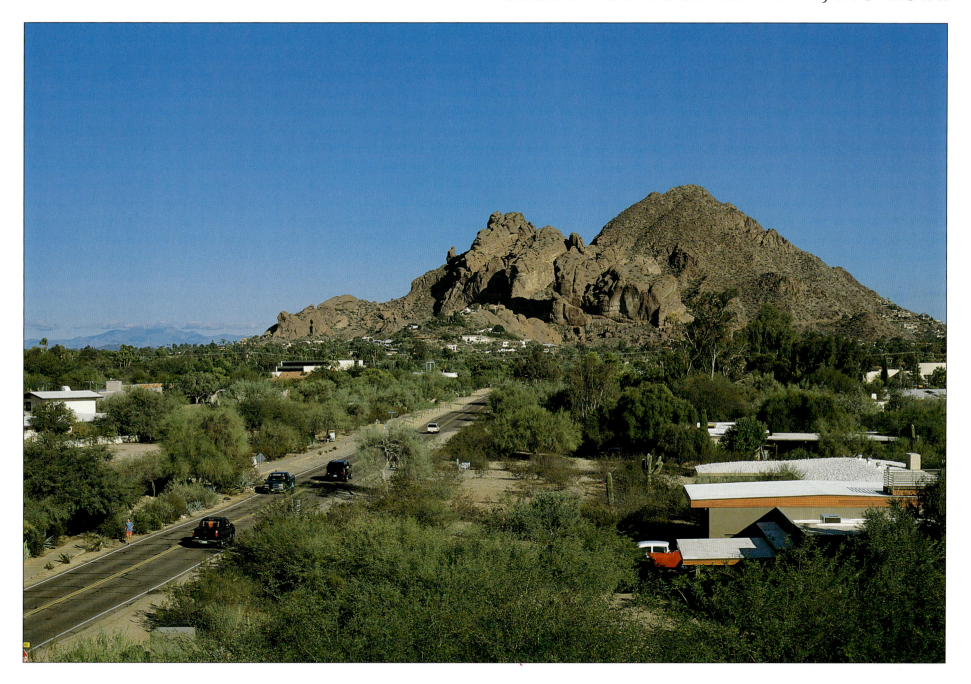

Today urban growth has swept around Camelback Mountain. The area west of the mountain is now part of the Town of Paradise Valley, an area of exclusive homes for the wealthy and famous. Several resorts also hug the mountain's base today. Upscale homes and fancy resorts moved toward the mountain in the late 1930s and flooded the area in the 1950s. Responding to public concern, attempts were made to limit development at the mountain's top in the 1950s. Yet none of these efforts succeeded until Barry Goldwater, Arizona senator and former presidential candidate, started a fund-raising campaign to purchase most of the remaining mountain in 1965. Using private money and public grants, the City of Phoenix bought most of the remaining open space by 1970. The Praying Monk can now be viewed by hikers in Echo Canyon Park.

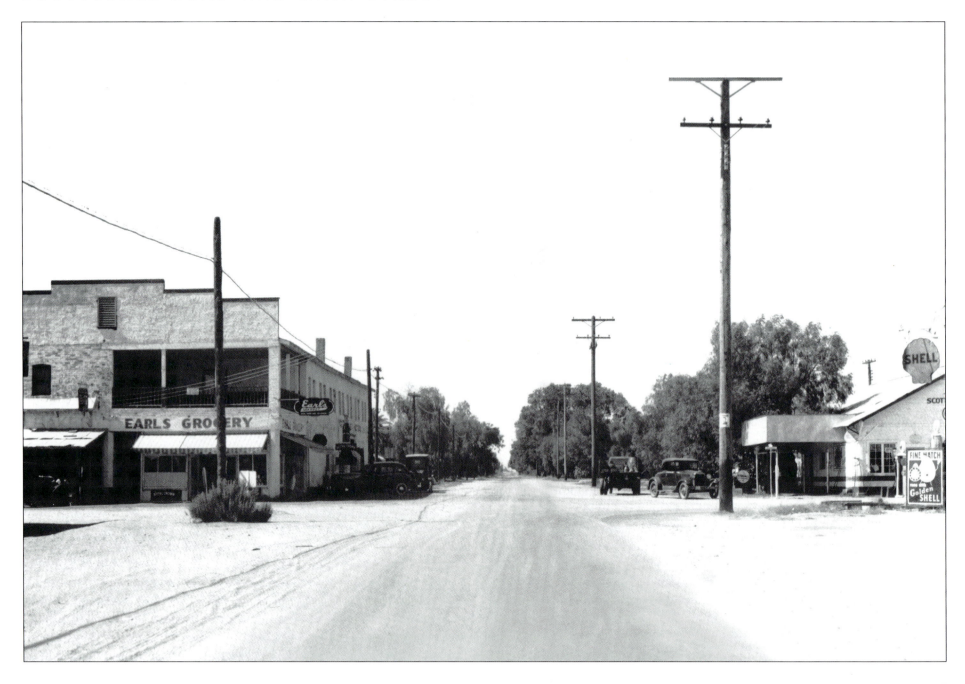

The intersection of Scottsdale Road and Main Street, looking north, about 1937. Located to the northeast of Phoenix, Scottsdale was just a small, unincorporated village in the 1930s and Scottsdale Road was unpaved and dusty. Earl's Grocery, located in a two-story adobe building, is on the left. Earl Shipp worked at the grocery store when it was called Byer's Market and later bought out his boss. Mort Kimsey's garage is to the right, on the northeast corner. Mort's family moved out to Scottsdale in 1915. Mort later became one of the first city councilmen when Scottsdale incorporated in 1951 and the town's second mayor.

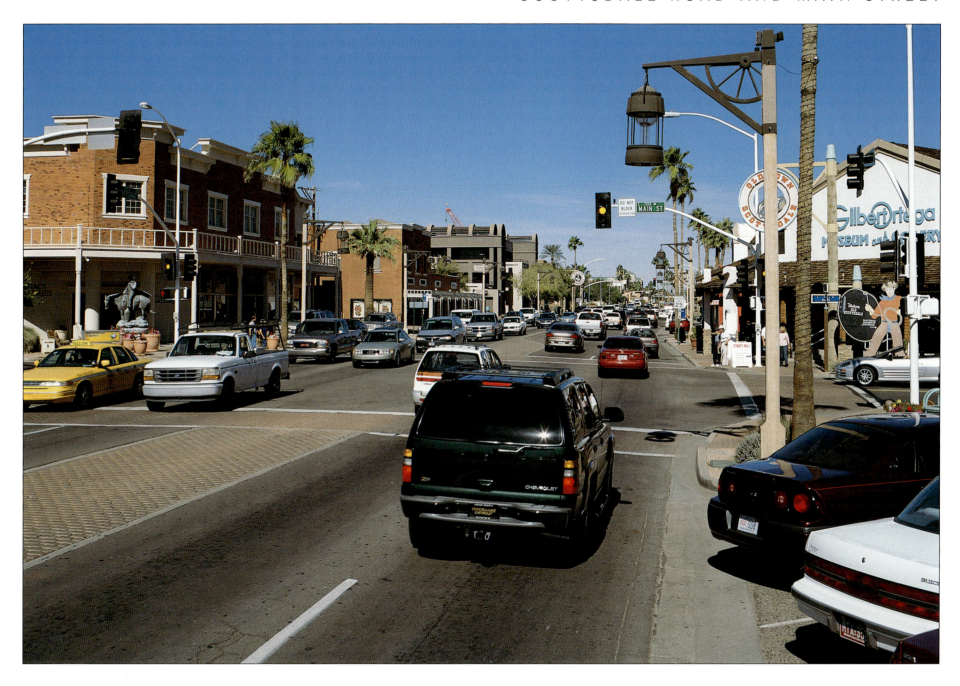

The intersection is today at the heart of Scottsdale's arts district. Art galleries take up the corners where Earl and Mort had their businesses. The village of Scottsdale is now a large city sprawling to the north, and Scottsdale Road is one of its major thoroughfares. Part of its early appeal came from the arrival of Western-themed artists in the 1930s and 1940s. Many of them established studios near this intersection. Later some of the artists moved a little north and started the Fifth Avenue district. The area became a popular tourist destination in the 1950s, and today art galleries and gift shops catering to tourists line Main Street.

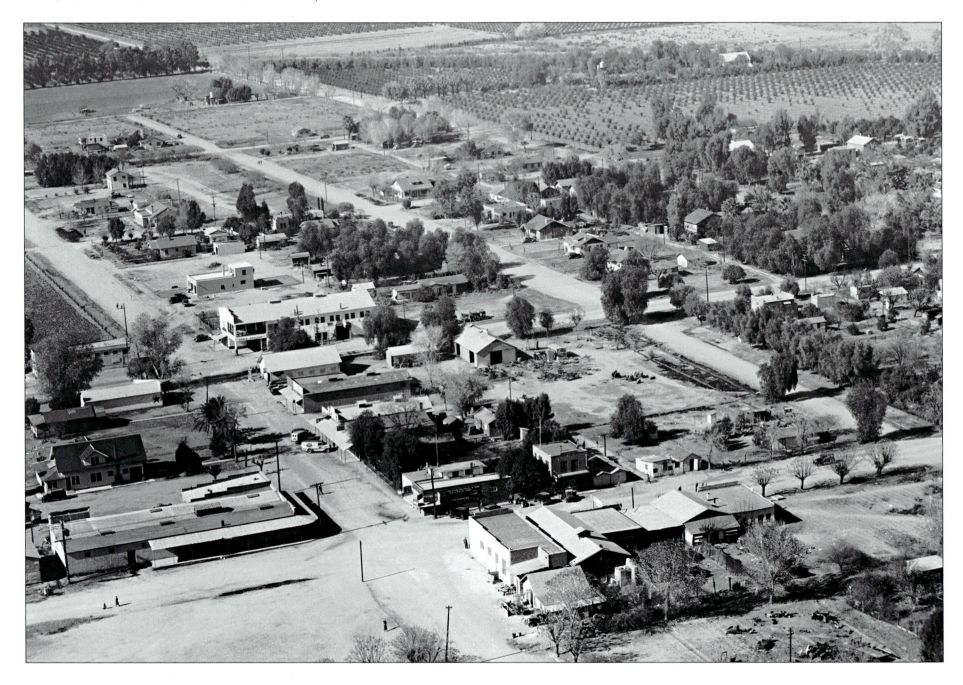

Here is the village of Scottsdale, northeast of Phoenix, about 1936. Looking northwest, Brown Road runs along the bottom of this view. Main Street runs upward from Brown, reaches Scottsdale Road, and continues west. Brown's Mercantile Store, operated by E. O. Brown, stands on the southwest corner of Brown and Main. There was a vital icehouse in the back of the store. Right above Brown's store is the Farmers State Bank Building. The bank, also established by Brown, closed its doors in 1931 in the early days of the Great Depression. On the northeast corner is the J. Chew Store. Of Chinese descent, Jew Chew Song bought this former pool hall in 1928 and turned it into a grocery. Across the street and one building to the right is Scottsdale's first post office.

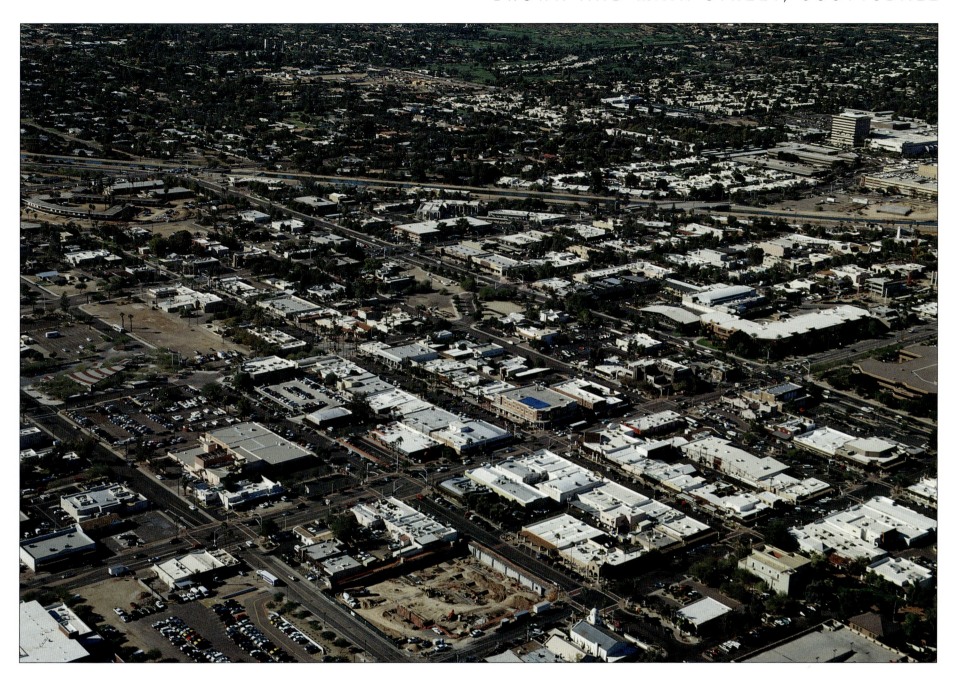

Now the intersection is part of a popular tourist shopping district. The new owner of the post office building started the rush of tourists when he installed a Western-style covered sidewalk in front of his Porter's Western Wear business, complete with a fake horse above the entrance. Soon the look caught on and Scottsdale promoted itself as "the West's most Western town." The Chew family still owns their old grocery, but now it's a Mexican imports store. Bischoff's Shades of the West is located where the Brown store used to be, and the bank building is now the Rusty Spur Saloon. In business since 1958, the saloon is everything tourists think a cowboy bar should be—with a rustic interior and live music. The Scottsdale Mall, an outdoor district of stores, restaurants, and museums, sits to the east of the intersection.

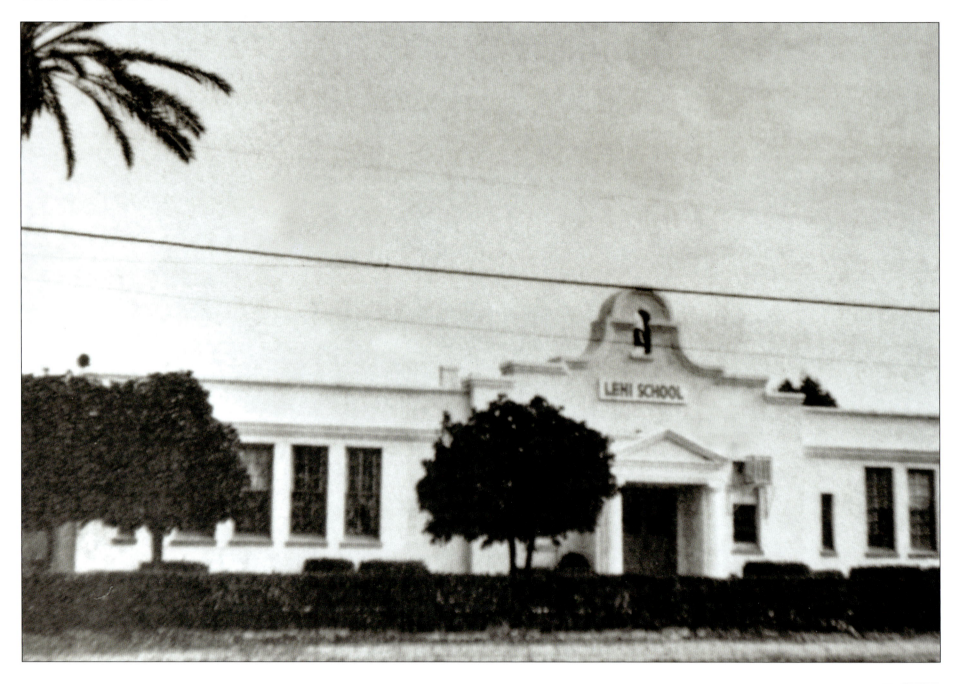

Mormon settlers out of Utah started Lehi in 1877. The Church of Jesus Christ of Latter-day Saints asked Daniel Webster Jones to establish a community in the area. Situated to the east of Phoenix and Tempe, Lehi was the first Mormon settlement in the area. They built a small fort, called Fort Utah, out of adobe bricks. The following year one of the settlers, Henry C. Rogers, donated five acres of land to start a school not far from the fort.

A different group founded another Mormon community a little south of Lehi in 1878 on a flat piece of land that was higher in elevation. Appropriately, residents called their new town Mesa. The Lehi School District built this neoclassical–Mission Revival school in 1913, shown shortly after its completion. Lehi never incorporated as a town, but the school represented Lehi's identity as a separate place.

The Mesa Historical Museum calls the old school home today. The town of Mesa grew and engulfed Lehi, forming a rural pocket in a vast city. A freeway now runs along the northern edge of Lehi, but doesn't go through the middle as was once planned. Mesa's school district absorbed the old Lehi school district in the 1940s and closed Lehi School in 1976. The building sat vacant for a long time because the cost of tearing it down was more than buying a new piece of land. The district turned the building over to the Mesa Historical Society in 1987, which opened the museum in the same year. In 1993 the society changed the name to the Mesa Historical Museum.

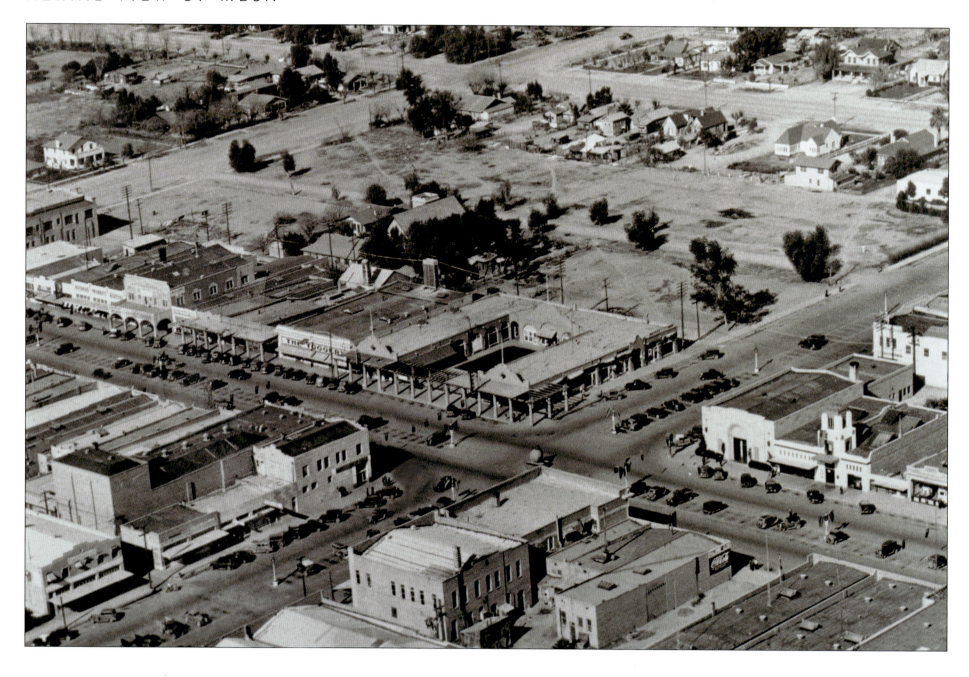

Downtown Mesa in the 1930s. Main Street runs across this view from the middle left. The other street, which crosses to the middle right, is Macdonald. Some of the town's most important commercial buildings can be seen here. The large building in the center with columns and a central courtyard is Chandler Court. Built in 1908 by developer and entrepreneur Dr. Alexander Chandler, who later founded the town of Chandler to the south, this was Mesa's first office building. Three buildings to the left is the Pomeroy Building. Built in 1891, it is one of Mesa's oldest commercial structures. Across from Chandler Court and fronting Main Street is Mesa's first bank, the Mesa State Bank, which opened in 1907. To the left of the bank is Mesa's first theater, the Nile, which started showing talkies in 1929. Main Street was a popular place for local farmers on Saturdays.

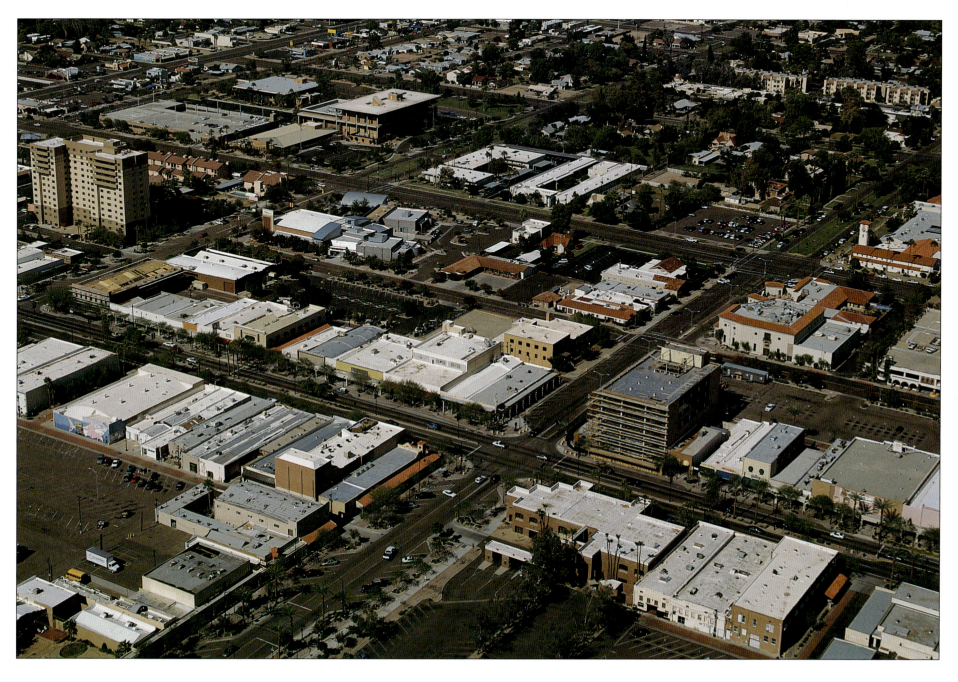

Today Main Street is more popular with antique hunters. Chandler Court has been enclosed and contains an antique store. The Mesa State Bank is long gone, but the Nile Theater remains. The building briefly returned to its entertainment roots in the 1990s as a music venue that featured raves. In great contrast, the building recently became a church. One Macdonald Center, a modern office building under construction, is on the northeast

corner. Just behind it is the city's large natural history museum, the Mesa Southwest Museum. Another museum, sitting just north of the old Pomeroy Building in this view, is the recently expanded Arizona Museum for Youth, which attracts families from throughout the region. The slightly curved white roof of the youth museum almost entirely subsumes a 1960s-era grocery store. The towers to the left are a senior-living community.

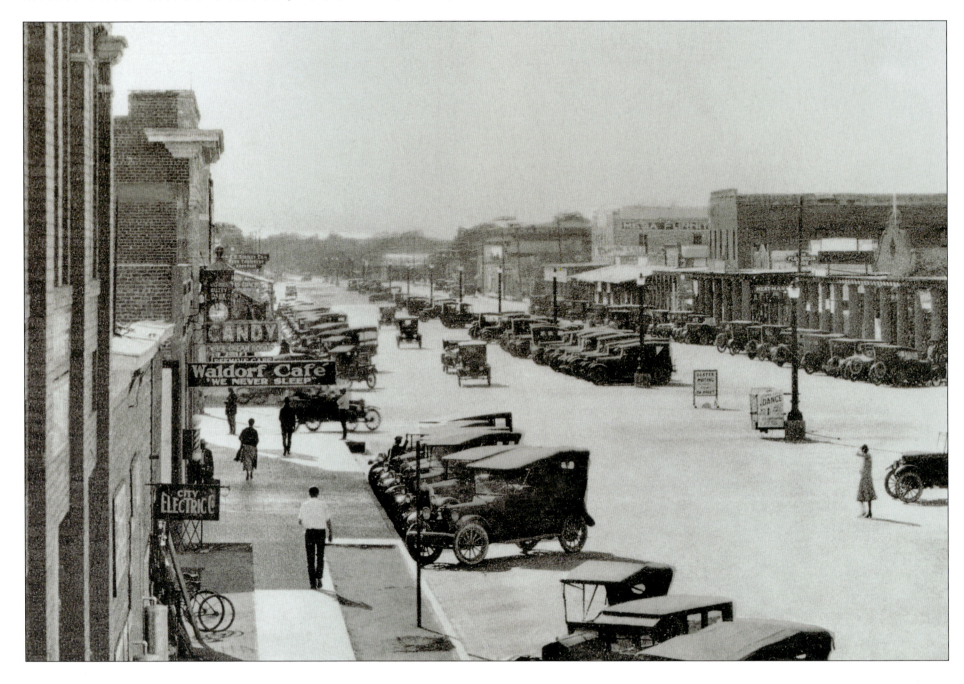

This is the intersection of Mesa's Main Street, the main street through town, and Macdonald around 1920. Mesa streets were famous for their width. Laws required the streets to be wide enough to turn a team of freight animals around without backing up. In 1915 this left enough room to park cars in the middle of the street. Looking west, the building to the right is Chandler Court. Built in 1908, it claims to be one of the first buildings with evaporative cooling in the world. The tall building to the left of Chandler Court is the Pomeroy Building. Its second floor had a large hall, and it hosted many of Mesa's early social events.

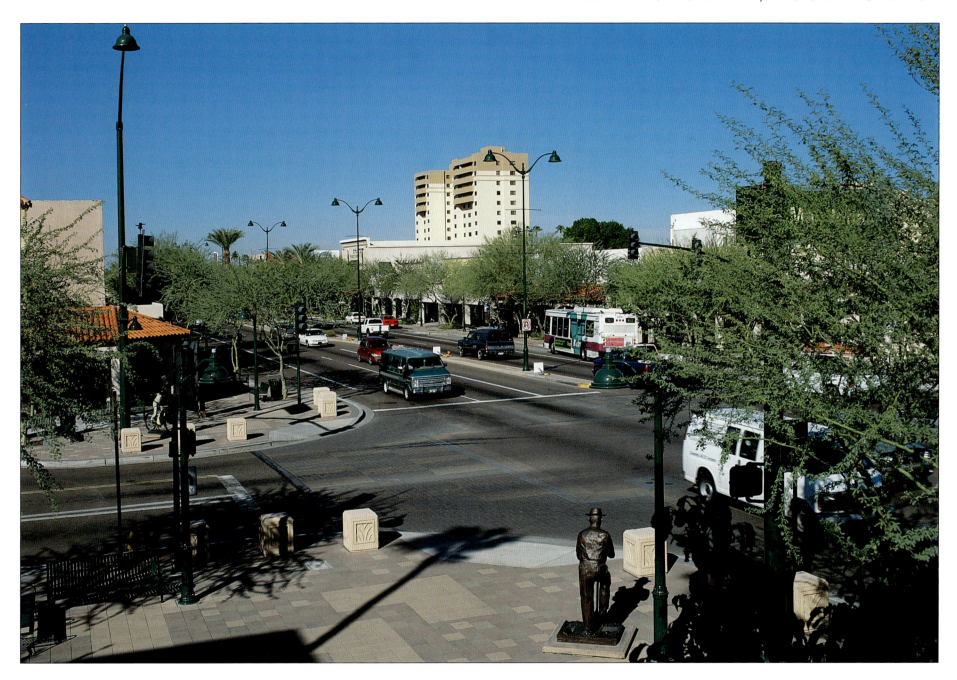

Now this intersection is the meeting of the old and new. This is still Main Street, but now it's just one of many places where Mesa residents can go to shop in their city. The middle-street parking disappeared around 1940. Chandler Court is still there and so is the Pomeroy Building. It still contains some of the businesses it has always had—a men's clothing store and a trophy shop—but almost everything else is different. Mesa added a unifying arcade or covered walkway in front of many of the old businesses in the 1970s. Recently the city added new sidewalks and benches to attract pedestrians. In the winter months, Mesa rents and installs bronze statues featuring the types of people once seen on Main Street.

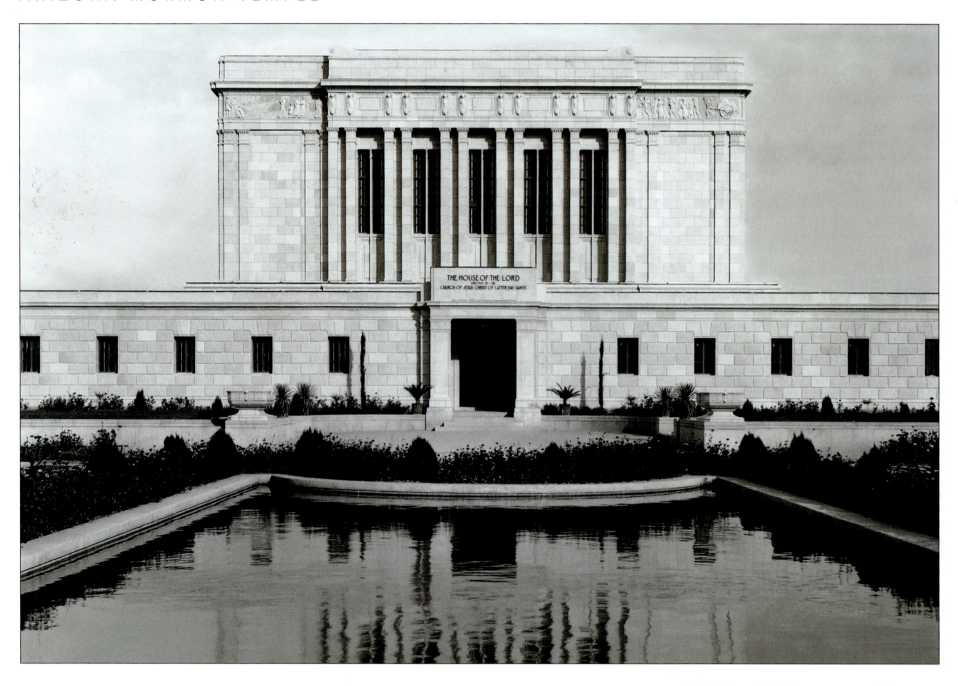

A temple is the most important building there is for members of the Church of Jesus Christ of Latter-day Saints. The temple is the sacred place where members can get married and participate in other important services. This was the first temple in Arizona, shown here shortly after its completion in 1927. Mormons, now called Latter-day Saints, first settled in Arizona in the 1860s and established Mesa in 1878. Mesa quickly became the center of the Mormon community in Arizona, yet church members had to travel to St. George, Utah—site of the nearest temple—to get married. The completed temple, located on the main road through Mesa, soon became the focus of the city.

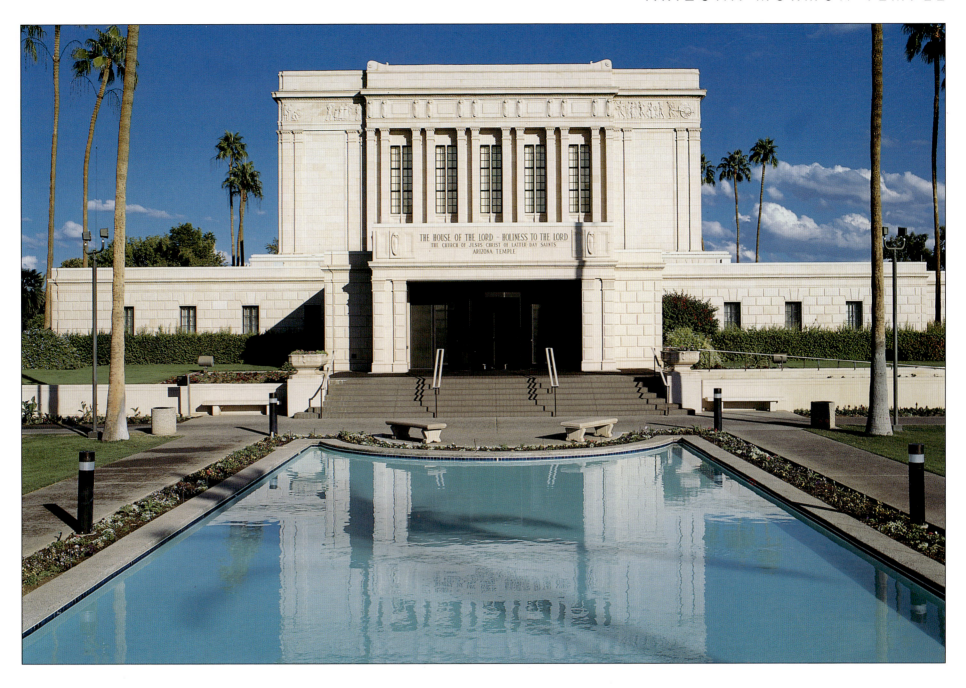

THE HOUSE OF THE LORD · HOLINESS TO THE LORD
THE CHURCH OF JESUS CHRIST OF LATTER-DAY SAINTS
ARIZONA TEMPLE

The Arizona Temple is still the most important place for Latter-day Saints in the Phoenix area today, but it is no longer the only temple in Arizona. The church built a second temple in Holbrook in 2003. The Mesa Temple was the first place where official ceremonies were performed in Spanish. The church rededicated the temple in 1975 after a major renovation.

Mesa is now the third-largest city in the state, and residential neighborhoods now surround the once-isolated temple. Across the street to the west is the Mesa Family History Center, which helps thousands of people research their heritage each year.

INDEX